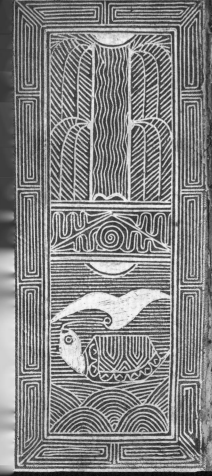

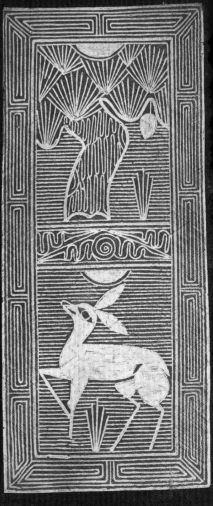

Korean Art and Design

THE
SAMSUNG
GALLERY OF
KOREAN ART

Korean Art and Design

TEXT
Beth McKillop

PHOTOGRAPHY
Ian Thomas

DESIGN AND PRODUCTION
Patrick Yapp

VICTORIA AND ALBERT MUSEUM

Published by the Victoria and Albert Museum
First published 1992

A catalogue record for this book is available from the
British Library

ISBN 1 85177 104 2

Cartography by Lee Gibbons and Rodney Paull
Index by Robert Hood
Typesetting by Southern Positives and Negatives (SPAN),
Lingfield, Surrey
Printed in Great Britain by the University Press,
Cambridge

Front cover:
RANK BADGE
Coloured silk thread on figured silk
1800–1900, late Chosŏn dynasty
21.5 × 20 cm
1848–1888

Back cover:
OIL BOTTLE
Stoneware, inlaid under a celadon glaze
1150–1250, Koryŏ dynasty
Height 5.9 cm
C.560-1918

Reverse of cover:
DETAILS OF BRUSHPOT
Iron inlaid with silver wire
1850–1900, late Chosŏn dynasty
Height 19.6 cm
M.401-1912

Contents

Prefaces

KOREAN ART FOR THE WORLD

I take great pleasure in congratulating the Victoria and Albert Museum on the opening of the Samsung Gallery of Korean Art and the publication of this precious book which presents Korea's brilliant cultural heritage to art lovers around the world.

Korea and England have maintained friendly ties for over a century since our two nations established formal relations in the late nineteenth century. We have had remarkable exchanges and co-operation over these years, not only in the political and economic areas, but in the cultural field as well. In particular, visiting exhibitions of masterpieces from Korea at the Victoria and Albert Museum in 1961 and at the British Museum in 1984 have made significant contributions to cultural exchange between our two nations.

Korean art, which has developed from roots in Korea's unique natural environment and social and religious milieu, embraces a consistent stream of thought: Korean artists have aspired to be at one with nature, which they adore as a spiritual paradise blessed by perfect selflessness. This spirit has permeated Korean art through the ages, from the Buddhist images of the Three Kingdoms period and the tomb murals of Koguryŏ to sculptures, paintings and ceramics of the Chosŏn dynasty.

It is more than gratifying that we can appreciate the spirit and beauty of Korean art in the exhibits at the Samsung Gallery of Korean Art at the prestigious Victoria and Albert Museum. I also believe that this book will help open the eyes of many people to the marvellous world of Korean art.

In this regard, I am pleased to note that the Samsung Group was honoured to make a small contribution to the opening of the gallery. I hope that both the establishment of the gallery and the publication of this book will serve as a momentous occasion to further increase the mutual understanding and cultural exchange between our two nations.

Kun Hee Lee
Chairman
The Samsung Group

The Victoria and Albert Museum has realised a long-standing ambition to display its extensive collection of Korean objects in a fitting manner with the opening of the new Samsung Gallery of Korean Art. It was as early as 1878, when Anglo-Korean relations were at an embryonic stage and the Museum had existed for less than thirty years, that the first Korean object was added to the collection. Subsequent British travellers, diplomats and collectors brought further Korean artefacts to the Museum's attention. The names of Thomas Watters for handicrafts and textiles, Aubrey Le Blond for ceramics of the Koryŏ period and William M. Tapp for Korean porcelains are outstanding among those whose interest in Korean art informed the growth of the V&A collection.

As part of the Far Eastern Section, the Korean collection and the Korean gallery can now make a very useful contribution to the important work of researching and displaying to the public the historic and contemporary artistic production of East Asia. The fine quality of the Museum's Korean ceramics collection is already widely recognized. The long-awaited opportunity to display bronze and other metal objects, textiles, lacquers inlaid with mother-of-pearl, paintings and contemporary crafts from Korea for the first time in environmentally-controlled surroundings is an exciting one. It will introduce a hitherto little-known segment of the Museum's collection of Korea's artistic heritage to our visitors.

I should like to express the heartfelt gratitude of the Trustees, Director and staff of the Museum to the Samsung Group for the generous support which has turned our plan to build a Korean Gallery from an aspiration into a reality.

Armstrong of Ilminster
Chairman
The Board of Trustees of the Victoria and Albert Museum

Acknowledgements

The opening of London's first permanent gallery of Korean art, and the publication of this book, would have been impossible without the generous support of a number of colleagues in Britain and in Korea. Director Han Byong-sam of the National Museum of Korea and Director Rhi Chong-sun of the Ho-Am Art Museum and their staff have given practical and detailed help in ways too numerous to mention. HE Oh Jay Hee and, since spring 1991, HE Lee Hong Kou and their colleagues at the Korean Embassy in London have steadily guided the many strands of the gallery plan towards successful completion, and to them we owe a special debt of gratitude. We also express our sincere thanks to Mr G.S. Im, Mr S.H. Yoon and Mr Wan Choi of Samsung (UK) Limited, who have taken an active interest in the new Korean gallery, a welcome addition to Samsung's financial support. We are grateful to Sir John Figgess, who chaired the Advisory Group which met regularly throughout the gallery's preparation period, making recommendations on every aspect of the project. I am grateful to Professor Martina Deuchler of the Centre for Korean Studies, London University, for her helpful comments on the draft manuscript of this book, and for her views about the slate chest and inscription for Paek Chun-min. Dr Pak Youngsook and Dr Keith Howard of the same Centre also generously offered guidance about specific topics relating to the preparation of the gallery. Naturally, responsibility for any errors is mine alone.

Many of my colleagues at the Victoria and Albert Museum contributed to the detailed planning of the gallery. They include the Museum's Director, Elizabeth Esteve-Coll, Gordon Charlesworth and Stephen King of the Department of Buildings and Estate, Amanda Ward of the Collections Department, and all members of staff in the Far Eastern Collection: Rose Kerr, Craig Clunas, Rupert Faulkner, Anna Jackson, Greg Irvine, Julia Hutt, Verity Wilson, Elaine Morze and Diana Coghill. Liz Wilkinson undertook the duties of gallery coordinator with patience and skill, drawing together the many schedules of work which paved the way for the gallery's opening. Ruth Bottomley organised a complex photographic programme, and Ian Thomas took the beautiful photographs. I also wish to thank Edmund Capon, formerly assistant keeper in this Museum and now Director of the

Art Gallery of New South Wales, for allowing me to make use of his extensive researches into the iconography and provenance of the painting of Samantabhadra, originally published in 1979 in *Oriental Art*.

Conservation scientists working in all media have worked tirelessly to prepare objects for display. Diana Heath coordinated a demanding conservation programme which entailed painstaking investigation of the composition and construction of the objects in the collection. Ann Amos, Sarah Boulter, Josephine Darrah and John Kitchin made important contributions to descriptions of objects, based on research carried out during conservation work. I also wish to thank Charles Kennett and his colleagues in the Museum's joinery section, and Peter Riley and his team of object handlers.

Tim Molloy and Emma Thompson of Malone Design Company have responded with imagination and flair to the challenge of designing a distinctive gallery with an environment suitable for objects that require sharply differing lighting and environmental control standards. In realising the Museum's aim of suggesting a Korean atmosphere, while respecting the integrity of the architectural environment in which the Korean gallery is situated, they have produced a splendid gallery design. Tim Molloy, who visited Korea in the course of his work, deserves particular mention for proposing the contruction of the Hangul Tower, an elegant solution to the problem of drawing the row of galleries along the Museum's east-west frontage to a clear conclusion. The Tower functions both as a powerful representation of calligraphy in the Korean script, and as a case displaying a regularly rotating selection of contemporary Korean crafts.

I am grateful to Faber and Faber Ltd for permission to quote from G. St G. M. Gompertz, *Koryo Celadon* and *Korean Pottery and Porcelain of the Yi Period*; W. B. Honey, *Corean Pottery*; and C. Kim and W. Kim, *The Arts of Korea*. British Museum Publications kindly gave permission to quote from Goepper and Whitfield, *Treasures from Korea*; and the quotation from B. Leach, *The Potter's Challenge* is by permission of Souvenir Press. In common with guides to the V&A Chinese and Japanese Galleries already published, this book has been written without footnotes. Those whose appetite for Korean art is whetted by the pages that follow can find suggested further readings on page 189.

Beth McKillop
Far Eastern Collection

Historical Introduction

THE Korean peninsula curves out from the land mass of North-East Asia, dividing the Yellow Sea from the Sea of Japan. It includes the island of Cheju to the south and stretches as far as the Yalu (Amnok) and Tumen (Tuman) rivers to the north, a distance of about 1,000 kilometres. There is a long land border with the Chinese province of Liaoning and a short sixteen-kilometre boundary with Russia, south-west of Vladivostok. At the end of the Second World War Korea was divided along the 38th Parallel and, since the truce which ended the Korean War in 1953, the country has been cut in two by the Demilitarized Zone. The Republic of Korea, with its capital at Seoul, governs the southern part of the country. P'yŏngyang is the capital of the Democratic People's Republic of Korea which rules the north.

Korea's climate tends to the extreme: the winter temperatures are sub-zero in most of the country, and summer sees monsoons that bring much of the year's rainfall. The variation in climate from north to south has influenced building and furniture styles across the country. The semi-tropical island of Cheju has its own distinctive culture. Because of the contrast in the seasonal climate, houses were designed to provide warmth in the long freezing winters, and to be readily adaptable to the need for ventilation and shade throughout the uncomfortably humid summer months.

Much of the country is mountainous. Mount Paektu, the highest point in the country, is 2,744 metres above sea level. A jagged, indented coastline runs along the west of the country; on the east it is smoother but sheer. River valleys have traditionally been centres of settlement, of which the most significant have been the Yalu and Tumen rivers, the Taedong river on which P'yŏngyang sits, the Han river where Seoul is located, and the Naktong, the river of the south-east, which flows through Kyŏngsang province towards the south coast, discharging west of Pusan.

The western provinces of P'yŏngan, Hwanghae, Kyŏnggi, Ch'ungch'ŏng and Chŏlla are separated from China by the Yellow Sea. The Sea of Japan, which Koreans refer to as the East Sea, washes the east coast of the peninsula, along the provinces of Hamgyŏng, Kangwŏn and Kyŏngsang. Korea is a land of spectacularly beautiful landscape, with densely wooded mountains providing a peaceful, uplifting setting for the country's artistic heritage. Many visitors remark on the Koreans' passion for the landscape of their

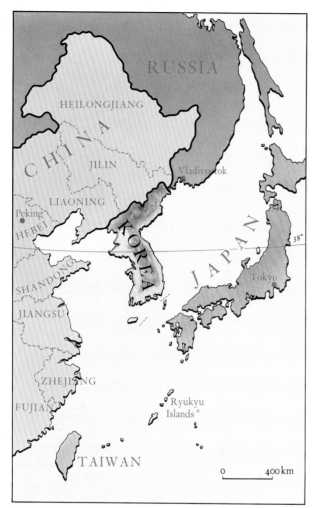

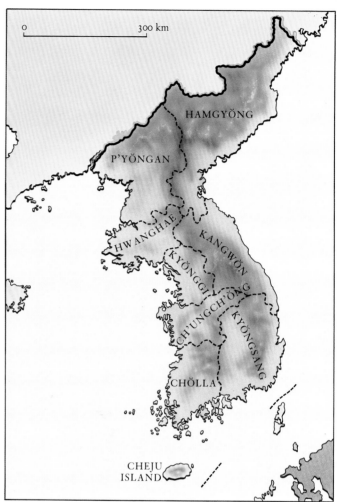

NEIGHBOURING
REGIONS (*top left*)
Russia – Vladivostok
Japan – Tokyo
 Ryukyu Islands
Taiwan
China – Peking
Heilongjiang province
Jilin province
Liaoning province
Hebei province
Shandong province
Jiangsu province
Zhejiang province
Fujian province

PROVINCES OF KOREA
IN THE CHOSŎN
DYNASTY (*top right*)
Hamgyŏng
P'yŏngan
Hwanghae

Kangwŏn
Kyŏnggi
Ch'ungch'ŏng
Kyŏngsang
Chŏlla

THREE KINGDOMS
AND HISTORICAL
SITES (*opposite*)

KINGDOMS
Koguryŏ
Paekche
Silla

CAPITALS ○
Kungnaesŏng
P'yŏngyang
Kaesŏng
Seoul
Kwangju
Kongju

Puyŏ
Kyŏngju

CITIES ●
Yŏnpo
Wŏnsan
Inch'ŏn
Wŏnju
Pusan

SITES ◉
Long Wall
Lelang
Kimhae

TOMBS ◼
Tomb of the Wrestlers
Tomb of the Dancers
Great Tomb

ISLANDS
Kanghwa
Cheju

MOUNTAINS ▲
Paektu
Diamond
Taebaek
Kyeryong
Kaya

RIVERS
Tumen
Yalu
Taedong
Han
Naktong

MAJOR KORYŎ KILN
SITES ☻

MAJOR CHOSŎN KILN
SITES ☻

LACQUER GROWING
AREAS Ψ

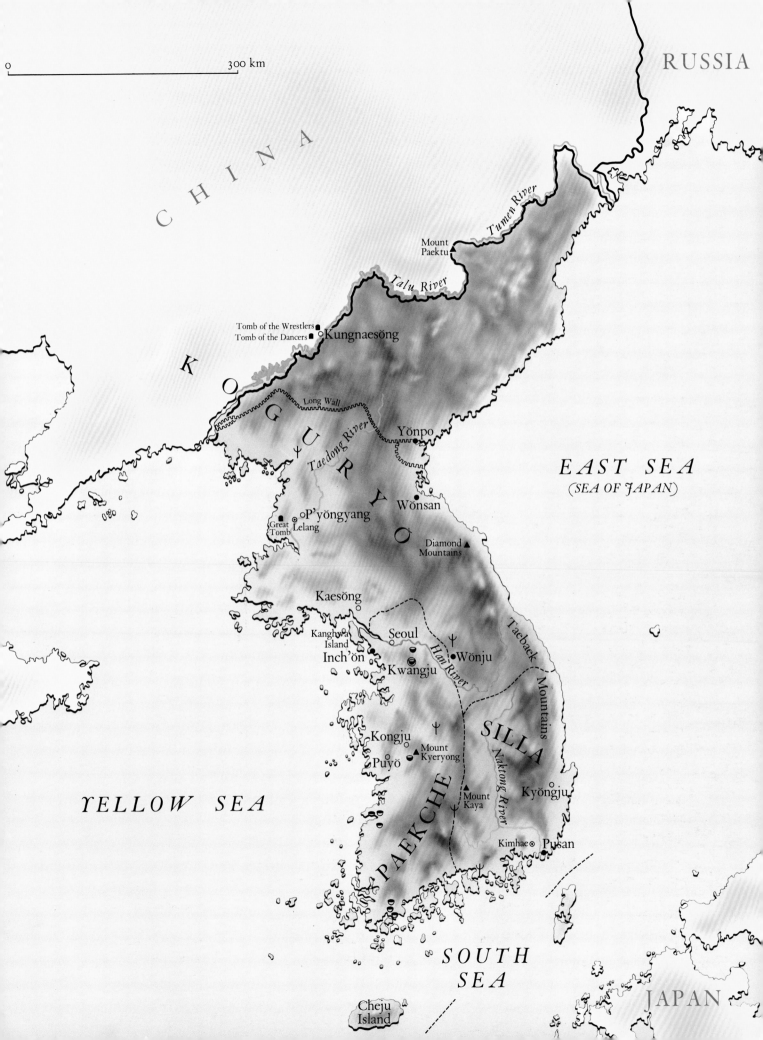

RUSSIA

CHINA

0 300 km

Tumen River

▲ Mount
Paektu

Talu River

Tomb of the Wrestlers ■
Tomb of the Dancers ■ ◉ Kungnaesŏng

K

O

G

Long Wall

Taedong River

U

● Yŏnpo

R

● Wŏnsan

Y

O

Great
Tomb ■ ◉ P'yŏngyang
Lelang

Diamond ▲
Mountains

EAST SEA
(SEA OF JAPAN)

Kaesŏng
◉

Seoul
Kanghwa ◉
Island
Inch'ŏn ●
Kwangju ◉

Han River

● Wŏnju

Taebaek

Mountains

SILLA

Kongju ◉
▲ Mount Kyeryong
Puyŏ ●

Naktong River

Kyŏngju ◉

P

A

E

K

C

H

E

▲ Mount
Kaya

Kimhae ◉ ● Pusan

YELLOW SEA

SOUTH
SEA

Cheju
Island

JAPAN

native land. The love of nature is a recurring theme in the history of Korean art and design, as artists and craftsmen in all media use local materials and draw inspiration from the mountains and rivers around them.

During the second half of the twentieth century, archaeologists have made significant advances in the study of Korea in prehistoric times. Where once little was known in a scientific sense of the earliest inhabitants of the Korean peninsula, their way of life and centres of settlement, it is now possible to sketch a general picture of the ancestors of the Korean people. Their story is told in terms of the objects and buildings found at settlements where they lived. Different periods are distinguished by association with the kind of decoration on vessels, or with the style of grave construction. The ability to test the dates of individual objects by carbon dating has also been extremely useful to archaeologists.

In spite of all these advances in the study of the past, however, our knowledge of life in this region before about 5000 BC remains sketchy. It has been established that Palaeolithic settlements were distributed over most of the Korean peninsula, but the significance of the information available has not yet been determined, as academics continue the debate about the development of man-made tools, the connections between Korean, Siberian and Chinese Palaeolithic technology, and the ethnic background of the Palaeolithic inhabitants of the peninsula.

The very earliest Korean Neolithic settlements that have been found (that is the dwellings of people who made polished stone tools and plain, round-bottomed earthenware pots) are believed to date from between 4000 to about 3000 BC. These earliest Neolithic people were possibly of the same ethnic stock as those who lived at that time in Siberia.

The next Neolithic period is distinguished by the comb-pattern pottery which is found in widely scattered sites. Lasting from about 3000 to 2000 BC, the second or mid-Neolithic period is a distinctive culture unique to the area which today comprises Korea, Manchuria (parts of the territory of the three north-eastern Chinese provinces of Liaoning, Jilin and Heilongjiang) and eastern Siberia. In the late Neolithic period, which lasted from about 2000 BC until about 1000 BC, a new population, called Yemaek in ancient Korean and Chinese records, migrated from Manchuria into the Korean peninsula. These incomers are thought to have brought the technology of bronze making with them, paving the way for the gradual replacement of Neolithic culture by Bronze. During this era, the earliest Korean state, Ancient Chosŏn, is said to have been founded and continued to exist until the second century BC.

The Bronze Age in Korea is thought to have lasted from about 900 to about 300 BC. Distinctive Korean artefacts were made, including mandolin-shaped daggers and a kind of knobbed mirror. As these objects have been

found in the region of North-East Asia encompassing present-day Manchuria and eastern Siberia, archaeologists believe that early Korean culture extended far beyond what we know today as Korea. During the Bronze Age, stone and wood tools such as axes, chisels and knives continued to be widely used. It seems likely that the bronze daggers, mirrors and ritual implements which have been excavated from tombs in various parts of the country were prized possessions of the powerful and wealthy, rather than everyday objects.

The three centuries before the beginning of the first millennium AD were a time of continuing technological and social change in Korea. Iron casting, introduced from China around 300 BC, had important effects on agriculture and weaponry. A new type of pottery, known as Kimhae from the site in the extreme south where it was first excavated, was made from about the first century BC onwards. Kimhae-type pottery was the first Korean ware to be thrown on a wheel. Historians believe the potter's wheel was introduced to Korea from Han dynasty China (206 BC–AD 220) through commanderies established in the northern area of Korea from 108 BC. The most important of these Chinese commanderies was Lelang (Nangnang) which remained an outpost of Chinese rule until the fourth century AD, when it fell to the rising might of the northern Korean state of Koguryŏ.

As a result of the introduction of closed kilns, which could reach a higher temperature than the open kilns in which the plain coarse pottery of the Bronze Age had been fired, high-fired vessels with thin, non-porous walls started to be made. In the first to third centuries AD, spherical jars, steamers with perforations, and pedestalled vessels all began to appear. These were the precursors of a distinctive pottery tradition which was to persist for nearly 1,000 years.

By about the third century AD, the first recognizable early states on the Korean peninsula emerged, as scattered settlements gradually coalesced to form larger political units controlled by leaders invested with the legitimizing trappings of power. Koguryŏ, the largest and most northerly of the early Korean states, developed into a consolidated kingdom in the first century AD, controlling a vast area stretching north from the Han River valley as far as southern Manchuria. The Buddhist faith reached Koguryŏ in the course of the fourth century, and stimulated the production of numerous images of devotion such as statues and paintings of Buddhist deities, and the building of temples.

Koguryŏ is also famous for the numerous tombs which surround the sites of its two capitals: Kungnaesŏng, at present-day Tonggou on the Yalu river, and after 427, P'yŏngyang, to the south, on the Taedong river. Wall paintings in tombs dating from the fifth to the seventh centuries depict scenes from the lives of the royal and noble persons buried in them, as well as mythological and Buddhist-inspired subjects.

South of Koguryŏ's domain, new political entities grew up between about 300 BC and AD 200: Mahan (modern Kyŏnggi, Ch'ungch'ŏng and Chŏlla provinces); Pyŏnhan (modern Kyŏngsang province, west of the Naktong river); and Chinhan (modern Kyŏngsang province, east of the Naktong river). The Three Han, as these southern confederations are called, are believed to have consisted of groups of independent walled-town states, and they formed the historical background from which the two important kingdoms of Paekche and Silla emerged.

The small state of Paekche in the Han river area in the centre and south-west of the peninsula, grew during the third and fourth centuries AD to become a kingdom controlling former Mahan territories. Paekche maintained contact by sea with Chinese states and with Japan, since land access to China was blocked by the hostile kingdom of Koguryŏ. Buddhism, which was adopted by Paekche in 384, is known to have been transmitted to Japan by way of Paekche. The Paekche capital was located first at Wiryesŏng (near present-day Seoul), and then moved south, to escape the expansionist forces of Koguryŏ, successively to Hansan (present-day Kwangju, Kyŏnggi province), Ungjin (present-day Kongju), and Sabi (present-day Puyŏ). Paekche had to fight for its survival against both Koguryŏ and Silla.

Silla had its origins as the small state of Saro in the Chinhan group of walled-town states. By about the second half of the fourth century, Silla was governed by kings and had become the most important power in the southeast of the peninsula. During the sixth century, Silla absorbed the federated states of Kaya which had occupied the territory of the former Pyŏnhan walled towns. Unlike Silla and Paekche, Kaya did not develop into a united kingdom, but is an area of enormous archaeological importance that produced fine earthenware and stoneware, as well as splendid gold, silver and bronze jewellery.

Early Silla should be distinguished from United Silla (668–935), the period after the territory of Paekche and parts of Koguryŏ were absorbed by the Silla rulers. During the sixth century, much later than Koguryŏ and Paekche, Early Silla adopted Buddhism as the state religion. Around this time, developments in China affected Korean history very profoundly. The Sui (581–618) and Tang (618–906) dynasties sent armies against Koguryŏ, whose territories, as we have seen, reached far into Manchuria. Having failed to defeat Koguryŏ, Tang forces allied with Silla, to defeat Paekche in 660 and Koguryŏ in 668. Some years later, having driven the Chinese off Korean territory, United Silla came to rule the area south of a line from the mouth of the Taedong river to present-day Wŏnsan on the east coast.

The area controlled by United Silla was thus considerably less than the sum of the Three Kingdoms: in parts of former Koguryŏ territory, a new kingdom known as Parhae (in Chinese, Pohai) was founded, which main-

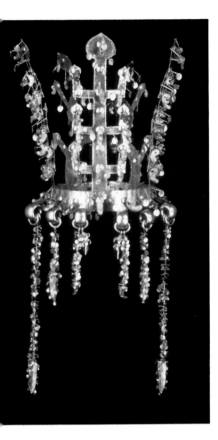

A gold crown from the Great Tomb of Hwangnam-ni, Kyŏngju. 400–700, Silla period. Kyŏngju National Museum

tained close links with Tang China. Parhae ruled northern Korea, extending beyond the Yalu and Tumen rivers, and the population included many Malgals, members of Tungusic tribes from Manchuria, Siberia and north-east Korea.

Both Early and United Silla are noted for magnificent gold crowns and ornaments, reflecting the pre-eminence of the royal house in an aristocratic and hierarchical society. The Silla capital, Kyŏngju, preserves astonishing evidence of the cosmopolitan splendour of court life. The city was modelled on the Tang Chinese capital, and, like Chang'an, welcomed foreigners from far-off lands, as testified by the distinctly non-East Asian features of some guardian figures found in tombs in and around Kyŏngju. Further proof that Kyŏngju was a crossroad of civilizations is the large quantity of glass vessels and beads found in tombs, since these were clearly inspired by, if not imported from, the glassmakers of Western Asia and Europe. Compared to the long-lived dynasties of Koryŏ and Chosŏn which succeeded it, United Silla ruled for a mere 250 years. It was, however, a crucial period in the establishment of Korea's autonomy and prosperity. In defeating Chinese ambitions to rule the peninsula as a directly governed protectorate, United Silla safeguarded the cultural and political identity of Korea.

The Buddhist faith permeated all levels of Silla society, before and after unification. Monks travelled to Tang China to study and obtain copies of the scriptures. The common people adhered to Pure Land Buddhism, which taught that repetition of an invocation to Amitābha Buddha would lead to rebirth in the Western Paradise. Among the aristocratic élite, the philosophically complex Hwaŏm school of Buddhist theology (Avataṃsaka) attracted adherents through its teaching that all living creatures are embraced by the unity of the Buddha-mind.

United Silla lost control of large areas of its territory towards the end of the ninth century, as popular uprisings and revolts by local potentates affected the collection of taxes needed to support the court. Decades of hostilities were ended in 935 when Silla surrendered to Wang Kŏn, posthumously known as T'aejo, first king of Koryŏ. The new dynasty embarked on a series of administrative reforms. Silla aristocrats were no longer able to monopolize all the important positions in the government bureaucracy, as access to political power was opened to a wider group of candidates who were eventually to form Koryŏ's hereditary aristocracy.

The capital of Koryŏ, Kaesŏng, was far from the Silla heartland in the south-east, and even the dynastic name, composed of two of the three characters in Koguryŏ, echoed the northern origins of the dynastic founder. The country's northern border was gradually pushed back during the tenth century, as Koryŏ attempted to regain territories formerly ruled by Koguryŏ.

Koryŏ had taken power in a time of armed conflict, and it was not long before the military skills of its armies were called upon to repel the Khitan, a nomadic people who launched a series of attacks on Koryŏ from their base in what is now Manchuria throughout the 990s and the first years of the new millennium. After the Khitan had been defeated in 1018, Koryŏ was soon under pressure from another Manchurian nomadic people, the Jurchen. From tribal origins in the Tumen river basin, the Jurchen grew increasingly powerful, eventually founding the Jin dynasty in China in 1115. Between 1033 and 1044, Koryŏ built a defensive barrier known as the 'Long Wall' running from the mouth of the Yalu to Yŏnpo on the east coast, in an attempt to keep out the Khitan and the Jurchen. The Long Wall failed however to protect Korea against the next wave of northern invaders to trouble the peace.

In 1231 the Mongols launched the first of a series of devastating attacks against Koryŏ. The court fled the capital and withdrew to the island of Kanghwa, at the mouth of the Han river, where it enjoyed its customary luxurious way of life. Much of the population took refuge in mountainous areas. After decades of repeated Mongol campaigns, which devastated wide areas of the countryside, the discredited court abandoned the struggle against the Mongols and in 1270 returned from Kanghwa island to Kaesŏng. The remaining years of the Koryŏ dynasty were marked by the decline in prestige of the ruling house, as many felt that resistance to Mongol domination ought to have continued. Intermarriage was practised between the Koryŏ royal house and the Mongol Yuan dynasty of China, and Korea became a 'son-in-law' to the Mongols: King Ch'ungnyŏl (reigned 1274–1308), for example, married a daughter of Kublai Khan, the first emperor of the Yuan dynasty. The Koryŏ royal house became 'Mongolized', adopting the Mongol language, dress and customs. It was a century later, after the Yuan dynasty in China had been defeated by the Ming in 1368, that the balance of power inside Korea changed and the influence of the pro-Mongol faction waned.

Koryŏ's rulers frequently invoked the protective powers of Buddhism to safeguard the country. The project of carving all the Buddhist scriptures on to woodblocks was undertaken during King Hyŏnjong's reign (1009–31) and completed in 1087, but the blocks were all destroyed during the Mongol invasions of the thirteenth century. A second set of woodblocks was completed in 1251, during the exile of the Koryŏ court on Kanghwa island, and survives in two special buildings at Haein temple on Mount Kaya in South Kyŏngsang province. Buddhist festivals and ceremonies involving thousands of monks were a regular occurrence, and there were seventy Buddhist temples in Kaesŏng alone.

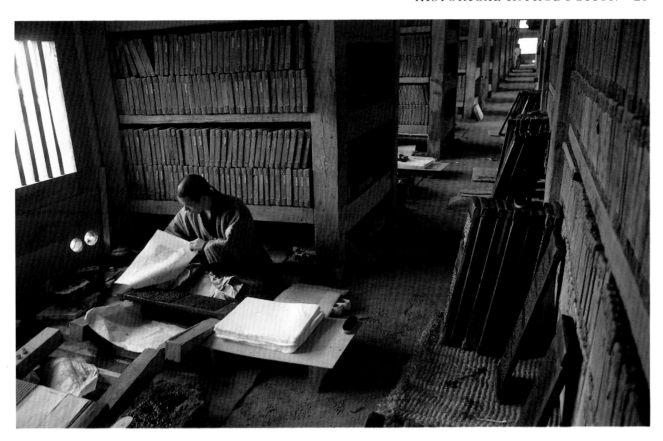

A monk at Haein temple examines a printed sheet from one of 80,000 woodblocks made in the thirteenth century to print the Buddhist scriptures. Photograph by Kang Woon-ku

One of the most important developments in Buddhist doctrine during the Koryŏ was the founding by the monk Ŭich'ŏn (1055–1101) of the Chŏnt'ae school (in Chinese, Tiantai) which partially resolved the disagreements between textual and contemplative Buddhists that had been a feature of early Koryŏ Buddhism.

Koryŏ aristocratic culture is notable also for the coexistence of Buddhism and Confucianism. Scholar-officials studied the Chinese classics as well as Buddhist scriptures. It was widely held that Confucian doctrine provided the basis for ordering human society, while Buddhist meditation and ceremonial practice were pursued in order to attain spiritual peace.

In the second half of the fourteenth century, Koryŏ was attacked from the north by bands of Chinese brigands known as Red Turbans, and along coastal areas by Japanese pirates. The Japanese attacked ships carrying tax grains to the capital, and destroyed farms and villages on the coast, causing the peasants to flee. It was during the struggle against these Japanese raiders that General Yi Sŏng-gye rose to prominence as a successful military commander. He seized power in a *coup d'état* and carried out a thorough land reform which curtailed the economic power of the Buddhist monasteries and the old aristocratic families who had dominated Koryŏ government. In 1392, Yi Sŏng-gye founded a new dynasty which he named Chosŏn. The capital was moved to Hanyang, a geomantically auspicious site, known today as

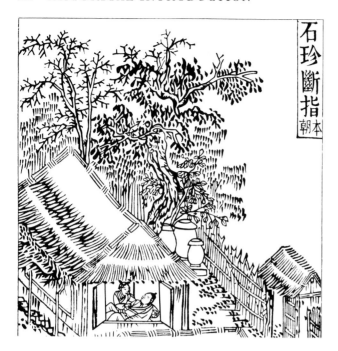 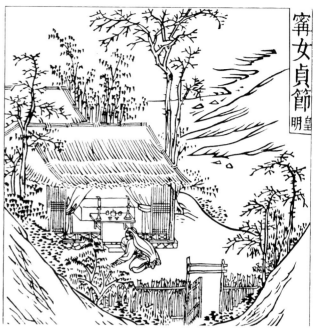

Seoul, which has remained the political, economic and cultural centre of Korea ever since.

The Chosŏn ruling class inherited an important legacy from the Mongol period in the form of familiarity with recent Chinese philosophical developments. Korean scholars and statesmen turned away from Buddhism towards Neo-Confucianism, the reworking of Confucian political and ethical philosophy completed by the Chinese scholar and statesman Zhu Xi (1130–1200). Although the teachings of Confucius had long constituted an important force in Korean political and ethical thought, the success of Neo-Confucianism in the first decades of the Chosŏn dynasty led to society being systematically reordered on principles of obedience and respect towards superior authority. The Neo-Confucian reforms had their roots in the so-called 'five relationships', which were between king and minister, father and son, husband and wife, elder and younger brother, friend and friend. All except the last were based on authority and the submission of junior to senior. The other principle to be stressed by the Neo-Confucians was 'self-cultivation'. If the ruler and the élite class were virtuous and moral, it was argued, the common people would follow their example and the country would prosper. The rigid application of these ideas, and the refusal to countenance any deviation from Neo-Confucian orthodoxy, coloured Korean society throughout the Chosŏn period. The path to officialdom started with success in the state examinations, which tested knowledge of the Chinese classics, as annotated by Zhu Xi. The government bureaucracy was run by civil and military bureaucrats (known as *yangban*, the 'two classes') who, as in Koryŏ times, came from aristocratic families. However, office-holding became as important a criterion of high social status as lineage.

Examples of good behaviour according to Confucian moralists from a compendium, *Oryun haengsil to* (*Examples of the Five Obligations*), which praised behaviour conforming to the principal Confucian virtues of loyalty, filial piety, chastity, brotherly love and friendship: Sŏk Chin, a dutiful son (*left*); Lady Ning, a virtuous woman (*right*)
British Library

Buddhist worship and funerary practices were outlawed, since the well-being of the country, the court, and individual families were all thought to depend on the correct observance of Confucian ceremonial. During the founding period of the new dynasty, Buddhist temples, which had grown economically, politically and militarily powerful in the Koryŏ, were severely curtailed in their numbers and landholdings. Becoming a monk and embracing a life of chastity was regarded by Confucians as an unfilial act, since the duty of a son was to produce offspring to continue the ancestral line. In 1406, the third king of the Chosŏn dynasty, T'aejong (reigned 1400–18), disestablished the majority of Buddhist temples in the country, thus ending for ever the pre-eminent position of Buddhism in Korean life.

The early years of Chosŏn rule saw a thoroughgoing attempt to create a model Confucian society. The fifteenth century is remembered as an age of peace and prosperity. King Sejong (reigned 1418–50), in particular, was an outstanding ruler who put the moral imperatives of Confucianism into practical form in directing the nation's affairs. An accomplished scholar with a passionate interest in science, Sejong encouraged outstanding men of learning to contribute to government policy. He was responsible for the creation of *han'gŭl*, the Korean alphabet, devised as a means of extending the functional literacy of the general population, who could not be expected to master classical Chinese, the language of officialdom. A Royal Printing Bureau had been founded in 1403 to produce movable-type editions of the many works

Vowels / Consonants	ㅏ [a]	ㅑ [ya]	ㅓ [ŏ]	ㅕ [yŏ]	ㅗ [o]	ㅛ [yo]	ㅜ [u]	ㅠ [yu]	ㅡ [ŭ]	ㅣ [i]
ㄱ [k,g]	가	갸	거	겨	고	교	구	규	그	기
ㄴ [n]	나	냐	너	녀	노	뇨	누	뉴	느	니
ㄷ [t,d]	다	댜	더	뎌	도	됴	두	듀	드	디
ㄹ [r,l]	라	랴	러	려	로	료	루	류	르	리
ㅁ [m]	마	먀	머	며	모	묘	무	뮤	므	미
ㅂ [p,b]	바	뱌	버	벼	보	뵤	부	뷰	브	비
ㅅ [s,sh]	사	샤	서	셔	소	쇼	수	슈	스	시
ㅇ	아	야	어	여	오	요	우	유	으	이
ㅈ [ch,j]	자	쟈	저	져	조	죠	주	쥬	즈	지
ㅊ [ch']	차	챠	처	쳐	초	쵸	추	츄	츠	치
ㅋ [k']	카	캬	커	켜	코	쿄	쿠	큐	크	키
ㅌ [t']	타	탸	터	텨	토	툐	투	튜	트	티
ㅍ [p']	파	퍄	퍼	펴	포	표	푸	퓨	프	피
ㅎ [h]	하	햐	허	혀	호	효	후	휴	흐	히

The sounds of the Korean alphabet, *han'gŭl*

needed by the Korean scholars and officials. Continuing the development of movable-type printing technology started in the Koryŏ period, the Printing Bureau was responsible for designing and making many fine types which were used to print dozens of works, decades before Johannes Gutenberg made Europe's first printed book in 1450.

In the late sixteenth century, Korea was shaken by invasions from Japan. Military affairs had been neglected as a consequence of the overwhelming importance attached to the civil class of officialdom by Neo-Confucian ideology, and so the Japanese forces met little effective resistance on land. They were eventually defeated at sea by Admiral Yi Sun-sin (1545–98), who used special armoured vessels known as turtle ships to defeat the invading flotilla. The fall of the Ming dynasty in 1644 and the rise of the Manchu Qing dynasty also disrupted Korean political life. Factional debates at court about which side to support led to a pro-Ming stance which provoked Manchu attacks in 1627 and 1636.

In contrast to the rather idealistic Neo-Confucianism of the first half of the Chosŏn period, seventeenth- and eighteenth-century Korea saw the rise of practical learning (sirhak), which influenced all branches of literature and the arts. In the period of recovery from the Japanese and Manchu invasions, a more down-to-earth brand of scholarship came to the fore. Instead of debating the qualities of the ideal Confucian state, scholars examined their own country's history, geography, agriculture, institutions and language.

Throughout the nineteenth century, the court was beset by rivalries between in-laws of the royal family. Factional disputes at court had long been a feature of Chosŏn government in earlier centuries, fanned by the Neo-Confucians' intolerance towards heterodox thought. By the mid-nineteenth century, the pressures of internal decline and external attempts to open Korea to trade posed intractable problems which neither reformers nor isolationists could resolve. Korea became a colony when Japan annexed the country in 1910, and gained independence after Japan's defeat in 1945.

Chronology

Neolithic	*c.* 4000−1000 BC
Bronze Age	*c.* 900−400 BC
Iron Age	400−200 BC
Division between North and South	
Chinese commanderies	108 BC−AD 313
Three Han states (Mahan, Chinhan, Pyŏnhan)	0−AD 200
Three Kingdoms	
Koguryŏ	37 BC−AD 668
Paekche	18 BC−AD 663
Early Silla	57 BC−AD 668
United Silla	668−935
Koryŏ	935−1392
Chosŏn	1392−1910
Japanese colonial period	1910−1945

NOTES

In this book, the convention that the Three Kingdoms of Koguryŏ, Paekche and Early Silla ruled from 37, 18 and 57 BC respectively is followed. This is done in the interest of brevity. Historians generally agree that the Three Kingdoms did not exist as states, as the term is generally understood, so early as the first century BC. The dates quoted for the foundation of the Three Kingdoms are based on legendary sources.

The foundation date of the Kingdom of Koryŏ is given as 935 AD. In fact Wang Kŏn proclaimed the establishment of the Koryŏ dynasty in 918, and 935 is the date when the last king of United Silla formally surrendered to Koryŏ. A full account of the formation of the Three Kingdoms and of the fall of United Silla and the rise of Koryŏ can be found in Yi, *A New History of Korea*, in the list of suggested reading.

The last of Korea's dynasties is called Chosŏn throughout this book. It is also often referred to in Western-language sources as the Yi dynasty, after the family name of the dynastic founder. In the interest of consistency, the dynastic title is used here.

NOTE TO READERS:
Numbered plates refer to objects in the Victoria and Albert Museum.
When more than one dimension is recorded, the order is height, width and depth.

Note on the Korean People and their Language

Koreans are an ethnically homogeneous people, belonging to the Altaic racial family which includes the Mongol, Turkish and Tungusic peoples. Korean belongs to the Altaic family of languages. Korean words and names are transcribed in this book according to the McCune–Reischauer system, the standard method of writing Korean in the Roman alphabet, with two exceptions: in the case of living authors or artists who have a preferred style of spelling their names, the standard version is given, followed by the personal transcription in brackets; and the capital of the Republic of Korea is spelled Seoul, not Sŏul. Korean, Chinese and Japanese names are cited in the order of family name first, then given name. The *pinyin* system of romanizing Chinese is used.

The Korean and Chinese languages have had a long and complex relationship. In the sounds it uses and in its grammar, Korean is entirely different from Chinese. The two languages belong to different linguistic families. Nevertheless, because of the long and dominant influence of Chinese culture on the educated élite in traditional Korea, the Chinese language has penetrated all levels of Korean written and spoken discourse. Before the invention of Korea's alphabet (*han'gŭl*) in the mid-fifteenth century, the only way to write Korean was by borrowing Chinese characters to convey one's sense through either the sound or the meaning of the word in Chinese. About fifty per cent of the vocabulary of modern Korean consists of Chinese loan words.

The Republic of Korea still uses a mixed script of Korean letters and Chinese characters in its publications. Schoolchildren are expected to master some 1,800 Chinese characters. Most place and personal names are usually rendered in Chinese characters. In North Korea, Chinese characters are no longer used, following the reform of the writing system by the communist government.

The relationship between modern Korean and classical Chinese can be compared to that between modern English and Latin: in earlier times, scholars of the upper classes were at home in both languages, while in the modern age of mass literacy, most speakers and writers are unaware of the etymological connections between the two.

GUIDE TO PRONUNCIATION:

ŏ is pronounced roughly as in English, 'mother'
o is pronounced roughly as in English, 'over'
ŭ is pronounced roughly as in English, 'fill'
u is pronounced roughly as in English, 'fool'

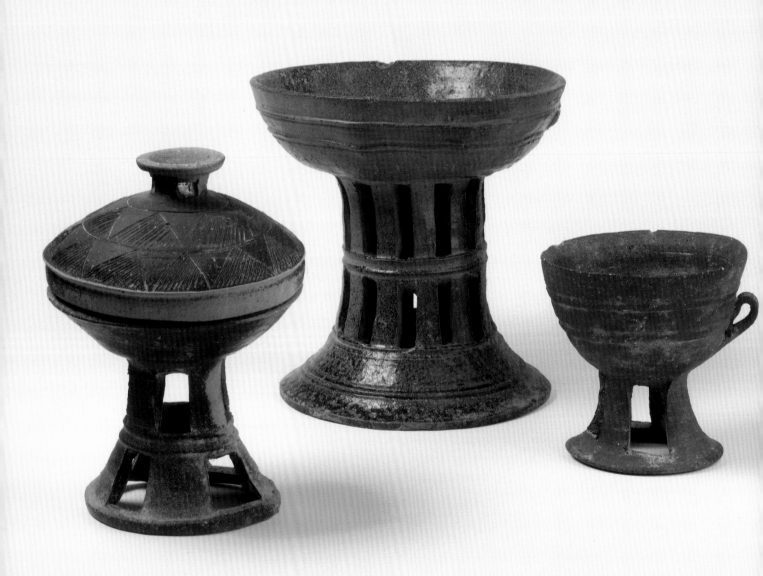

Ceramics

Wɪᴛʜ the introduction of the potter's wheel to Korea, some 2,000 years ago, an important shift occurred in the technical process of making earthenware and later stoneware vessels. The wheel began to be widely used after reaching Korea probably from the Chinese commandery in Lelang (Nangnang), in the north. It became possible to produce hard, thin-walled vessels by firing in closed kilns which could reach higher temperatures than the earlier open kilns. Plain and patterned high-fired vessels survive from the first to fourth centuries; characteristically, the form is round-bottomed with a wide, everted mouth rim, suitable for storing liquids. Depending on the firing atmosphere, the body can be brown or grey.

From the fifth to seventh centuries onwards, plain, blackish-grey stoneware became the predominant type of ceramic, although low-fired wares continued to be produced. During the United Silla era (668–935), high-fired wares were made in large quantities. Most Western museums, including the Victoria and Albert Museum, which acquired examples of early Korean pottery in the early decades of the twentieth century did so in ignorance of the circumstances in which the pots had been removed from tombs. This led to mistakes in identifying their dates and provenance. Since these first steps in collecting Korean antiquities were taken, striking advances have been made in the field of early Korean art history. Tombs, temples, palace sites and kilns have been excavated, and regional differences in ceramic development have been identified and researched. For example, comparison with scientifically excavated pieces has led scholars to suggest that pedestal pots with parallel bands of pierced openings, in the centre of (*1*), are likely to originate in the area of the Kaya confederacy, a historically important group of states in the Naktong river basin. On the other hand, pedestal vessels with alternating rows of openings, on the left of (*1*), are commonly found in the area of the Kingdom of Silla.

The group of pedestal pots, (*1*), dates from the fifth to sixth centuries. These are by far the most common shape of Early Silla pottery, and examples are found with and without covers. Some pedestals were evidently made as supports for round-bottomed bowls, while others had top sections used as containers for food and drink. The little covered pedestal pot is of the second type. Its lid, with two rows of alternating plain and scored triangles, is topped by an everted circular handle, also pierced, with a rounded lip.

1

Pᴇᴅᴇsᴛᴀʟ ᴘᴏᴛs

Stoneware
400–600, Early Silla
Maximum height 17.5 cm
c.168-1926, c.489-1918,
c.440-1920

The stand, consisting of two rows of rectangular pierced holes separated by a double band, has an outward-sloping base. The tall pedestal vessel with a wide outward-sloping foot, by contrast, has closely spaced, narrow, rectangular, pierced openings in two parallel lines. It is difficult to know if this particular pedestal vessel was designed to hold a round-bottomed pot or if it had a lid. It tilts to one side and has a rough body with many visible impurities.

The third pedestal pot in the group, a deep-bowled cup with a small looped handle, is of yet another design: it has pierced openings extending to the full height of the stand. Its only decoration is a pair of incised lines on the exterior wall of the bowl.

The earthenware cup with a handle, (2), is quite plain, and echoes the undecorated pottery of the Kimhae type. Its light brown body colour, simple lines, and rounded base indicate that the seventh-century date previously suggested for it is too late, and that we can infer from its plain form and low-fired body that it was made in the fifth century.

Among Three Kingdoms period ceramics generally, wares from Silla have survived in far greater numbers than those of Paekche (18 BC–AD 663) and Koguryŏ (37 BC–AD 668). This may be because Silla's relative isolation beyond the mountains in the south-east of the country distanced her from the main battlefields of dynastic change in later times. It has also been suggested that the design of Silla tomb mounds kept tomb robbers out, because large piles of boulders blocked access to the chamber containing the body and funerary goods.

The chronology of the development of Silla stoneware can be clearly traced. The characteristic vessel form of the mid-fourth to early seventh centuries is the pierced pedestal pot. Sparsely patterned with incised lines, repeating triangles or, more unusually, animal and human silhouettes, Early Silla ceramics display a beauty of form which finds echoes in later Korean ceramics of all eras. Recalling the shapes of earrings and pendants from royal tombs of the Kyŏngju area, some of the more outstanding pieces have hanging decorations of rings and leaves, or themselves take animal or bird shapes.

In the United Silla period, burial practices changed under the influence of Buddhism, and people apparently no longer required a large number of ornate and impressive vessels to accompany them into the afterworld. Instead, because of the Buddhist belief in rebirth, funerary wares of United Silla are dominated by lidded urns which contained the cremated remains of the deceased person. Although other forms, such as jars, bowls and vases have also survived, these funerary urns are the most common vessel type to survive from the United Silla period. Typically, they are covered by close-set repeating patterns of flowers, geometric shapes, waves or dotted lines, cut into the greater part of the surface. With rare exceptions, Silla wares are

2
CUP
Earthenware
400–600, Early Silla
Height 18.4 cm
C.166-1926

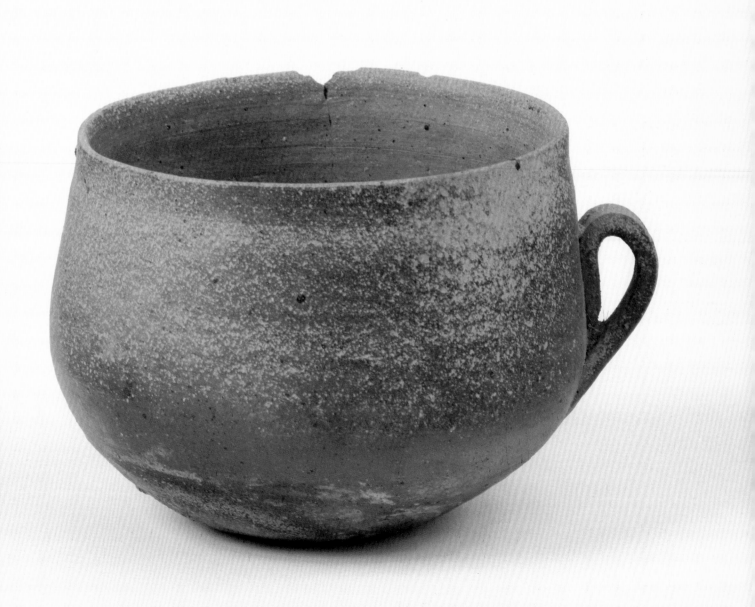

unglazed apart from accidental kiln gloss caused by ash from the burning fuel settling on the surface of the body and fusing into a glaze. However, the use of green glazes was by no means unknown, and examples exist in Korean museums. In the ninth and tenth centuries, the admiration of the Korean aristocrats, who were the potters' customers, for green-glazed ceramics imported from China, led to experiments in glazing. Both lead-glazed ware and high-fired ash-glazed stoneware were produced, albeit in small quantities. These have excited the interest of ceramic historians, because they represent a significant shift in the pottery manufacturing tradition, from unglazed ware to intentionally glazed ceramics, foreshadowing the manufacture of celadons in the Koryŏ period.

Two funerary urns, (3), were made in the eighth century after Silla had unified most of the territory of Korea south of a line running roughly from the mouth of the Taedong river on the west coast to Wŏnsan on the East Sea (see map p.15). Buddhist practice required the ashes of the cremated person to be placed in a special container for burial. Many similar vessels have been excavated from the Kyŏngju area. These urns were buried singly and not, like the pedestalled pots of Early Silla, placed in tombs where numerous objects were assembled to ensure that the departed soul was well provided for in the next life. It is not surprising, therefore, that many, like the two shown here, have Buddhist emblems such as precious jewels and lotus flowers stamped into the decoration. The example to the right is covered with bands of zigzag and comma-like patterns. Floral sprays and a row of jewels complete the stamped decoration. The shape is pleasantly curved, forming a harmonious, unimposing receptacle.

The second covered bowl, which stands on a low pierced pedestal, has a plain surface broken only by a repeating pattern of small circles gouged from the cover exterior, which is deeper than the bowl. Once again, the form is quiet and restrained, in sharp contrast to the more angular outlines of the pedestal pots of the Early Silla. The contemplative spirit of the Buddhist faith had taken root among Korea's potters.

A round-bodied jar with a spreading rim, (4), was probably also produced to contain the cremated remains of a Buddhist believer. The hard grey body has traces of natural ash glaze and is sparsely decorated, with a pattern of triangular motifs on top of a row of concentric circles repeated on the shoulder and on the neck. Its rather plain surface suggests a seventh-century date.

The bowl on a high splayed foot, (5), is another example of the art of the United Silla potter. There are traces of kiln gloss over much of the surface. The decoration is complex. On the bowl are three double rows of stamped circles beneath a row of larger triangles which themselves lie above a row of circles linked by small circles. Above all these are two double registers of

3 (opposite)
FUNERARY URNS
Stoneware with incised patterns
650–800, United Silla
Maximum height 13.5 cm
C.488, C.487-1918
Le Blond Gift

4 (overleaf left)
LONG-NECKED JAR
Stoneware
650–750 United Silla
Height 12.5 cm
C.167-1926

5 (overleaf right)
BOWL ON A HIGH FOOT
Stoneware, with traces of kiln glaze
700–900, United Silla
Height 20.5 cm
FE.31-1982

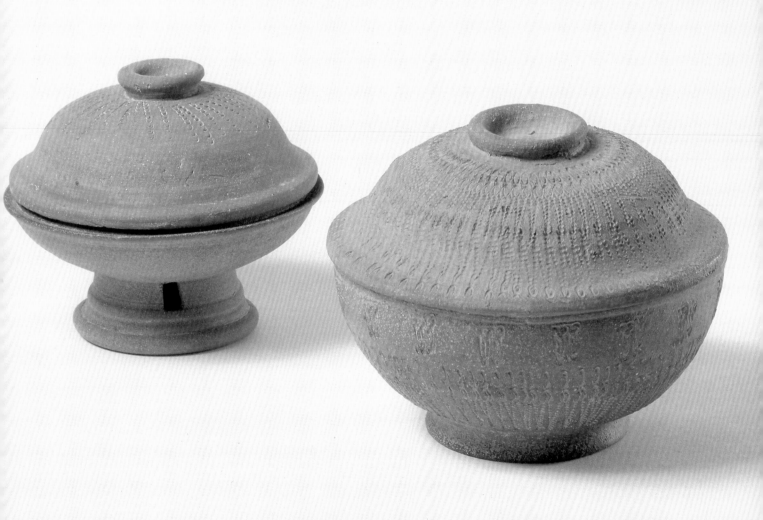

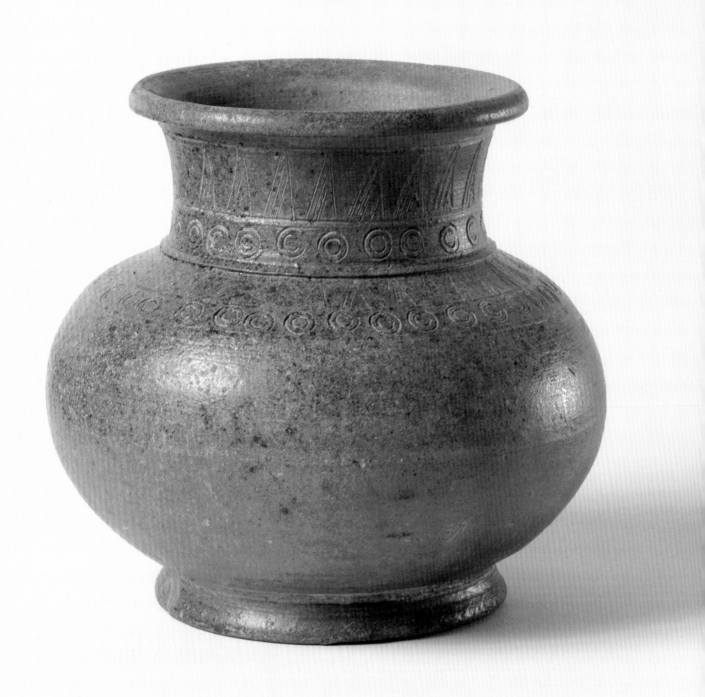

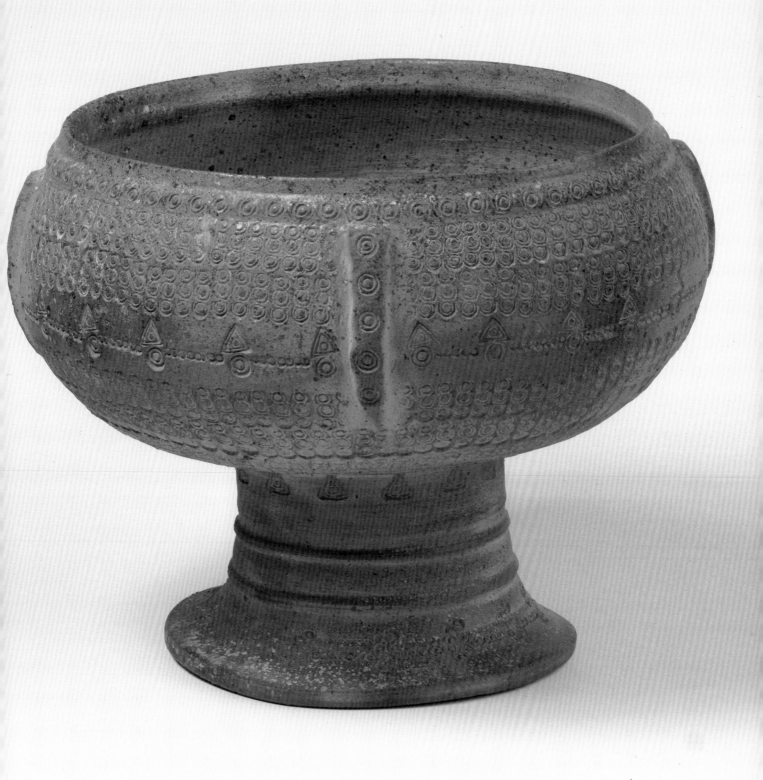

stamped circles and a single row of larger circles, just below the rim. The whole bowl is divided into sections by four relief flanges. The stem too is covered with stamped triangles, ridges and a chain of circles. In spite of this dense decorative scheme, the overall effect is almost restful, again reflecting the Silla potter's devotion to the Buddhist faith.

In 1975 and 1976 Korean archaeologists excavated the Pond of Geese and Ducks (Anapchi) in Kyŏngju. Historical records place its construction in the reign of King Munmu, who ruled from 661 to 681 and led Silla to victory over the kingdoms of Koguryŏ and Paekche, before defeating his erstwhile Tang Chinese allies, and becoming the first king of the United Silla dynasty. The Pond of Geese and Ducks probably gained its name after the fall of Silla in 935, when it became a desolate, abandoned spot. In Silla times, by contrast, it was a pleasure resort on a large scale, and through the excavation of the artificial pond and its pavilions and palaces scholars have extended our understanding of life in the United Silla period very considerably. As well as dishes and bowls of pottery and wood, spoons and scissors, Buddhist images and jewels of metal and jade, thousands of roof tiles have been unearthed, all datable to the United Silla period. Most of the tiles are plain greyish black earthenware of the typical Silla type, but there are also a few glazed examples. An impressively diverse repertoire of designs is found, including lotus heads, grasses, clouds, deer, bird figures, monster masks and geometric patterns. Many of the lotus pattern tiles are similar in size and design to (6), which, like the tiles found in the Pond of Geese and Ducks, is of Silla origin. Even an apparently simple design like this lotus flower is in fact a complex pattern of five concentric circular motifs. A central seed pod is outlined by a narrow band of radiating lines, followed by two rows of petals. The rim of the tile is completed by triangular zigzags.

The ceramic art of the Koryŏ dynasty (935–1392) is famous in Korea and abroad for the achievement of a beautiful, refined grey-green glaze. White-glazed porcelain was also produced in small quantities, but to reflect the strength of the Victoria and Albert Museum's collection, our discussion here will focus on celadon, as this green ware is usually called. The term derives from the colour of the robe worn by Celadon, hero of *L'Astrée*, a pastoral drama by Honoré d'Urfé, French dramatist of the seventeenth century. Celadon was dressed in clothes of a subtly haunting hue. Today the word 'celadon' speaks of grace and refinement, and few are aware of its origins.

The finest plain Korean celadons were produced between 1100 and 1150. Korean potters then introduced a unique decorative feature on their celadon bowls, vases, cups, bottles and sprinklers (7). Known in Korean as *sanggam*, it involved pressing white and red slip (clay mixed with water) into pre-carved outlines on the vessel before the application of glaze and firing. In the

6 (*opposite*)
CIRCULAR TILE
Earthenware
650–800, United Silla
Diameter 13.5 cm
C.153-1926

Tiles, Silla period (*above*)
Kyŏngju National Museum

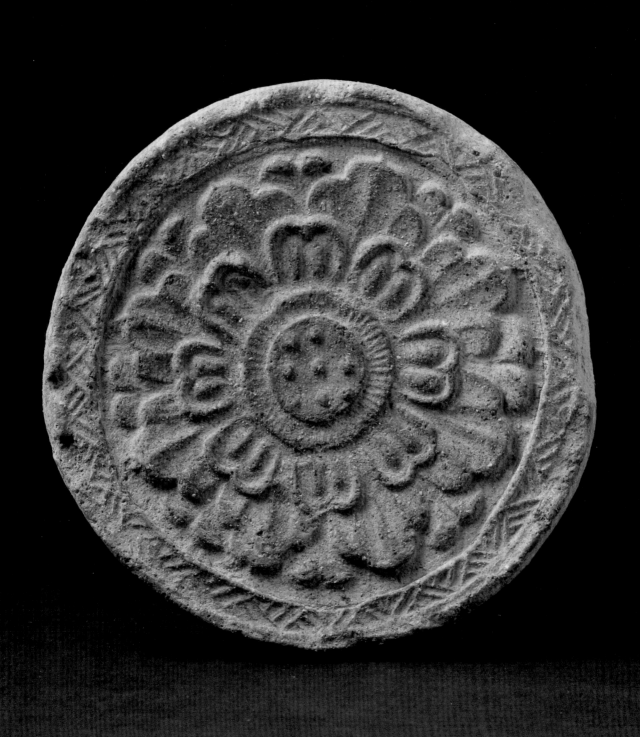

heat of the kiln, the iron-rich red slip oxidized and blackened. The result was an ingenious and attractive inlaid decoration of sparkling colours which enhanced the shimmering brightness of the celadon glaze. These inlaid designs were easier to discern with the naked eye than the incised and impressed patterns on plain celadon wares. Inlaid decoration of this kind never flourished outside Korea, where it was in vogue from about 1150 until Korea was weakened by successive Mongol attacks starting in 1231, (see p.20). Just as the Koryŏ state never fully recovered its vigour after the violent depredations of the Mongol domination, so the quality of Koryŏ celadon never regained the peak of perfection attained during the twelfth and thirteenth centuries.

Excavations at kilns in Chŏlla province, south-west Korea, have demonstrated that celadon wares were first produced in southern and southwestern coastal areas where there was good access to the Zhejiang area of China, home of the kilns producing green-glazed Yue wares, (see map p.15). Art historians disagree about when the first celadons were produced in Korea. We have noted above that as early as the ninth century green-glazed stoneware was being made in kilns along the southern coast, no doubt in an attempt to imitate the Chinese green-glazed wares which were by then reaching the Korean peninsula. By the eleventh century, potters had fully mastered the technology required to produce celadons with an even, rich glaze colour, but since they did not always succeed in maintaining a reducing atmosphere in the kiln, the glazes they produced ranged from brownish-yellow to the sought-after blue-green 'kingfisher' colour.

Gompertz describes a typical kiln as follows:

> The Koryŏ pottery kilns as a rule were constructed by excavating a shallow ditch some sixty feet long and four feet wide on the slope of a hill; on either side clay-filled saggars were heaped up and the interior was thickly faced with clay, which was used also to form an arched roof. Sometimes the entire structure was built of clay. Twenty or thirty openings were made along the sides for the insertion of fuel, but the principal fuelling point was the lower end. At the highest point to the rear another opening served as a smoke-vent. The floor was covered with sand. The whole structure resembled a tunnel or chimney laid horizontally on the hill-slope, and it was probably not more than two or three feet in height. At first the kilns were single chambered, but towards the end of the Koryŏ period the interior was often divided by partitions, with openings to allow the passage of heat; however, this type of kiln was used mainly for firing unglazed wares. A reducing atmosphere within the kiln was the objective, and the use of wood-fuel was invariable.

7
ENLARGED DETAILS OF
INLAID DECORATION
ON VARIOUS VESSELS
Celadon-glazed stoneware
1150–1400, Koryŏ dynasty
C.580-1918, C.72-1911,
C.77-1927, C.65-1910,
C.570-1918, C.560-1918

Potters in Korea had low social status. They were not regarded as artists, and no records remain of the makers of individual pieces. Since celadons were luxury goods made for aristocrats and members of the royal family, the kilns were supervised by officials appointed by the court. Primary historical records from the Koryŏ period were destroyed at various times in Korea's troubled history, but isolated references have survived to the numbers and remuneration of officials who supervised the manufacture of ceramics at the main kilns. Evidence of how highly the nobles of Koryŏ times prized celadon wares can be deduced from the complex logistics involved in the moving of ceramics by sea from the kilns of Chŏlla province to the capital, Kaesŏng, (see map p.15).

It is likely that the scholar and official, Yi Kyu-bo (1168–1241) was referring to kilns near Kaesŏng in the following lines from a poem, which evokes the astonishing pace and extent of ceramic production in various parts of the country during his lifetime.

> The felling of trees left Mount Namsan bare and the smoke from the fires obscured the sun.
> The wares produced were celadon bowls: out of every ten, one was selected – for it had the bluish green lustre of jade.
> It was clear and bright as crystal, it was hard as rock.
> With what skill did the potters work – it seemed as if they borrowed the secret from Heaven!
> Delicate floral patterns were made: their beauty is like a picture . . .

Xu Jing, a Chinese official, visited Kaesŏng in 1123, and wrote in his account of his travels, *Illustrated Record of an Embassy to Korea in the Xuanhe Reign Period*, about Koreans' love of celadon: 'Many of their wares and vessels are gilded or made of silver, but green pottery wares are held in esteem.' Xu Jing made many interesting comments about Koryŏ celadon, and although in places it is difficult to be sure that we understand him correctly, he describes some vessels that are familiar to us today. For example, Xu Jing singled out the 'kingfisher' glaze colour for special praise, and was evidently captivated by the playful spirit of the Koryŏ potters, because he wrote about an incense burner in the shape of a lion whose mouth emitted smoke, just like one in the National Museum of Korea shown here.

Judging from its elegant shape and precise relief and incised decoration, the ewer in the form of a bamboo shoot, (8), dates from the period of the highest achievements in plain celadon production, 1100 to 1150. The body and lid compose one unbroken whole, with alternating rows of leaves forming the body and continuing without interruption into the growing shoot on the lid. The leaves in high relief are etched with fine veins. The spout and handle are also in the shape of sections of bamboo, and the lid has a loop for a

Celadon-glazed incense-burners, 1100–50, Koryŏ dynasty
Museum of Oriental Ceramics, Osaka (*top*) and National Museum of Korea, Seoul (*above*)

8 (*opposite*)
EWER IN THE FORM OF BAMBOO SHOOT
Celadon-glazed stoneware
1100–50, Koryŏ dynasty
Height 25.4 cm
C.527-1918
Le Blond Gift

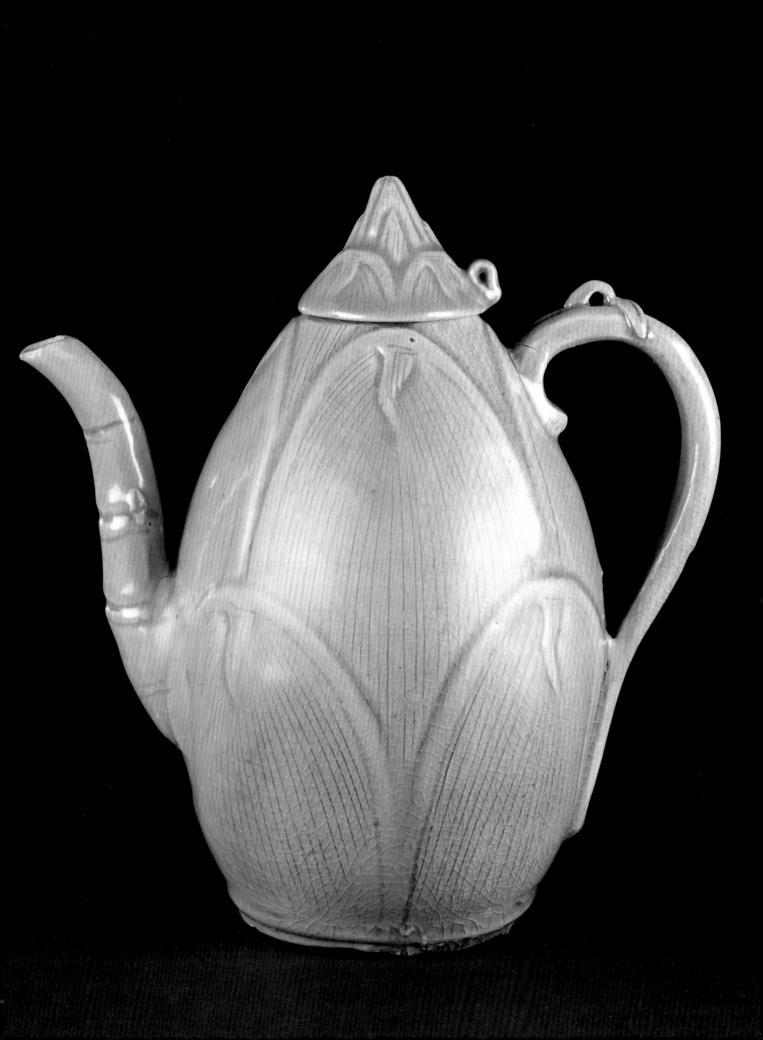

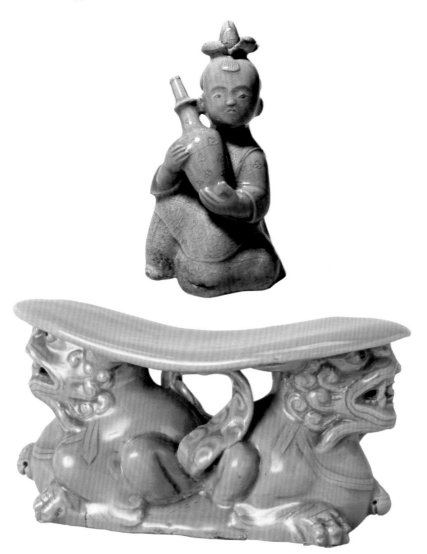

cord to attach it to the body. The foot is unglazed, and there are six spur marks which were left when the supports used for firing were broken off. Koryŏ potters placed vessels for firing either on heaps of sand, or on spurs of readily available material such as clay or silica. When the fired wares were removed from the kilns, the spurs were often rather roughly broken off.

Ewers of the Koryŏ period are found in a variety of shapes inspired by nature. Gourds and melons are the most common, but several bamboo shoot ewers similar to the one shown here are in collections in Korea and Japan. It is hard to say if such ewers contained wine or water. The contemplative sect of Buddhism known in Korean as Sŏn (in Japanese, Zen; in Chinese, Chan) had many adherents among the upper classes, and it is known that ceremonial water holders and bowls for tea made of celadon were used in Buddhist temples. Whether for wine or water, ewers of this kind were highly prized.

A bowl carved in the shape of an opening lotus, (9), demonstrates the Koryŏ love of natural forms. The interior is plain, and the rows of overlapping petals on the exterior embellish the shape. The glaze has crackled,

Celadon-glazed water dropper (*top*) and pillow (*above*), 1100–50, Koryŏ dynasty Museum of Oriental Ceramics, Osaka

9 (*opposite*)
BOWL IN LOTUS SHAPE
Celadon-glazed stoneware
1100–50, Koryŏ dynasty
Diameter 16.5 cm
C.540-1918
Le Blond Gift

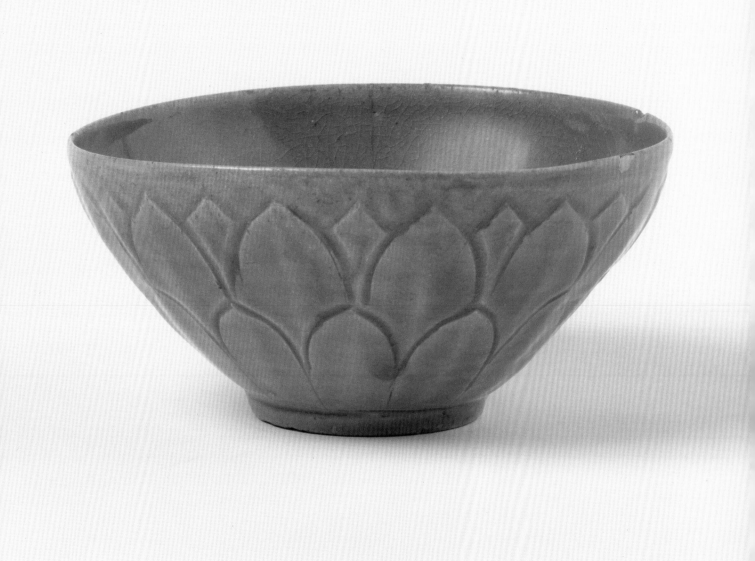

producing a clear, sparkling effect. The bowl to the right in the group of three, (*10*), has an exquisite moulded design of babies among lotus flowers on its inside walls. Two favourite motifs of the Koryŏ potter, parrots and fish, appear on the neighbouring bowls. This type of incised decoration is extremely subtle, and appealed strongly to the cultured aristocratic élite.

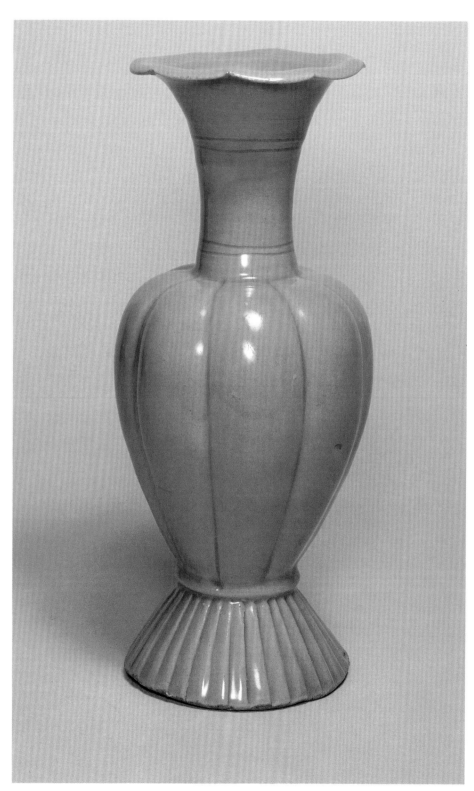

Celadon-glazed vase (*left*)
1100–50, Koryŏ dynasty,
Museum of Oriental Ceramics,
Osaka

10
BOWLS WITH INCISED
DECORATION
(*opposite left*)
Celadon-glazed stoneware with
design of parrots
1100–50, Koryŏ dynasty
Diameter 20.3 cm
C.543-1918
Le Blond Gift

(*opposite centre*)
Celadon-glazed stoneware with
fish design
1100–50, Koryŏ dynasty
Diameter 16 cm
C.545-1918
Le Blond Gift

BOWL WITH IMPRESSED
DECORATION
(*opposite right*)
Celadon-glazed stoneware with
design of babies among lotus
flowers
1100–50, Koryŏ dynasty
Diameter 18.3 cm
C.584-1918
Le Blond Gift

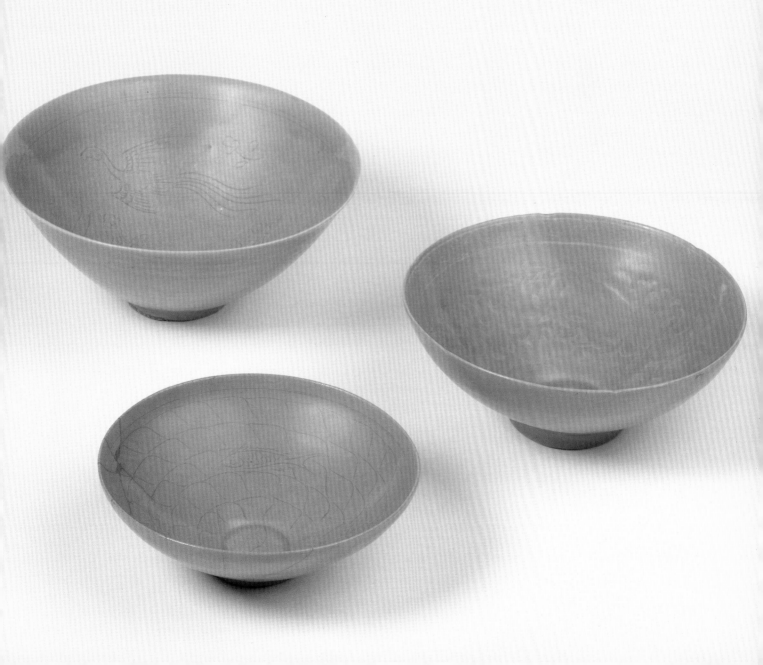

Two drinking vessels, (*11*), hint at another aspect of Koryŏ life: love of social gatherings. The Koryŏ nobility enjoyed drinking and composing poetry. A poem on a celadon bottle in the National Museum of Korea evokes the atmosphere of an aristocratic drinking party:

The bottle is like green jade, finely engraved with golden flowers.
A noble family should use it, filling it joyfully with wine.
One should revere old age and know how to greet an honoured guest.
We cherish the spring, and sit intoxicated by the mirror of the lake.

The stemcup is undecorated, and has a lobed rim and a splayed foot. The body is divided by vertical lines into six lobes, and is covered with a celadon glaze, pooling at the foot. The pointed-base cup has four black-and-white inlaid chrysanthemums within double circles, a band of lotus petals near the base and a border of squared spirals near the mouth. On the interior, spur marks are visible. The shape has a long history in Korea, with known examples from as early as United Silla. It is clearly a kind of saddle cup, designed to be carried on horseback.

Another characteristic Koryŏ vessel is the wine cup with saucer. Plain and inlaid examples are shown, (*12*). Cups and stands of this type were modelled on Korean or Chinese silver prototypes. The foliate shape of both cup and saucer reflects once more the love of natural forms that characterizes Korean art. The plain cup and stand, which have been matched from two separate sets because each originally had an imperfect partner, display a beauty of form deriving from the curved lines of the cup rim, suggestive of the edges of a petal. Upturned lotus petals form the raised receptacle on the base, designed to hold the cup. The inlaid cup and stand on the left already formed a pair when the Museum acquired them from the collector William Tapp. The cup is fluted and lobed to suggest a chrysanthemum flower, and each division is inlaid with a chrysanthemum spray. The inlaid chrysanthemum blooms on the lobes of the stand echo this decorative scheme. The slightly splayed foot sets off the rounded, out-turned shape of the cup, and the celadon glaze has a good, blue-tinged colour.

Like the wine cups, the receptacle for wine dregs, (*13*), was made for a noble client. It has a wide, incurving rim and a deep, narrow basin, seemingly designed to catch slops thrown from a distance. The noticeable lacquer repair is typical of many on Koryŏ celadons. When collectors' interest in these wares became apparent in the last decade of the nineteenth century, local inhabitants of the area near the former Koryŏ capital, Kaesŏng, would search for tombs by sticking sharp metal pointers into the ground. This was as effective in establishing the presence of a cavity as it was dangerous to the ceramics therein, and consequently a great many pieces of Koryŏ ceramics have smashed mouths and rims.

11
STEMCUP (*left*)
Celadon-glazed stoneware
1100–50, Koryŏ dynasty
Height 7.5 cm
FE.128-1978

CUP WITH POINTED
BASE (*right*)
Stoneware, inlaid under a celadon glaze
1200-1300, Koryŏ dynasty
Height 10.2 cm
C.872-1936

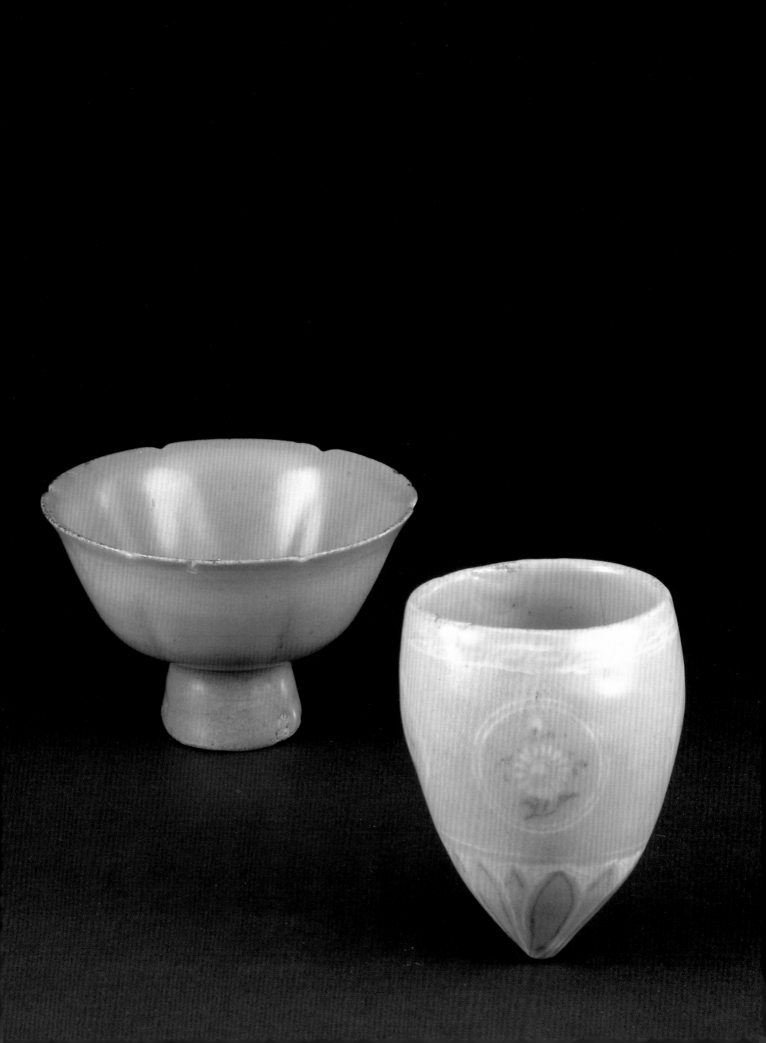

12

WINE CUPS WITH
SAUCERS

(left)
Stoneware, inlaid under a celadon
glaze
1150–1250, Koryŏ dynasty
Maximum diameter 14 cm
C.86-1930
Tapp Gift

(right)
Celadon-glazed stoneware
1100–50, Koryŏ dynasty
Maximum diameter 10.2 cm
C.231-1921, C.332-1912

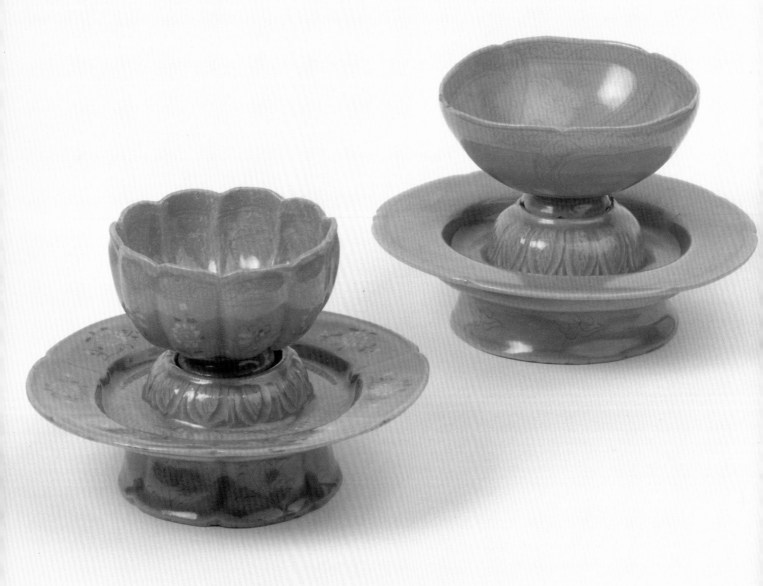

13

RECEPTACLE FOR WINE
DREGS
Celadon-glazed stoneware
1100–50, Koryŏ dynasty
Height 10.2 cm
C.535-1918
Le Blond Gift

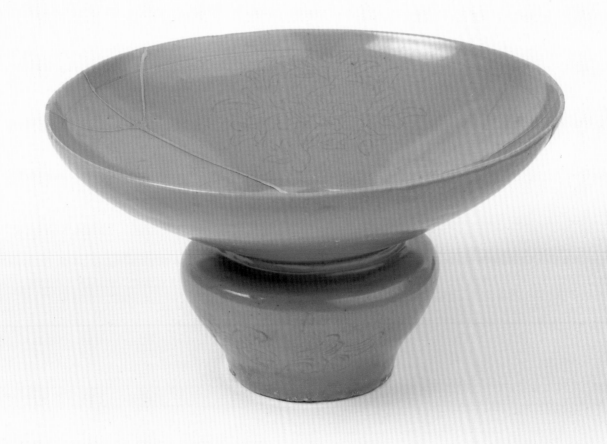

Cosmetic boxes and squat oil bottles, (*14*), were made for the court and aristocrats in the Koryŏ dynasty. The boxes all have flat lids with rounded shoulders, and are all inlaid with well-loved motifs such as cranes in flight, at the back; chrysanthemum flowers in a circular diamond-shaped frame, in front and second from the back of the group; and alternating chubby babies and flower-heads. The colour of the two brown painted bottles is noticeably yellower than the bluish-tinged celadon of the cosmetic boxes. The bottles were fired in an oxygen-rich atmosphere, as were many Koryŏ celadons with brown-painted decoration. It is hard to tell if this was a failure on the potter's part to achieve the sought-after 'kingfisher' hue of the finest celadons, or a deliberate decision to set off the dark brown abstract flourish against a yellow-brown glaze. The illustration on the back cover of this catalogue shows another oil bottle, with a crane decoration like the one on the cosmetic box here.

Several sets of celadon cosmetic boxes housed in a container are known. One example is a splendid openwork rectangular container excavated in South Chŏlla province in 1939, and now in the National Museum of Korea. It consists of five small boxes, an oil bottle, a silver needle case and a bronze mirror, and was clearly made to be used by a woman.

14 (*opposite*)
COSMETIC BOXES
Stoneware, inlaid under a celadon glaze
1150–1250, Koryŏ dynasty
Maximum height 6.3 cm
C.561, C.562-1918,
C.65-1910, C.77-1927

OIL BOTTLES
Stoneware, painted under a celadon glaze
1075–1150, Koryŏ dynasty
Maximum height 7.6 cm
C.586, C.587-1918

Openwork cosmetic box (*below*)
Stoneware with inlaid decoration under a celadon glaze, 1150–1200, Koryŏ dynasty
National Museum of Korea, Seoul

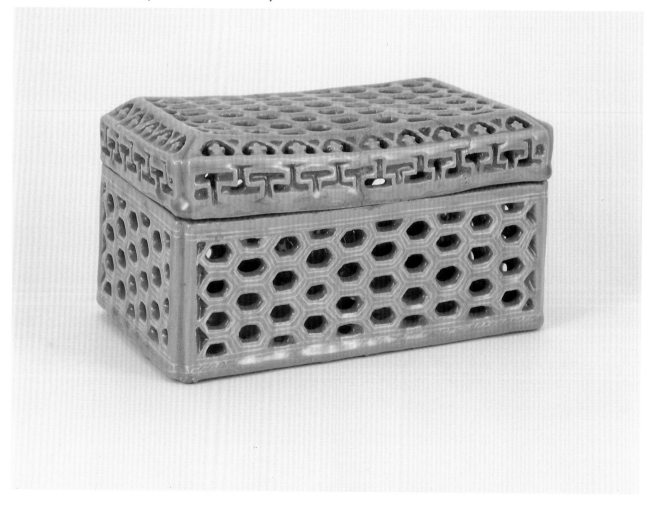

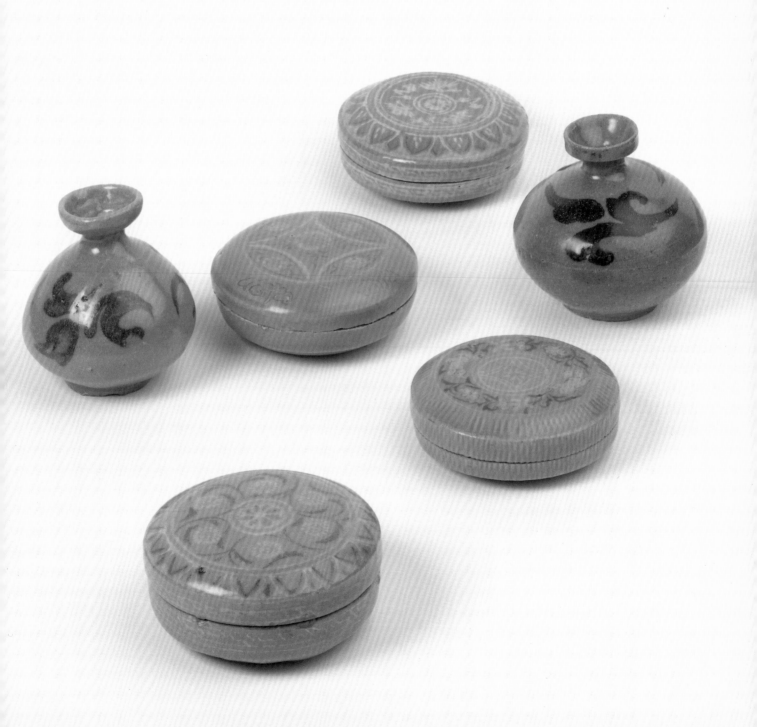

Unlike the drinking and toilet utensils we have examined so far, which were predominantly used in secular life, the ritual water sprinkler, (15), is a Buddhist shape, which reached China and then Korea from the homeland of Buddhism, India. This kind of sprinkler, which is often called by its Sanskrit name *kuṇḍikā*, has two openings. The narrow mouth at the top of the neck was for scattering water for purification during temple services. The *kuṇḍikā* was filled through the short spout, which probably had a lid, now lost. Many bronze as well as plain and inlaid ceramic sprinklers have survived as a reminder of the widespread devotion to the Buddhist religion in Koryŏ times. The Museum archive says that this example came from Kaesŏng.

One of the frustrations of the study of Koryŏ ceramics is the paucity of adequately documented excavation details for pieces like this one. We have no way of establishing where it was buried or with whom. The Buddhist clergy was hierarchically ranked, in imitation of the government official ranks. We know that eminent Buddhist monks were given burials dignified by pomp and ceremony, and it seems reasonable to suppose that a ritual vessel like this one could have been buried with a monk. Gregory Henderson, an authority on Korean ceramics, described the early decades of the twentieth century as a period of 'virtual hysteria of uncontrolled tomb looting', when 'hundreds made their living in this manner for years. The greatest part of the celadon came from the many thousands of tombs near the Koryo capital at what is now Kaesong, some thirty-five miles north of Seoul. Rather many pieces of good quality were found in the tombs of Kanghwa and neighbouring islands whither the Koryo court fled during the Mongol invasion.' The interregnum between the demise of Chosŏn in 1910 and the effective prohibition of 'unauthorized' excavations by the colonial Japanese government allowed uncontrolled access to what are now protected historic sites. The Japanese authorities in their turn were responsible for a massive flow of Korea's material cultural heritage to Japan, where still today public and private collections of Korean arts remain immensely strong in almost all media.

The shape of the *kuṇḍikā* is an unmistakable one, and it is found only in the Koryŏ period, when Buddhist fervour combined with a strong influence of Chinese taste to produce a ceramic art which embraced both Korean and foreign artistic values. Another ceramic shape found in large numbers in Koryŏ times only to die out in the fifteenth century is a kind of vase called *maebyŏng* (in Chinese, *meiping*), meaning prunus vase. They may indeed have been used to hold prunus, but they were certainly also used to hold wine. They were made with cup-shaped lids, lost in most cases, but surviving often enough to prove that *maebyŏng* were really jars. An alternative explanation for the term may be that the shape of the *maebyŏng* resembles a plum stone.

15
RITUAL WATER
SPRINKLER
Stoneware, inlaid under a
celadon glaze
1150–1200, Koryŏ dynasty
Height 35.5 cm
C.743-1909

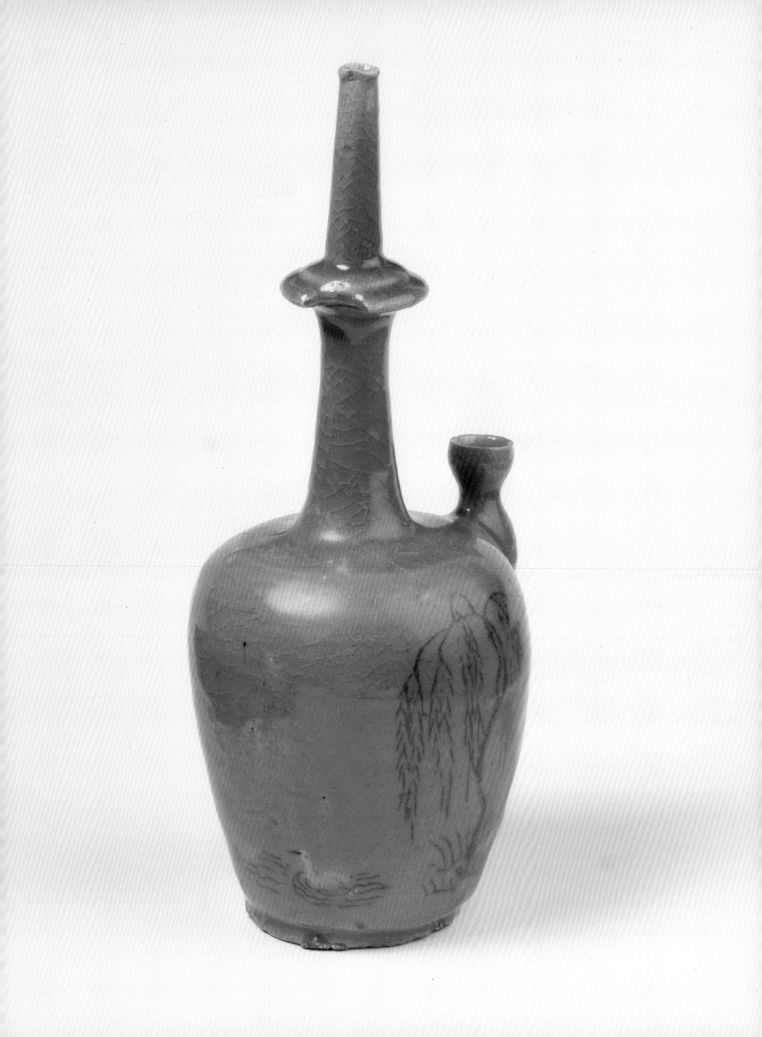

Examples of *maebyŏng* vases are shown (*16, 17* and *18*). Plate (*16*) is an interesting reminder that unglazed high-fired stoneware did not disappear with the demise of United Silla in 935. When it was first displayed in the Museum in 1918, it was described as a Silla vase, because it was then believed that all Koryŏ wares without exception were glazed. With the current knowledge of Koryŏ's ceramic history, it is clear that both glazed and unglazed pottery was made throughout the dynasty. Numerous other examples of Koryŏ vases, ewers and bottles in black unglazed stoneware were made as the ceramics of the common people. The vase which is divided into six lobes is of a typical ash-grey colour. Its shape shows pronounced falling away from the shoulders, below a narrow neck and outward sloping mouth.

Celadon-glazed ceramics, by contrast, were precious artefacts used by the nobility and in temple ceremonial. An elegant *maebyŏng* vase with swelling shoulders and a constricted base, (*17*), is a fine example of the plain celadons which are characteristic of the early twelfth century. Formerly in the Eumorfopoulos collection, the vase is notable for the fine, clear, shiny glaze that covers its ample form. An incised decorative lotus scroll flows gracefully over the entire outer surface.

The rare eight-lobed *maebyŏng* vase, (*18*), has a painted pattern of alternating lotus and peony sprays, and achieves a quiet dignity appealing to the sensibility of a cultivated scholar. It is a technically complex and interesting piece. The potter has incised the leaf veins inside the peony sprays. The shoulder has an overlapping border of lotus leaves, and at the base is a deep lotus band.

16 (*opposite*)
VASE
Unglazed stoneware
1200–1300, Koryŏ dynasty
Height 34.2 cm
C.486-1918
Le Blond Gift

17 (*overleaf left*)
VASE
Celadon-glazed stoneware
1100–50, Koryŏ dynasty
Height 34.1 cm
C.70-1935

18 (*overleaf right*)
LOBED VASE
Stoneware, painted and incised under a celadon glaze
1100–50, Koryŏ dynasty
Height 30.5 cm
C.615-1920

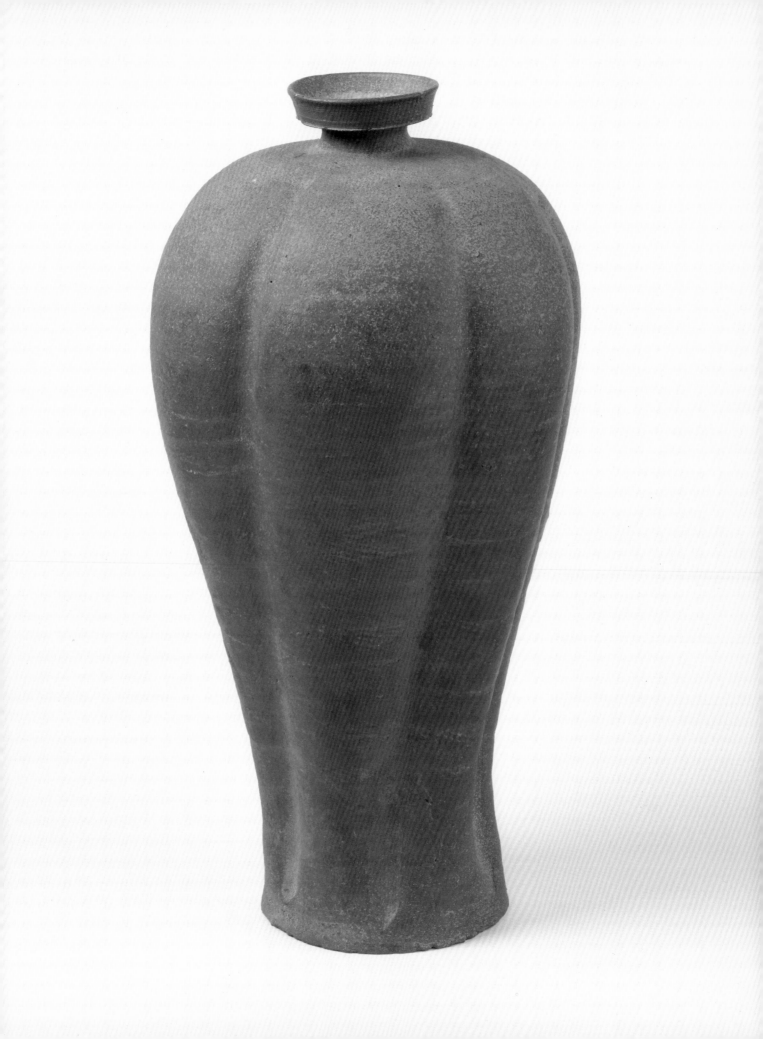

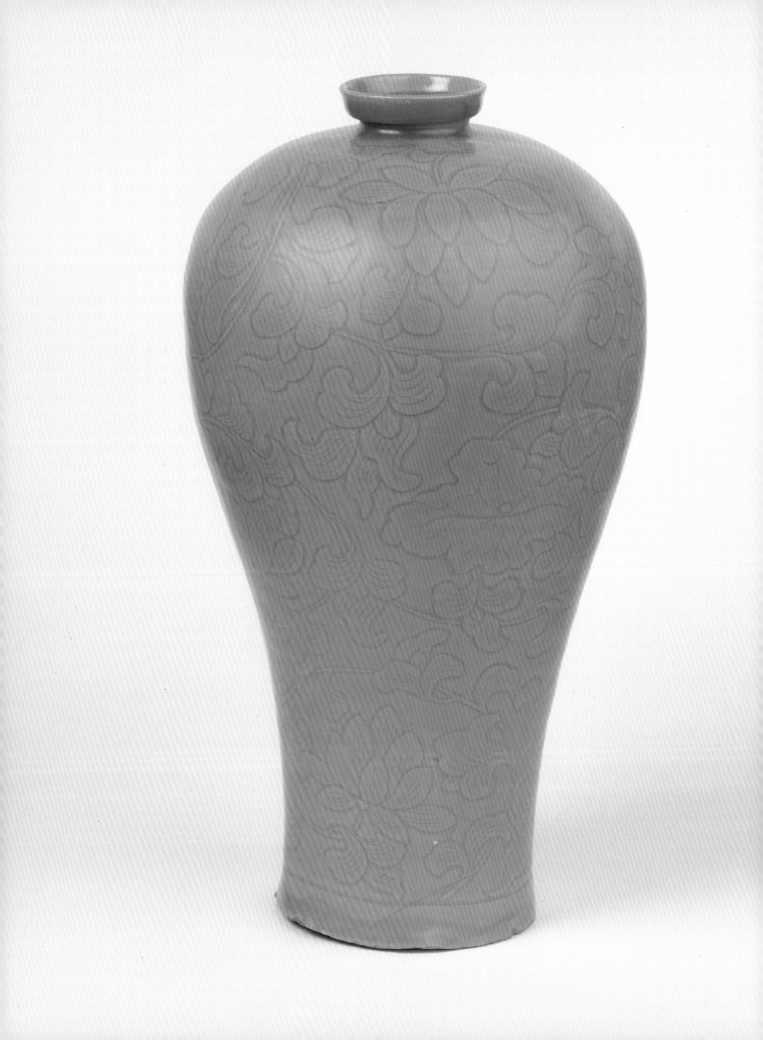

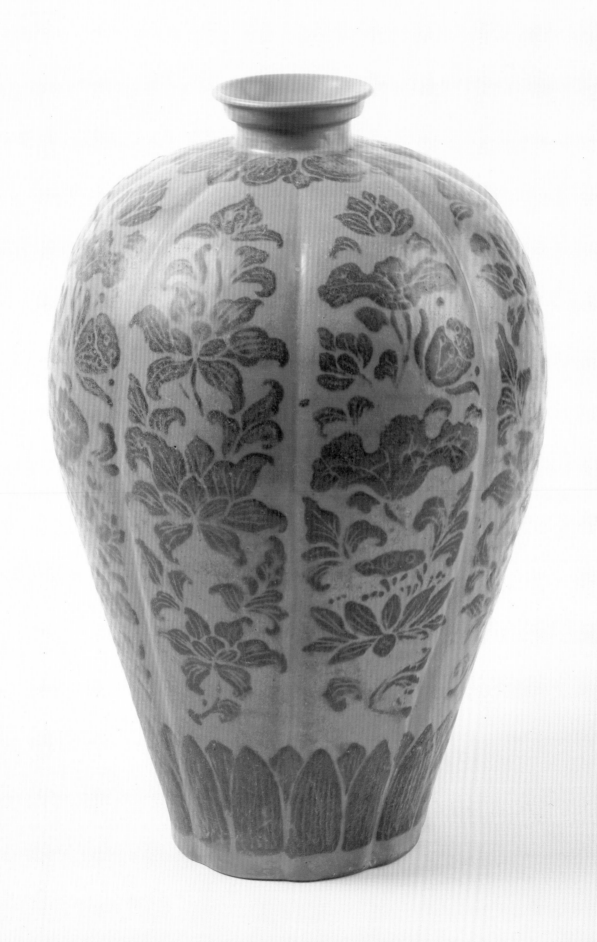

Another fine *maebyŏng* vase in the Victoria and Albert Museum collection, (*19*), has a naïve inlaid design of lotus and waterfowl. Despite an unfortunate break at the neck, no doubt dating from the time of its unearthing, it remains a striking example of the fresh, almost innocent quality of the Koryŏ potter's art. The generous contours of the shoulders taper gracefully towards the foot, suggesting a late twelfth- or early thirteenth-century date.

The *maebyŏng* is one of the commoner vase shapes of the Koryŏ, but not the only one. Vases and bottles in numerous shapes remind us of the continuation of Silla's sculptural stoneware tradition in the Koryŏ potters' inventive flair for celadon manufacture. A pear-shaped bottle, (*20*), is divided by vertical ribs and grooves into panels, and has a flaring mouth which has been repaired with lacquer. Each panel has strings of white and black inlaid chrysanthemum heads. At the shoulder is a band of white inlay with small circles and the foot has a band of lotus petals.

Another inlaid bottle, (*21*), is long-necked with a bell-shaped body. The tiny ring near the mouth hints again at the close relationship between ceramic and metalwork vessels in Koryŏ times. The special feature of this bottle is the red painted peonies that occupy two of the four roundels spaced evenly around the body. Underglaze copper-red decoration on Koryŏ celadon is fairly rare. It is a risky technique with the ever-present danger of a muddy colour resulting from excessive fluxing during firing.

At one time, scholars of Korean ceramics believed that the use of underglaze copper-red decoration was an invention of Korean potters, because significant numbers of twelfth- and thirteenth-century inlaid celadons with underglaze copper-red decoration are known in Korea, while Chinese copper-red wares associated with the Jingdezhen kilns began to appear in serious quantities only in the fourteenth century. It is now accepted that kilns at Tongguan in China's Hunan province were producing red underglaze decorated ware based on copper derivatives as early as the Tang dynasty (618–906). The use of copper-red painting in twelfth-century Korea is none the less impressive, and appears to have occurred independently of foreign inspiration.

In addition to the finely executed floral discs, this bottle has three bands of inlay. Two are overlapping lotus motifs incorporating the use of reverse inlay at the points of the leaves. One lotus band, at the foot, points upwards and the other, at the shoulder, points downwards. The floral roundels are separated by slender, drooping willows, a favourite Koryŏ device which occurs in metalwork as well as ceramics. The neck has an inlaid flourish, but its glaze has been carelessly applied, leaving an obvious gap where the body peeps through.

19 (*opposite*)
VASE WITH REPAIRED LIP
Stoneware, inlaid under a celadon glaze
1200–1300, Koryŏ dynasty
Height 30 cm
C.558-1918
Le Blond Gift

20 (*overleaf left*)
PEAR-SHAPED BOTTLE
Stoneware, inlaid under a celadon glaze
1200–1300, Koryŏ dynasty
Height 30 cm
C.612-1920

21 (*overleaf right*)
LONG-NECKED BOTTLE
Stoneware, inlaid under a celadon glaze
1200–1300, Koryŏ dynasty
Height 34.6 cm
C.72-1911

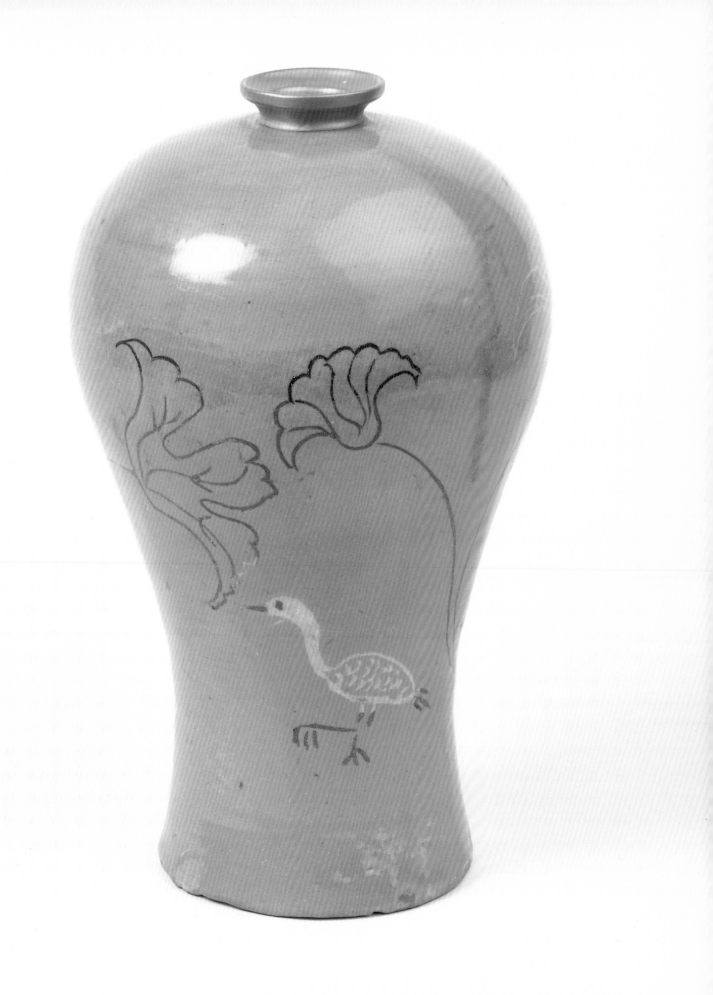

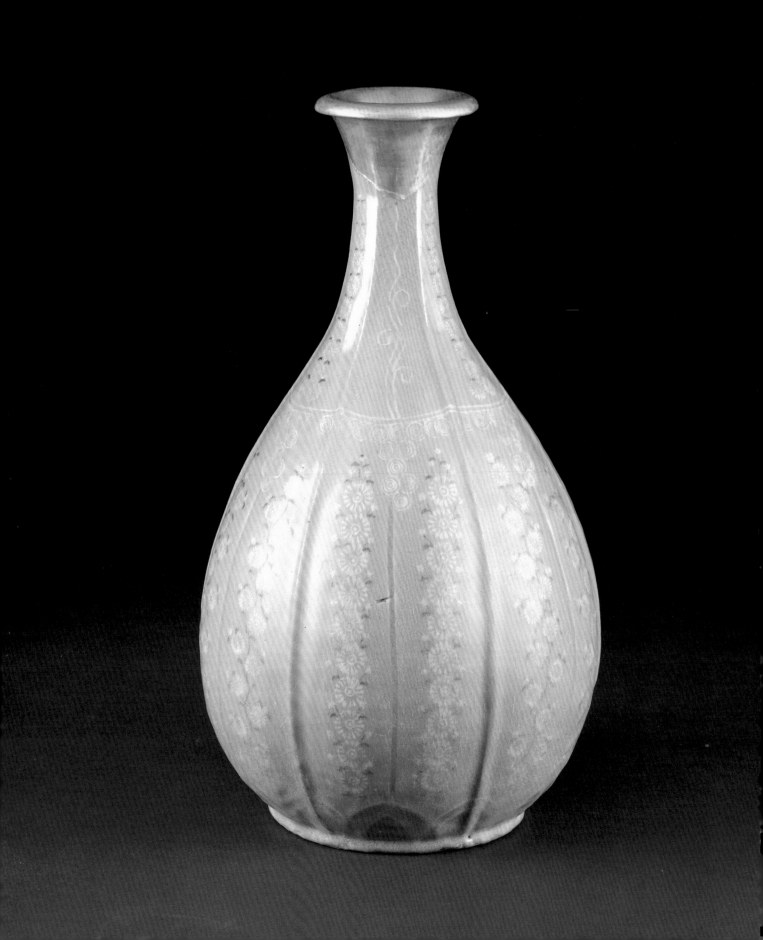

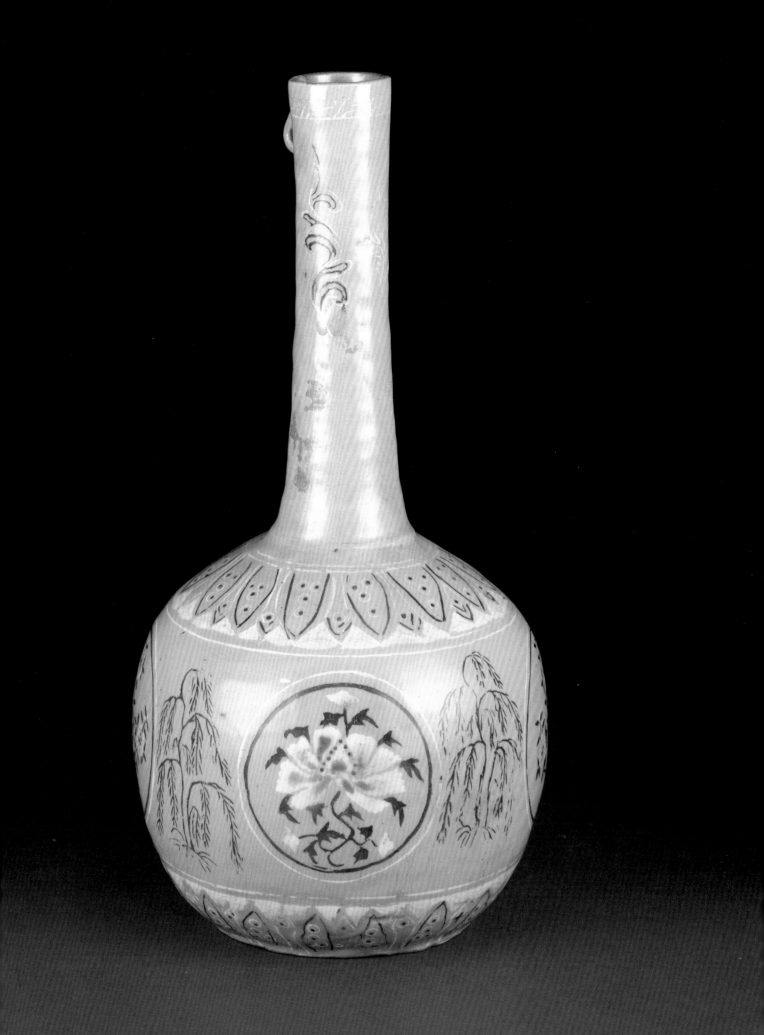

Historical records from the Chosŏn period (1392–1910) have survived in greater numbers than those from earlier periods, but our knowledge of the circumstances in which Chosŏn ceramics were manufactured remains fairly scant, and we certainly cannot identify individual potters. Like other artisans, ceramics workers were registered on official government lists. The profession was hereditary, and government kilns produced the higher quality jars, cups, bowls, rice-cake stands and other vessels required by the court, while private kilns made utensils for sale. According to records kept in the royal household, the Office of the Royal Kitchen was responsible for ensuring that utensils were available for all ceremonial and everyday needs in the royal palaces.

The Neo-Confucian scholar-officials of the early Chosŏn set enormous store by Confucian ceremony, both at court and in their own households. The official kilns turned out both refined Chinese-influenced blue-and-white painted porcelain, and plain and decorated vessels in a native Korean taste. As registered potters, the workers at the official kilns had to put the government requirements first, and to limit occasional private work to slack times. Officials from Seoul visited the kilns at firing times, to ensure that the correct designs were produced, and perhaps to guard against pilfering. For part of the Chosŏn period, decorations were painted on to the ceramics by government-registered artists from the Office of Paintings.

Ceramic production of the Chosŏn period can be divided into two types of wares, *punch'ŏng* and white porcelain. The former were made in the first two centuries of the dynasty, while the latter were produced throughout the entire period. *Punch'ŏng* is a contraction of a modern Korean term, *punjang hoech'ŏng sagi* meaning 'green, powder-like dressing on a grey vessel'. Because of its distinctive repertoire of shapes and decoration, and since the term is rather difficult to translate, ceramic historians generally use the Korean word. Japanese art collectors, who have long held *punch'ŏng* wares in high esteem, have also called them *mishima*, and many older books on Korean ceramics use this term, which probably stems from the Japanese pronunciation of the port of Samdo (Three Islands), from where these ceramics were exported to Japan. The other traditional explanation suggests that Japanese ceramic lovers saw a resemblance between the close-set stamped decorations on stamped and inlaid *punch'ŏng* and the fine printing executed at Mishima Shrine in Shizuoka prefecture. In either case, modern scholars avoid the use of the term *mishima*, because it has been used imprecisely to describe *punch'ŏng* with stamped or inlaid designs, and as a general term for all the varied styles of *punch'ŏng* ware: inlaid, stamped, carved, painted or dipped. The term as now used by art historians is the standard description of Korean green-glazed, slip-decorated stoneware of the fifteenth and sixteenth centuries. Although *punch'ŏng* looks very different from Koryŏ celadon, it is

22

VASE

Punch'ŏng ware, with painted and inlaid decoration
1400–1500, Chosŏn dynasty
Height 31.7 cm
C.1163-1917
Bequeathed by Mrs Grace Anderson in memory of her husband John Anderson

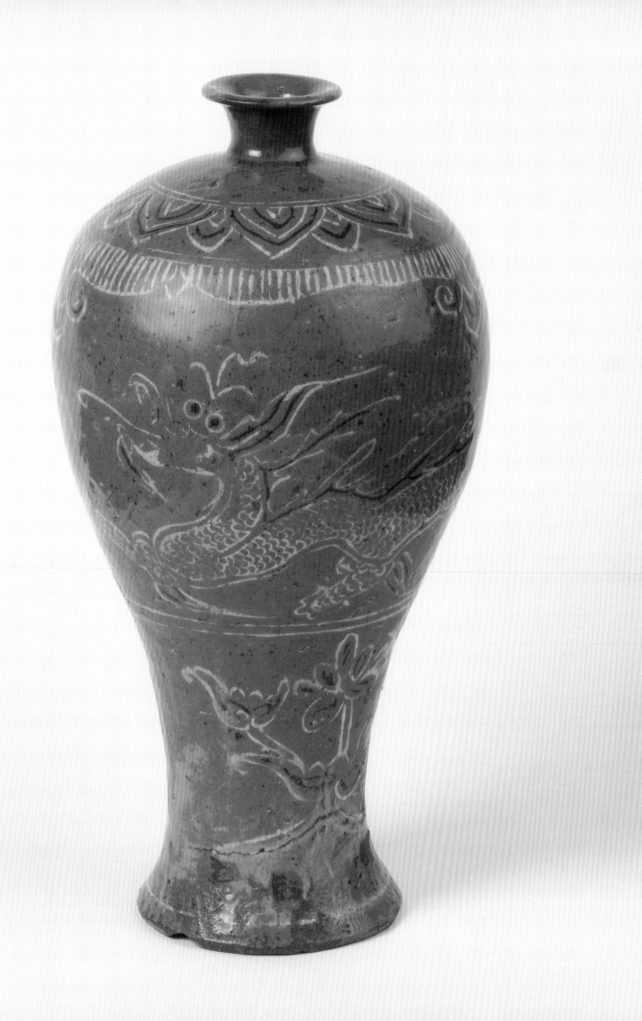

technically a continuation of the tradition of green-glazed stoneware decorated with white slip.

Punch'ŏng has generally been considered a household ware, and it is true that its decoration is often rather rough and that many simple bowls and cups were made. However, evidence for its use in ritual and aristocratic settings exists in the form of large jars, a model shrine in the shape of a house, lidded containers for burial of a placenta (it was customary to bury the placenta underground in a specially constructed chamber) and even funerary epitaphs, all made in *punch'ŏng* ware.

On some *punch'ŏng* vessels, the glaze is so thinly applied as to appear creamy grey or transparent. Floral and abstract motifs are common, but unlike the careful, inlaid patterns of the Koryŏ dynasty, which had to be laboriously carved by hand, *punch'ŏng* decoration includes labour-saving stamped patterns, as well as inlaid, painted, incised and carved designs.

The connection between inlaid celadons and Chosŏn *punch'ŏng* ware is clear when we look at a transitional *maebyŏng* vase, (*22*). It is an example of a type of vase with exaggerated S-shaped outlines which was made in the first century of Chosŏn rule. The body is rough and impure and the greyish yellow glaze is typical of early *punch'ŏng* ware. The inlaid decoration is divided horizontally into sections, which bear little relation to each other. Its band of lotus petals and striped canopy at the shoulder and large lotus blossom near the foot recall the floral motifs of inlaid celadons of the twelfth and thirteenth centuries, but the upper body is covered by a scaly dragonfish of a type not seen on Koryŏ celadons.

During the fifteenth century, Chosŏn potters gradually broke away from the ornate decoration typical of the late Koryŏ period to work in a comparatively free, unaffected style. The globular bottle with a short neck and repaired lip, (*23*), for example, is quite plain apart from the lines carved at the shoulder and on the body. White slip has been applied by dipping or painting, giving a rather powdery effect, so that the bottle's shape and texture command undivided attention. This type of *punch'ŏng* decoration is known as brushed slip ware.

The rounded bowl on the left shows *punch'ŏng* techniques of another type. The inside walls are covered with tiny, closely packed chrysanthemum heads. On the exterior, two rows of flowers are closed off by horizontal lines near the rim. The decoration has been stamped into the drying clay and filled with white slip before glazing and firing. This is the most common kind of *punch'ŏng* ware to be found, and was evidently appreciated by commoners as well as noble families, as rough specimens and finely finished pieces, some with the name of the office of the royal household inscribed, have both been preserved in considerable numbers.

23
BOWL (*left*)
Punch'ŏng ware
1400–1600, Chosŏn dynasty
Height 7.9 cm
C.593-1918

DISH (*centre*)
Punch'ŏng ware
1400–1600, Chosŏn dynasty
Height 3.8 cm
C.594-1918

BOTTLE (*right*)
Punch'ŏng ware
1400–1600, Chosŏn dynasty
Height 21.6 cm
FE.11-1984

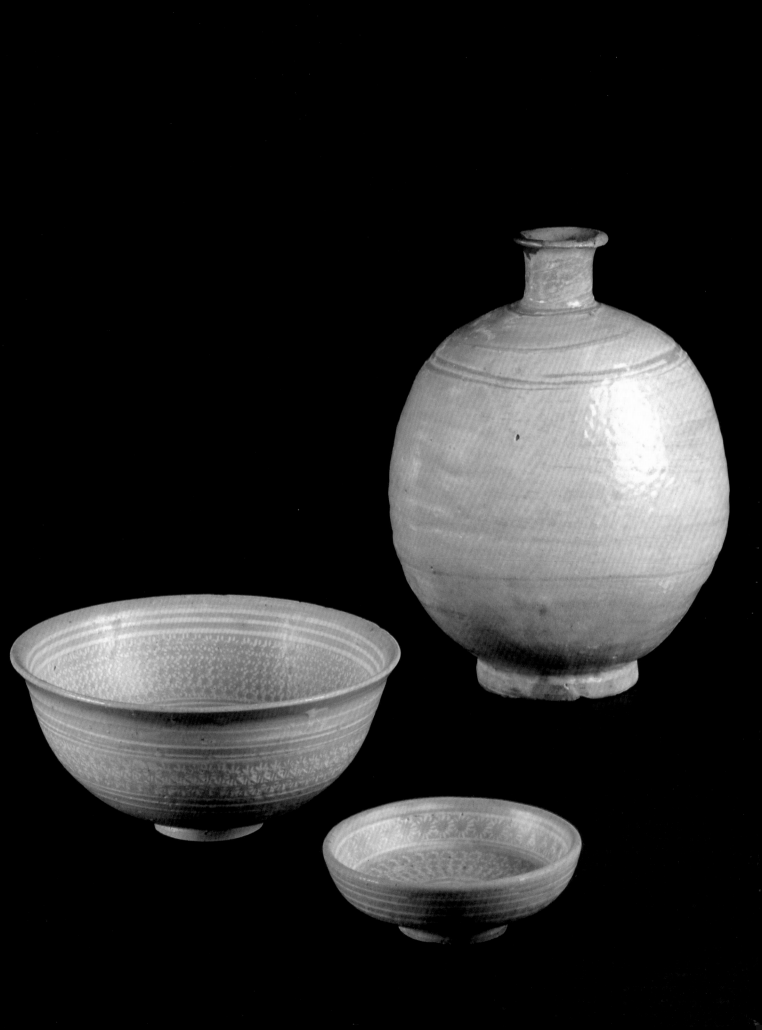

The small dish with straight sides has also been stamped with a repeating chrysanthemum pattern and masses of tiny flower heads inside, and four plain lines outside. Korean potters did not trouble to finish the bases of their wares to a consistent standard. Three spur marks on the foot ring indicate how the vessel was fired, and the base is unglazed.

The base of the large rounded jar, (24), with a band of lotus petals above another band of wavy lines, is partially glazed. The decoration here is white slip inlaid under a fairly thick, darkish green glaze. As we have seen, the use of inlay came naturally to potters working in the tradition of Koryŏ celadons, but the two types of wares are technically of very different standards.

Punch'ŏng wares were made at over 200 kilns throughout central and southern Korea. Korean ceramic historians have compared works in collections around the world with excavated pieces which can be firmly dated, and with discarded vessels and potsherds found at kilns mentioned in the historical records at the time. Evidence from kilns scientifically excavated in Korea is continuously improving knowledge of the production patterns and dating of punch'ŏng wares. Although a single kiln often produced various types of punch'ŏng ware, it is possible to associate particular places to the manufacture of certain types of punch'ŏng. Sgraffito (cutting a design through slip) and brushed slip decoration, for example, are particularly associated with kilns in Chŏlla province in the south-west. An example is the repaired pear-shaped bottle, (25), with underglaze brushed white slip. The decorative scheme is divided into sections by a series of thin lines, and the main interest of the bottle lies in a splendidly free lotus bloom occupying the main panel. By carving the outline of the flower-head through fairly thick slip, the potter has created a raised effect which gives extra volume to the flower. The greenish tone of the glaze sets off the creamy slip, producing an interesting grouping of textures where the glaze line reveals the reddish body below the cream of the flower-head and the dense green where slip has been carved away.

The kilns near Mount Kyeryong, Ch'ungch'ŏng province, are noted for modern-spirited vessels with brown-black designs of fishes, plants and abstract flourishes painted over a coat of slip. Kiln sites at Mount Kyeryong were excavated by a Japanese ceramics expert in 1927, during the Japanese colonial period (1910–45). A misshapen jar, (26), was made in a Mount Kyeryong kiln. Its rough body is full of impurities and the shape is careless. The upper half has been dipped or painted in white slip, over which a carefree abstract pattern has been painted. The green tinge of the glaze is visible in the bowl where it has pooled.

24 (opposite)
JAR
Punch'ŏng ware with inlaid decoration
1400–1500, Chosŏn dynasty
Height 22 cm
C.590-1918
Le Blond Gift

25 (overleaf left)
PEAR-SHAPED BOTTLE
Punch'ŏng ware, with underglazed white brushed slip and carved floral design
1400–1500, Chosŏn dynasty
Maximum height 30.5 cm
C.614-1920

26 (overleaf right)
JAR
Punch'ŏng ware, with painted decoration under white slip
1400–1600, Chosŏn dynasty
Height 10.5 cm
Anonymous loan

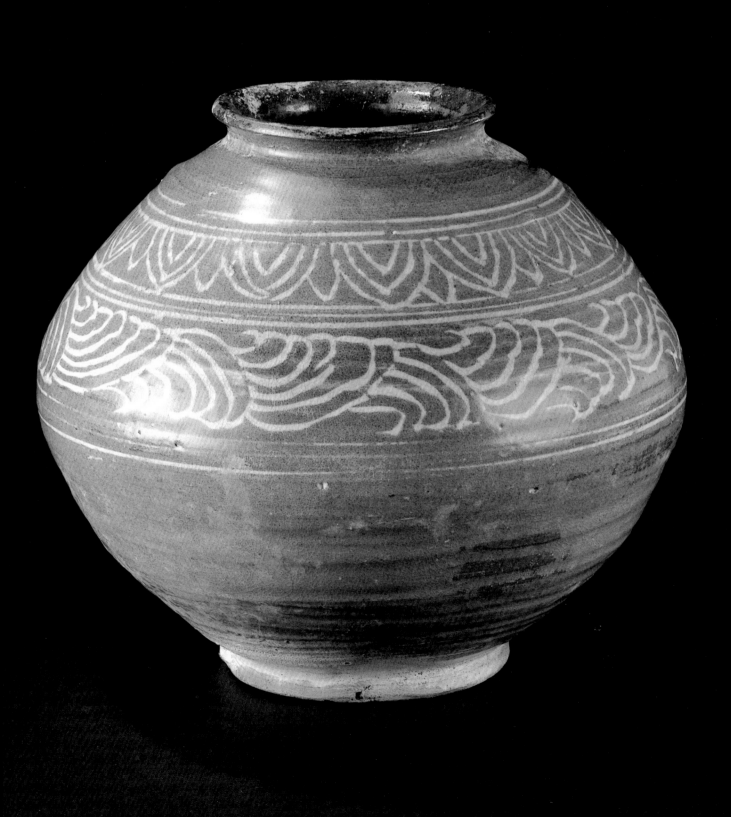

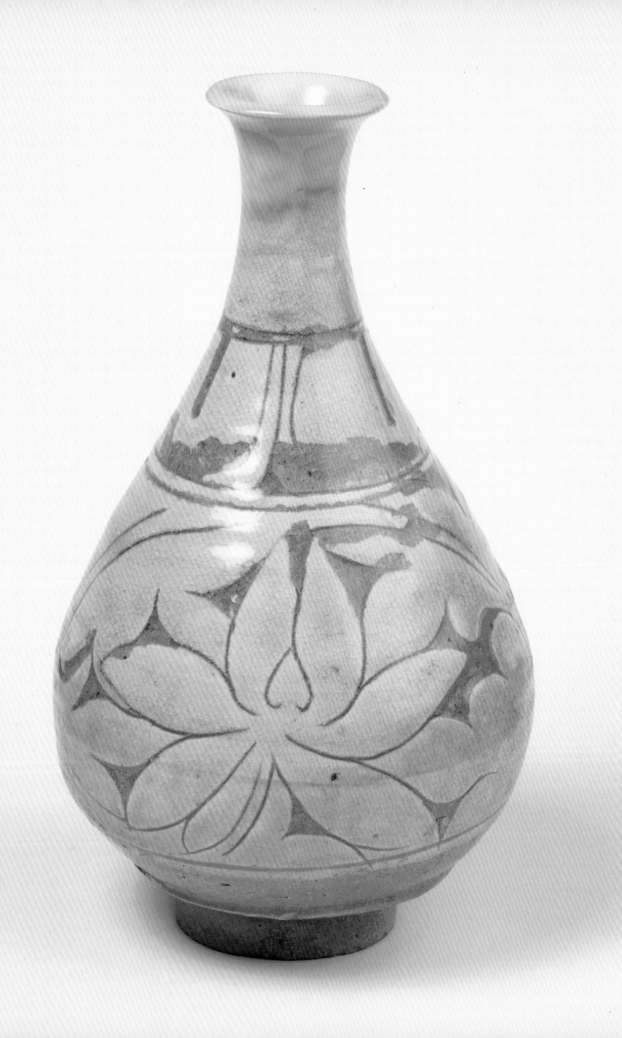

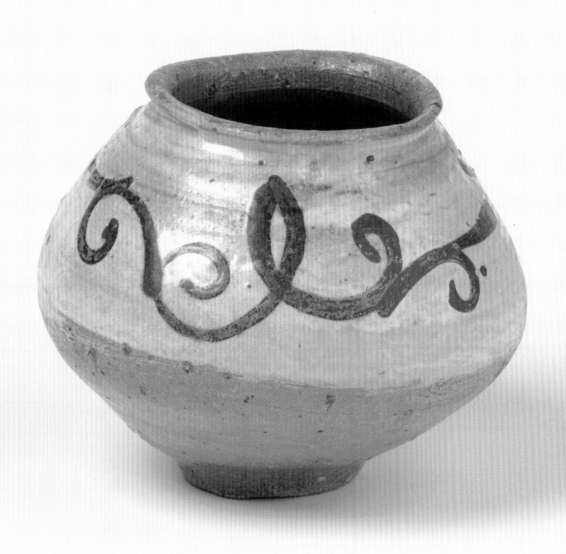

After the Japanese invasions of Korea in the 1590s, when the warlord Hideyoshi sent a force to conquer Ming China by way of the Korean peninsula, no more *punch'ŏng* wares were made in Korea. Hideyoshi failed to achieve his ultimate aim, but succeeded in devastating much of Korea, leaving behind famine and social unrest. Although no conclusive evidence exists to demonstrate why *punch'ŏng* production ended, several factors can be noted. Firstly, the desire for white wares was intense. Commoners and nobles alike prized the clear, shiny purity of white-glazed porcelain, and it seems that during the sixteenth century *punch'ŏng* versions of pots produced in white porcelain for the court and nobility were made for commoners. Secondly, the Japanese invasions severely disrupted all economic activity, including work at official (government-regulated) and private kilns. Thirdly, many *punch'ŏng* potters were kidnapped and taken to Japan, where *punch'ŏng* wares have traditionally been highly prized. For whatever reason then, the production of *punch'ŏng* wares ceased around the beginning of the seventeenth century and the other type of later Korean ceramic manufacture, white porcelain, dominated for the rest of the Chosŏn period. Green-glazed wares had been produced in Korea for over six centuries, but the taste for celadon and *punch'ŏng* was overtaken by the love of white ceramics. Only in the twentieth century have the subtle colours of Koryŏ celadon and Chosŏn *punch'ŏng* wares gained new admirers and collectors. A few contemporary Korean potters have devoted themselves to rediscovering the recipe and method for producing celadon and *punch'ŏng* ware, (see pp.180–4).

We now turn to look at Chosŏn white wares in the Victoria and Albert Museum collection, noting that white porcelain had been produced from Koryŏ times (935–1392), in fairly small quantities. Although many white porcelains found in Koryŏ tombs were not in fact made in Korea, but were Ding or Yingqing wares imported from China, a small number of entire vessels, and a larger quantity of sherds from kilns in Chŏlla and Kyŏnggi provinces survive to prove that white porcelain was manufactured in Korea in Koryŏ times. The *Veritable Records* of King Sejong (reigned 1418–50) note 139 kilns producing porcelain and 185 producing earthenware.

White porcelain was the mainstay of ceramic production in Chosŏn dynasty Korea, and survived through the upheavals of the sixteenth and seventeenth centuries almost until the collapse of the dynasty in the early twentieth century. Refined Chinese white wares entered Korea either officially as exchange of gifts or illegally by trade from China during the Yuan (1279–1368) and Ming (1368–1644) periods. They stimulated Korea's potters to make both high-fired plain white ritual vessels and underglaze cobalt-blue decorated wares which echoed Chinese models.

Early Chosŏn white porcelains are rare, and connoisseurs prize their snow-white colour and the soft tones of the blue pigment. The intellectual climate in the scholar-official class of the time was strongly influenced by China, and by the quest for the ideal Confucian state, which practised austerity in government and meticulous adherence to the ritual observances of the sages of antiquity. Confucian ceremonies in the imposing buildings of the court, or the ancestral halls of noble households required appropriate ceramics. On a domestic scale, the homes of the *yangban* élite required ceramics for everyday use, as can be seen in the illustrations from a collection of exemplary tales compiled and published to encourage virtuous Confucian behaviour (see p.22).

It is also clear that ceramic artists in the fifteenth century went through a process of experimentation with styles and subjects of decoration for blue-and-white wares. Because imported cobalt was scarce, strenuous efforts, ultimately successful, were made to find a native source. Korean-produced cobalt is distinguished from imported Middle-Eastern cobalt by its greyish-blue tinges.

The sixteenth century was a lean time for the Korean potter. Internally, the country suffered political upheavals and the economy was depressed. Tax receipts were insufficient to pay the wages of craftsmen in the official workshops. The Japanese invasions of the 1590s then had catastrophic effects on the ceramic industry, lasting into the seventeenth century. The government, which had been exposed as unprepared and negligent in its response to the threatened Japanese onslaught, lost the authority to control and direct the operations of the hundreds of kilns it had recorded at the outset of Chosŏn.

Even after the defeat of the Japanese, the kilns were slow to resume production as many potters had been kidnapped and taken to Japan. By about 1700, considerable numbers of fine pots were again being produced. In the first half of the eighteenth century, work progressed on moving the royal kilns at Kwangju, Kyŏnggi province, to a permanent site. Kwangju district close to the Han river, offers plentiful firewood and good river transport to Seoul, and remains an important centre of Korean ceramic production to this day. By 1752 the royal kiln was established at Punwŏn-ni, and we can reasonably assume that a good number of the eighteenth- and nineteenth-century pieces in the Victoria and Albert Museum collection were made at Punwŏn-ni between 1752 and the ending of production at these royal kilns around 1883.

A plain white jar of the seventeenth century, (*27*), exemplifies Korean taste for plain, undecorated form. Despite several apparent faults (irregular oval profile, visible central seam and pooling of the greenish tinged glaze on

27 (overleaf)
LARGE JAR
Porcelain
1600–1700, Chosŏn dynasty
Height 36 cm
FE.32-1983
Given by Nicholas Grindley in memory of his parents

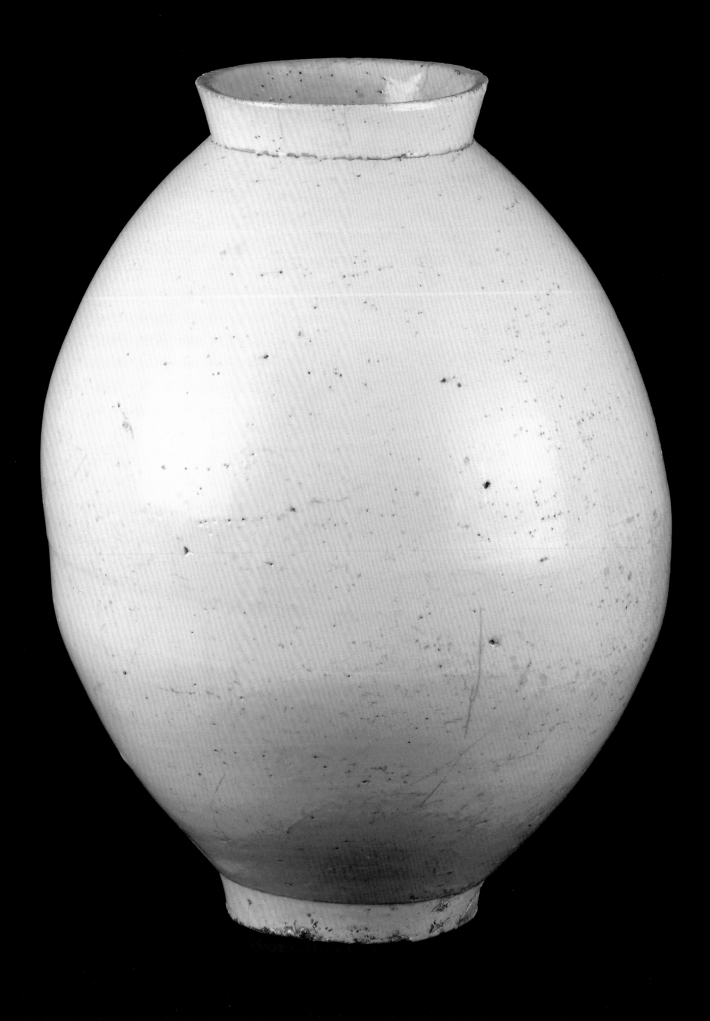

one side) this jar conveys an impression of restful ease, reducing all these imperfections to insignificance. The contrast between pots of this type and the ceramics of seventeenth-century China could not be greater. Chinese love of colourful ornamentation led to the development of overglaze and underglaze decorative techniques of increasing intricacy and elaboration. In Korea, for reasons of technology and of taste, these decorative styles never entered the potter's repertoire.

It seems that the jar fulfilled a functional purpose as a lampstand at one stage in its life, because a hole was drilled into its base to allow an electric cable to pass through.

A memorable vessel dating from the late seventeenth century, (28), was a favourite of an early champion of Korean pottery in the West, W.B. Honey, a former Keeper of Ceramics at the Victoria and Albert Museum. Honey thought highly of Chosŏn period painted wares, and wrote about their 'hard but immensely vital linear fantasy in scroll work, soft indefinite but suggestive washes and blotches, and . . . vital and rhythmical brushwork, with an authentic life of its own, abstract like music and independent of any imitation of natural forms.' Certainly, the dragon bestrides the shoulder of this jar with a vigorous and easy confidence, seeming to push aside the stylized clouds that surround him. Short-necked with a flat base, this powerful jar, painted under the glaze in rusty brown and grey iron pigment, exemplifies the manly and free-spirited ethos of the Chosŏn period.

An arresting jar painted with a red lotus, (29), has a more exaggerated shape than the two previous examples. It can be dated on stylistic grounds to the eighteenth century. The oxidation of the iron content of the body can be seen through gaps in the glaze where the neck joins the body and around the foot. A line at the bottom of the lotus stem shows where the two halves of the body were luted together, and the higher neck and S-shaped foot contribute to an ample, strong form, with a peculiar sense of repose. Honey described this jar movingly: 'It was this example that first revealed to me the beauty of the Yi [Chosŏn] dynasty wares. It is painted in an impure copper-red, and this is of course a lotus plant. The large gestures of the drawing have an almost sublime quality, and the design fills its space in a most satisfying way.' The lotus rising unsullied from the mud is a Buddhist symbol of the passage of those who are saved from the transient world into a higher realm.

The enormous blue-and-white dragon jar, (30), can also be dated to the eighteenth century. Its full form and the spreading, curved dragons encircling the shoulders produce an imposing yet unthreatening effect. It has a narrow base, swelling shoulders and a short neck. Painted with two five-clawed dragons and flaming pearls among clouds, the foot has two rows of vertical decoration, below an elongated lotus band, where the centre of the lotus leaf is blue, outlined in white. The dragons' scales are skilfully painted

28 (*previous page*)
JAR
Porcelain, with underglaze brown painted decoration
1600–1800, Chosŏn dynasty
Height 34.6 cm
C.356-1912

29 (*opposite*)
JAR
Porcelain, with underglaze red painted decoration
1700–1800, Chosŏn dynasty
Height 28.9 cm
C.131-1913

30 (*overleaf*)
JAR
Porcelain, with underglaze blue painted decoration
1750–1850, Chosŏn dynasty
Height 51 cm
C.83-1927
Tapp Gift

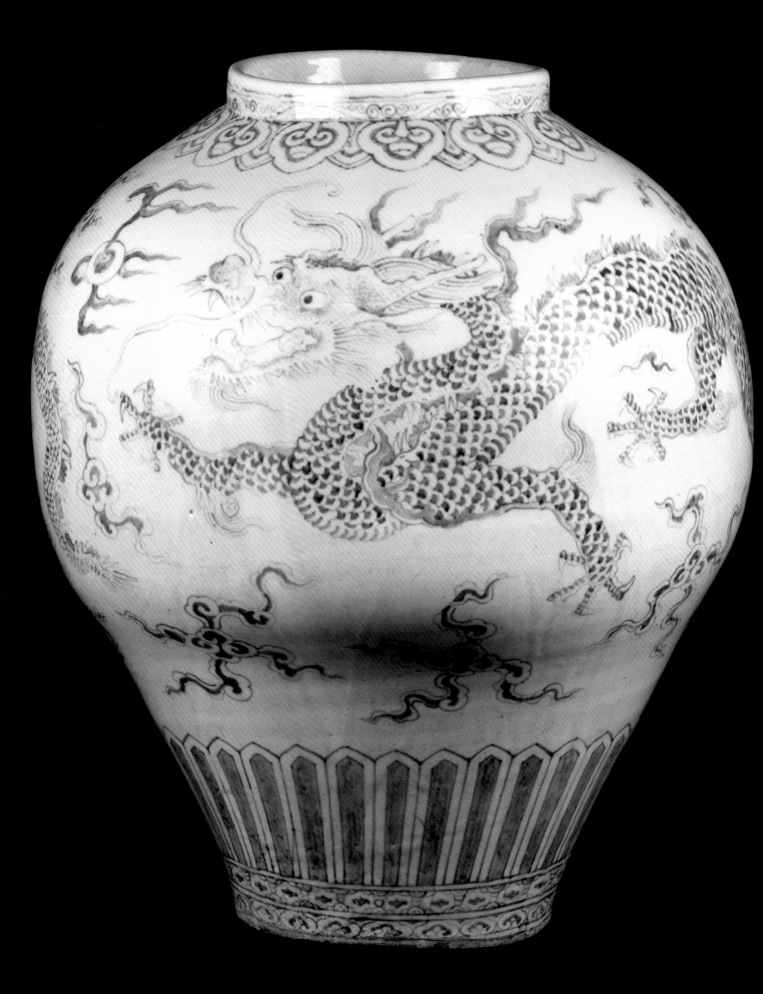

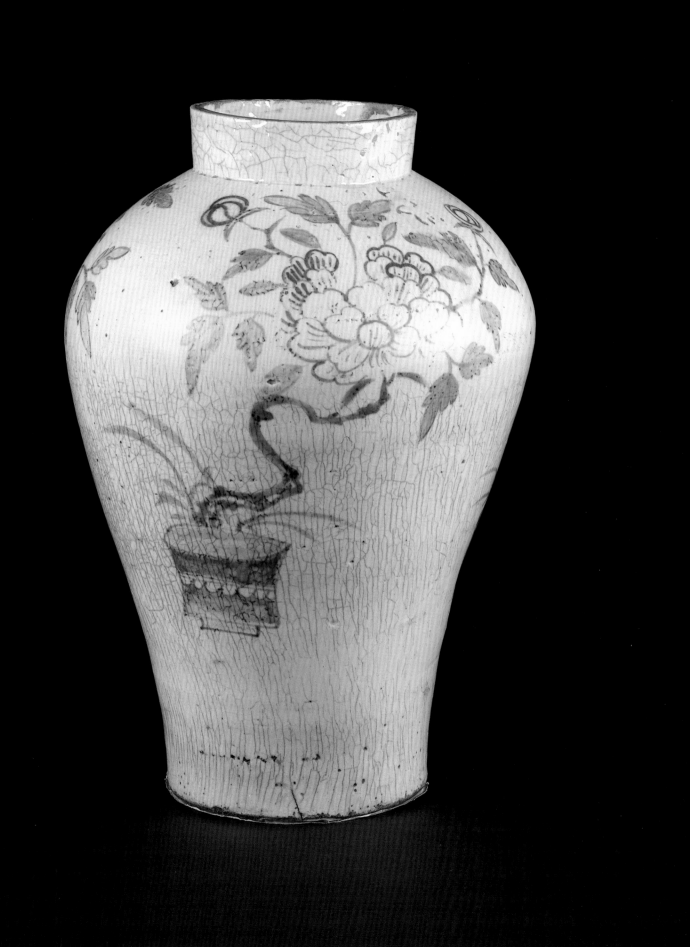

in varying intensities, and the clouds trail across the pot in wispy formations. Each cloud grows out of a *yin-yang* symbol, representing the world as a dynamic marriage of opposing, complementary forces. At the neck is a band of lappets. The lavish use of cobalt-blue pigment on this and a similar jar in the collection not illustrated here, suggests that they were products of the official kilns at Punwŏn-ni. Since the five-clawed dragon was usually reserved for royal use, this jar may have been made for ceremonies at which the king was present. The foot shows signs of having been forcibly removed from the kiln, and this flaw had been covered by a rough repair. In the course of preparing the jar for display it was decided to leave the break exposed.

The official kilns at Punwŏn-ni also made blue-and-white porcelain combined with underglaze copper-red. The jar with marked crazing, (*31*), is an example, decorated with red and blue peonies curving out of plant pots over the vessels' shoulders. The blue flower-heads are delicately painted to create contrasting intensity of colour, while the red blooms are shown mainly in outline. Porcelain decorated in both cobalt-blue and copper-red was regarded as a luxury product, and was only produced at the official kilns.

A group of red-painted jars, (*32*), appears to have had more modest origins. All are of a basically globular form which has been carved to make faceted sides. Chosŏn potters produced numerous facets of various types, by making the vessel walls extra thick to allow pieces to be carved off. The decoration of overlapping discs enclosing stylized flower-and-bird motifs is common to all the jars, but there are differences in the simple neck decoration: the graduated pointed panels on the jar to the right form groups of five, while the jar on the left has a similar neck decoration, but grouped in threes. A simple floral motif encircles the neck of the central jar. All three jars have similar wide mouths and short feet.

These jars, like the lotus jar, (*29*), are examples of the use of copper-red decoration in Chosŏn Korea. We have seen earlier that Koryŏ potters had experimented with copper-red pigment to extend the range of decorative effects on celadon (see *28*). There is no documentary evidence of the transmission of knowledge about copper-red painted ceramics between Koryŏ and Chosŏn potters. Since the earliest Chosŏn red-decorated wares date from the eighteenth century, we surmise that the technique died out in the late fourteenth century, to be rediscovered in the mid-Chosŏn.

31 (*previous page*)
JAR
Porcelain, with underglaze blue and red painted decoration
1700–1800, Chosŏn dynasty
Height 42 cm
C.81-1937

32 (*opposite*)
THREE FACETED JARS
Porcelain, with underglaze red painted decoration
1700–1850, Chosŏn dynasty
Maximum height 20.5 cm
C.78-1930, C.18-1919, C.86-1937

As well as large ritual vessels for court and temple use, Chosŏn potters produced many decorative vessel types for the kitchen, for wine or tea drinking, and for the scholar's desk. In the eighteenth and nineteenth centuries, the government-supervised kilns at Punwŏn-ni produced quantities of these decorative pieces for private ownership. The two blue-and-white water or wine pots, (33), for example, would have been used either to add hot water to tea, or to serve wine. The pot with the twisted cord handle has a carved abstract rendering of a dragon rising from the waves on the body. The lid is painted with another dragon. The second example is deep-bodied with a semi-circular handle, and is more conventionally decorated with floral sprays, which meander gracefully around its sides. The circular lid has three leaves spaced evenly around its surface, and is edged with a band of key fret.

Wine flasks, (34), were made in large numbers in the late Chosŏn, usually with blue-and-white decoration in floral, abstract or pictorial designs. Along with dragon jars like (30) they are the type of Korean ceramic most familiar to the public in the West, since many post-1880 Western travellers to Korea seem to have acquired similar pieces. All the bottles display the typical full, low-bodied, long-necked shape of Korean wine flasks of the eighteenth- and nineteenth-century. Comparing the blue of the two bottles painted with birds on a branch, we notice the restrained greyish tint of the eighteenth-century bottle on the left and the clearer royal blue of the later bottle on the right, typical of their periods. The decorations on these bottles range from the abstract hexagon pattern, through the symbols of longevity (the illustration shows a deer with pine tree in the centre of this group), to mounted warriors from a historical novel. As Gompertz has written, late Chosŏn wine bottles 'with tubular necks and broad bases [are] a solid satisfying shape which had the practical advantage of making the vessels difficult to overturn.' It is hard to disagree with his observation that 'extravagant use of cobalt decoration' and 'poor draughtsmanship showing a tendency to become pretentious or fussy' are features of some nineteenth-century Korean flasks. Gompertz made the point that 'these later wares have too often been taken as typical of Yi [Chosŏn] period blue-and-white, whereas they represent the final stages in the decline of a ware which, in the sixteenth and seventeenth centuries, reached great heights.'

33
TWO TEA OR WINE
POTS
Porcelain, with underglaze blue painted decoration
1800–70, Chosŏn dynasty
Maximum height 16.3 cm
C.667-1923, C.342-1912

34
FLASKS
Porcelain, with underglaze blue
painted decoration
1750–1850, Chosŏn dynasty
Maximum height 34.3 cm
(*left to right*)
C.90-1937, C.92-1937,
C.89-1927
Tapp Gift
C.346-1912,
FE.143-1975
Eveleigh Gift

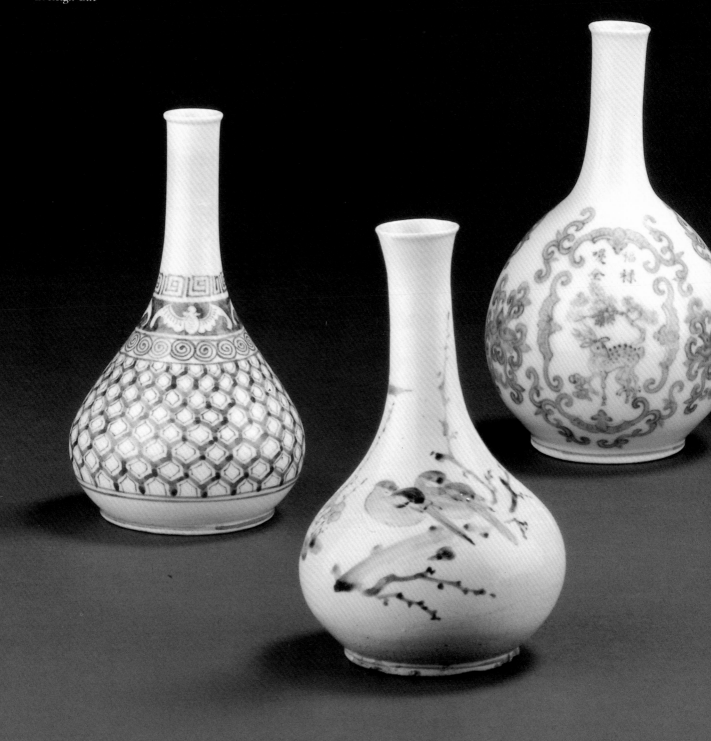

Rice is an essential part of the Korean diet, and anyone who has been to Korea will be familiar with the distinctive covered bowls in which rice is served. The two nineteenth-century blue-and-white examples, (35), are essentially of the same shape as covered rice bowls dating from the Koryŏ period (935–1392) and contemporary rice bowls for everyday use. The larger bowl is fairly plain with dark blue characters painted at regular intervals on bowl and lid; the smaller one has a more decorative floral spray and bat motif. In Korean canteens today, one can see bowls of this shape neatly stacked together to keep the rice warm while it waits to be collected. Rice has been grown in Korea for over 3,000 years, having been introduced from China either overland from the north or by sea from the south. The variety of short-grained rice grown in Korea is slightly sticky when cooked and is not affected by being kept damp, unlike long-grain Chinese rice which becomes soft and mushy when covered. Covered rice bowls are found in metal and ceramic types. The two examples shown here both have happiness (*pok*) and longevity (*su*) characters, as was common on all kinds of artefacts of the time. The lids themselves form a shallow bowl when inverted.

Turning from the dining table to the scholar's study, we arrive at a distinctive and highly accomplished class of late Chosŏn ceramics. The group of white porcelain openwork brushpots and a tobacco pipe rest, (36), delights the eye through shape, rather than surface decoration. Being small, personal pieces, they were made to be appreciated at close quarters, and their carved designs are fresh and original. Every *yangban* or Korean noble-man practised painting and calligraphy, which were regarded as essential accomplishments of a Confucian gentleman. Brushholders like these held the brushes of various thicknesses needed, but they also had an ornamental purpose. One has been cleverly carved to imitate sections of bamboo; another takes the form of stylized peonies and foliage on winding stems with incised markings; and a third brushpot is composed of two phoenixes in flight. As the enlarged detail of this brushpot shows, the bird is in a folk-art idiom, with its wide spreading wings and angular outstretched neck and head. As mentioned earlier, the fine detailing on these brushpots is speci-fically intended for the pleasure of the scholar-owner, who would have spent many hours in the *sarangbang*, the male living area of the traditional Korean house, where scholar's table pieces like these were kept (see p.150).

Another carved openwork brushpot with a bluish-tinged glaze, (37), is unusually large. The decoration portrays a vine with a squirrel nibbling a bunch of grapes and the potter has incised the fine vein lines on the leaves and the squirrel's tail. The life-like representation of a scene from nature is a striking achievement from a period when the potters at Punwŏn-ni near Kwangju were producing fine ceramics in considerable quantities.

35
RICE BOWLS
Porcelain, with underglaze blue painted decoration
1800–70, Chosŏn dynasty
Maximum height 16.5 cm
C.84-1930, C.358-1912

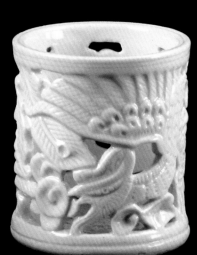

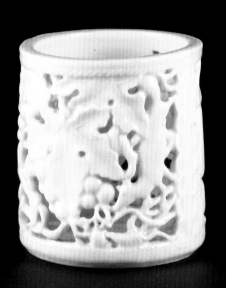

36 (*left*)
BRUSHPOTS AND PIPE
REST
Porcelain
1700–1800, Chosŏn dynasty
Maximum height 14 cm
C.351-1921, C.447-1920,
C.343-1912, C.94-1937

37 (*right*)
BRUSHPOT
Porcelain
1750–1800, Chosŏn dynasty
Height 14 cm
C.340-1912

The scholar's studio would usually contain the accoutrements necessary for writing and painting: brushpots, brushes, an inkstick and an inkstone for mixing ink with water which was dropped on to the stone from a dropper. These water droppers were made in a wide variety of amusing and attractive forms. They were often painted in blue or red, or carved with openwork designs. They demonstrate the continuing preoccupation with sculptural ceramics which characterized the output of Korea's potters of all eras.

Calligraphy in *hanja* (Chinese characters) and *han'gŭl* (Korean script) alike requires the writer to use a water dropper. Before writing with a brush, one grinds an inkstick on an inkstone with a few drops of water to prepare the ink. Water droppers, (*38*), are used for the purpose, and take the form of a receptacle with one hole for filling and another for pouring. Potters of the eighteenth and nineteenth centuries created many novel forms for water droppers, such as the blue carp with a serrated-edged tail, curving its body into a semi-circle.

Another coiled creature, this time a dragon, is composed of a double sphere with a small spout. The outer wall is pierced and moulded to form a dragon amid clouds. The inner wall forms the receptacle for water. The glaze is a bluish-white colour typical of eighteenth- and nineteenth-century porcelains, and some features are highlighted in blue.

The third water dropper is globe-shaped with holes on the top and side. Its decoration comprises stellar constellations and trigrams, suggesting that it was used as an auspicious gift for an individual with a particular horoscope.

38
WATER DROPPERS
Porcelain, with underglaze blue painted decoration
1800–70, Chosŏn dynasty
Maximum height 11 cm
C.960-1922, C.341-1912, C.100-1937

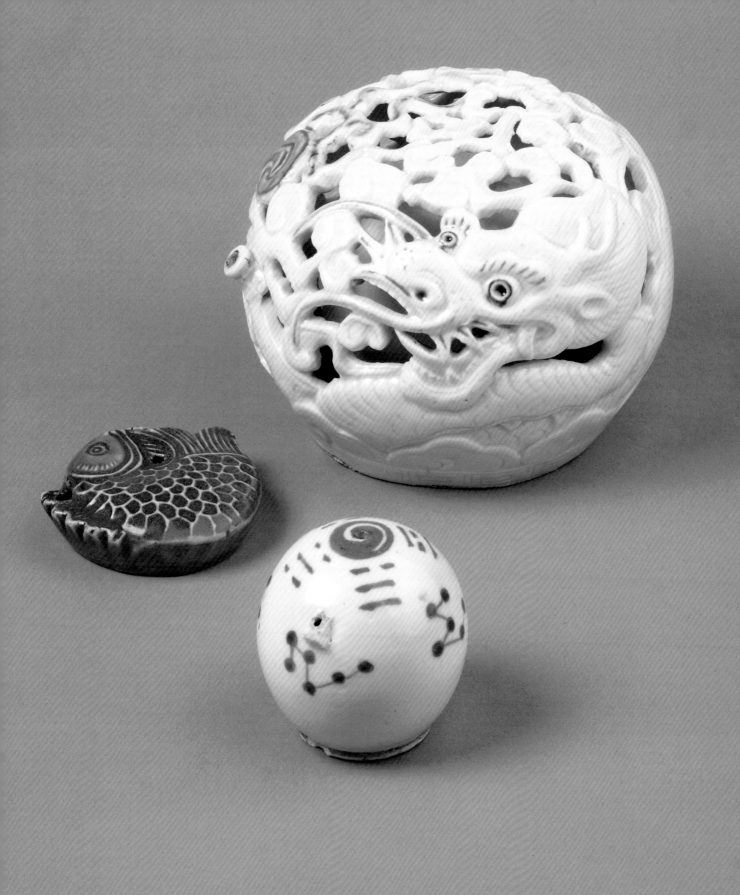

The beliefs of the well-to-do owners of the porcelains we have been discussing are also expressed in the decoration of the rectangular white bottle, (39). Narrow-necked, with flat shoulders and base, the bottle was made by pressing the four sides separately into moulds and then joining them. Two of the four slightly concave faces show pine trees, with a deer in one scene and a crane in another; a tortoise and clouds and a bamboo design cover the other sides. Some of the fine detail, such as the fur of the animals' coats and the surfaces of rocks and foliage, was incised on to the moulded design.

All the elements in the decoration of this vase are associated in Daoist mythology with long life. The crane is widely depicted on Korean and Chinese paintings and ceramics, always with associations of flying towards Paradise. The pine, an evergreen which can grow to a great age, represents steadfastness. The tortoise, a long-lived creature, was believed to possess magical powers, and is common in Chinese and Korean sculpture, forming the bases for memorial stelae which were carved to commemorate important men. The bamboo, another evergreen, is a symbol of old age and of modesty, while the deer also represents the hope of longevity. The God of Longevity is frequently portrayed riding a deer; and deer, like cranes, were believed to have accompanied the Daoist Immortals to Peng Lai, the Paradise of the Eastern Sea. When looking at Korean works of art, it is important to remember that the people they were made for would have registered all these associations almost unconsciously, rather as a British person can instantly recognize St George killing the dragon or associate red and white roses with Lancaster and York.

39
RECTANGULAR BOTTLE
Porcelain
1700–1800, Chosŏn dynasty
Height 24.2 cm
C.446-1920

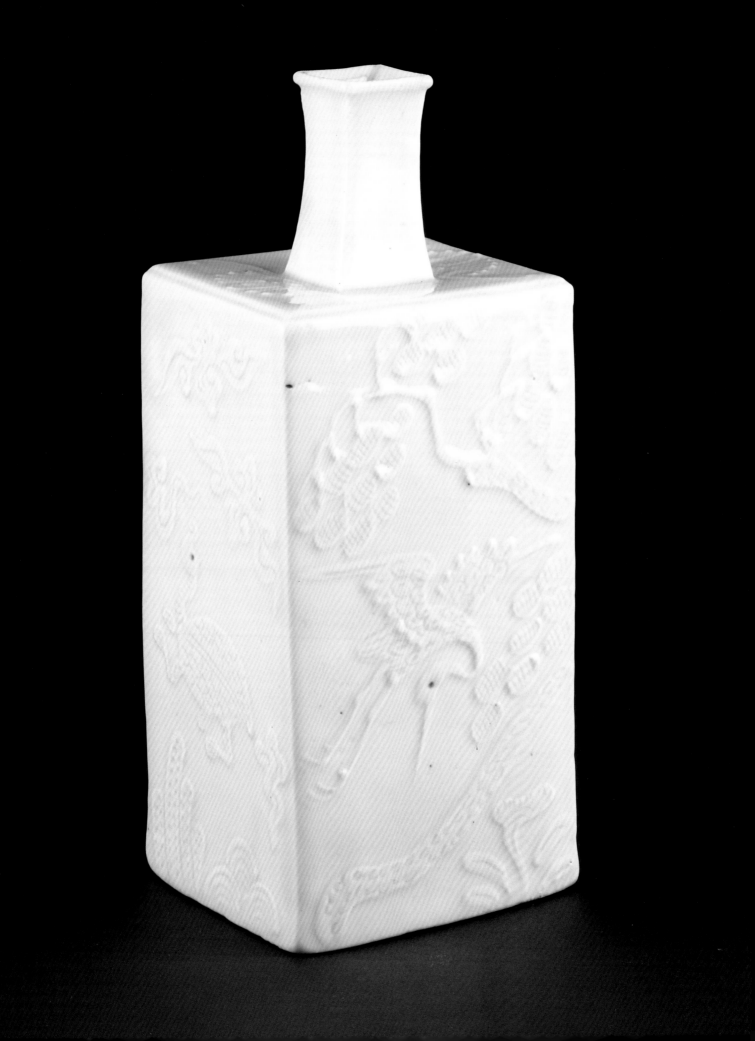

Porcelain remained a luxury product, and commoners used plain brown glazed stoneware like the bottles and faceted jar, (*40*). The dark brown colour of the bottles, flecked with lighter spots, is rich and gleaming. The straight sides of the lidded jar are thought to have been designed to facilitate tight packing with straw ties, since this kind of jar was used to store honey. In the twentieth century, these unpretentious kitchen wares have been influential for Japanese and Western potters of the folk-art school. Produced by anonymous potters in provincial kilns, they have a functional beauty which has attracted admiration in Korea and elsewhere.

Bernard Leach (1887–1979) chose a brown, faceted jar of this type as an 'exemplary pot' when he published *The Potter's Challenge*, praising 'the way in which contrasting angles and freely cut facets hold together in a good articulation within the main spherical form.' Shoji Hamada (1894–1977), the well-known potter and friend of Leach, was also inspired by Korean faceted forms, and introduced them into the vocabulary of Western potters.

Black- and brown-glazed stoneware was made throughout the Koryŏ and Chosŏn dynasties. Early examples, which are rare, usually have a fairly thick, matt, dark glaze. In the eighteenth and nineteenth centuries black- and brown-glazed stoneware known as *onggi* jars were made to store pickles and condiments. Large *onggi* jars were once a ubiquitous feature of Korean homes, but in recent years they have been gradually replaced by refrigerators and industrially produced storage utensils.

40
BOTTLES AND JAR
Glazed stoneware
1800–1900, Chosŏn dynasty
Maximum height 30 cm
C.362-1912, C.170-1926, C.46-1962

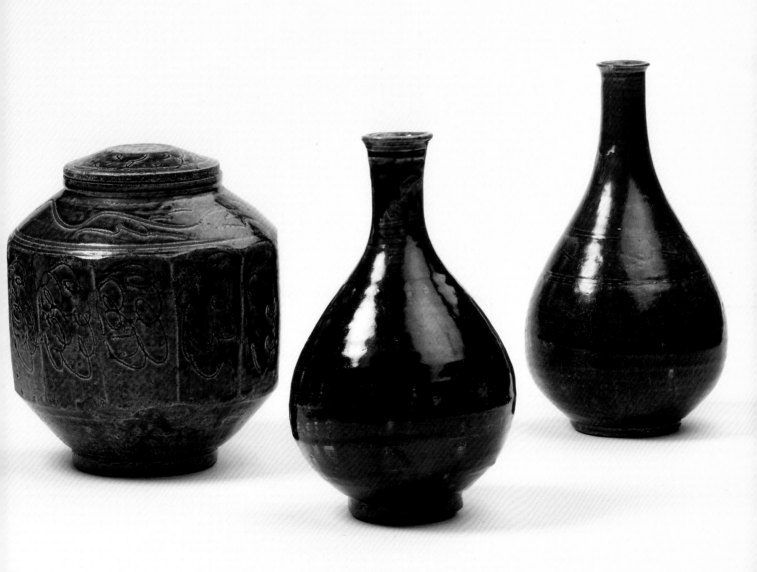

Mortuary Objects

THE rectangular slate cinerary chest, or container for cremated remains, (*41*), which was presented to the V&A in 1918 with the Le Blond collection of Korean and Chinese ceramics, is to the writer's knowledge the only one of its kind outside Korea. The records of the museum state that porcelain vessels had been placed in the container, but it is impossible to confirm this. Investigation of the ring marks on the base yielded no final conclusion, since it was not clear whether the marks resulted from treatment of the slate before or after its removal from its original site, and because some of the rings overlap. Slate chests of this type were constructed in the Koryŏ period (935–1392) to hold the remains of the deceased after cremation, the custom that became prevalent during the Buddhist period of Korea's history.

The chest, which contained the ashes of a member of an aristocratic family, was constructed of six pieces of a grey slate which has been identified as a marine mud rock, formed under reducing conditions (in the absence of oxygen) and compressed by distortion as a result of movements of the earth's crust. Before it was conserved for display, the inner surfaces had developed a white and brown crust, probably formed by water trickling into the chest, reacting with calcium ions in the slate and forming calcium carbonate, rather like limescale. A small square of the crust has been left near the top of one of the sides, to give an idea of the appearance before conservation.

Removal of the crust has restored the fine plain appearance of the slate, and accentuated the high quality of the carvings that decorate its sides. The chest is held together by the weight of the sides pushing against each other: grooves cut near the edges allow them to do so.

The outer vertical faces are incised with images of the Four Guardian Animals: the Dark Tortoise of the North, the Vermilion Bird of the South, the Blue Dragon of the Left, or East, and the White Tiger of the Right, or West. Although we have no documentary evidence of the circumstances of the excavation, it is certain that the chest was aligned to place the animals in their correct positions, since burial sites were carefully selected on geomantic criteria. The guardian animals are not merely decorative, they also symbolize protection, and can be interpreted as expressions of hope for the safety of the departed soul. The four directions also had associations with the

41

CHEST FOR CREMATED
REMAINS
Carved slate
1150–1250, Koryŏ dynasty
74.5 × 39 × 39 cm
A.117-1918
Le Blond Gift

seasons of the year (the cold north with winter; the hot south with summer; the west, where the sun sets, with autumn; and the east, where the sun rises, with spring). The animals were thus believed to protect the deceased in all places and at all times.

Like the famous Koguryŏ (37 BC–AD 668) tomb paintings of the Four Guardian Animals near P'yŏngyang, this chest was discovered in the northern part of Korea, at Mount Songak, near Kaesŏng, capital of the Koryŏ dynasty. The earliest representations of the Four Guardian Animals are found in China, which exerted a strong artistic and cultural influence over northern Korea in the early centuries of the first millennium.

The chest's inner walls all have finely incised lotus flowers with buds and leaves. The lotus is always associated with Buddhism. The coffin presents a nice instance of the coexistence of belief systems in Korea, since protective images deriving from two different traditions embellish two sides of the same object.

There are other, similar slate containers for cremated remains in the National Museum of Korea. One bears an inscription to Hŏ Chae, who died in 1144, and another is carved with figures of Buddhist deities and passages from Buddhist scriptures. They support the assertion that the chest shown here was made in the Koryŏ period, and demonstrate that fervent belief in Buddhism influenced burial customs along with all other aspects of aristocratic life.

Funerary customs provide a fascinating insight into the history of belief in Korea, and we can note in the Victoria and Albert Museum collection not only this container for cremated remains, but also the two United Silla (668–935) funerary urns, (3). These are evidence of the practice of cremation, which became common from about the seventh century as a result of the spread of the Buddhist faith. Various schools of Buddhist doctrine continued to claim adherents from all levels of society in the Koryŏ period, when the coffin was made, and cremation continued to be practised. The change of dynasty from Koryŏ to Chosŏn in the late fourteenth century brought in its wake a far-reaching reform of social and religious organization in Korea. Funerary rites became a hotly debated matter as reforming scholar-officials, influenced by China's Neo-Confucian philosophy, argued that mourning rituals described in ancient Chinese texts should be observed. The *Family Rites of Master Zhu*, a compendium of the four rites (capping, wedding, funeral and ancestral sacrifices) attributed to the Chinese philosopher Zhu Xi (1130–1200), recounted the correct ceremonies in great detail, and became the most important ritual handbook in Chosŏn Korea. Consequently, earth burial eventually replaced cremation among the aristocracy, although Koreans never totally abandoned the Buddhist and shamanist mourning ceremonies which had long since become part of popular practice.

Tomb paintings of the Tortoise, Guardian Animal of the North intertwined with the Snake (*top*); and of the Dragon, Guardian Animal of the East (*bottom*). From the Great Tomb, P'yŏngan province, 500–600, Koguryŏ period

Funerary epitaphs have been found in Korean tombs from as early as the
sixth century, but the greatest number to survive date from the Chosŏn
dynasty. Some are carved stone, and others are white ceramic or *punch'ŏng*
ware. The inscription always outlines the career and family history of the
deceased, which in some instances is so long that several 'pages' are needed
to contain it. In these cases, a container was sometimes made to hold the
inscription plaques. There are also examples of texts so short that they only
covered the sides of a jar or bowl. Epitaphs occupied an important place in
the ritual of mourning, which both symbolized the departure of the dead
person's soul from the realm of the living, and marked the surviving family's
return to everyday life after a period of complete absorption in taking leave
of their relative.

The epitaph of a seventeenth-century official, (*42*), was presented to the
Museum by Le Blond along with the cinerary chest, although there is no
connection between the two pieces except a possible origin in the same area.
The elegant calligraphy of the epitaph offers a poignant contrast with the
rather lowly status of the man it commemorated. Paek Chun-min was a
junior official of the fifth rank in the Military Training Academy, who died
in 1698 at the age of sixty-four. The inscription also gives details of his
ancestors over three generations and descendants for four generations. The
epitaph was composed by Paek's great-great-grandson and great-grand-
nephew, and is dated 'the third *kabin* year after the first year of the [Ming]
Chongzhen reign period [1628–44]', corresponding to 1794. At the time the
epitaph was composed, the Chinese Ming dynasty had been supplanted by
the Manchu Qing dynasty for 150 years, and yet Paek's descendants dated
their memorial text according to the Ming calendar. This was because in the
eighteenth century, Koreans still regarded the Qing as barbarian usurpers of
the imperial throne. Paek was remembered by his descendants with an
epitaph because he was the first in his family to achieve success in the
military examinations, which, however, were less prestigious than the civil
examinations. Paek's ancestors had been commoners who had improved
their social status by buying office, a practice introduced in the years of
hardship after the Japanese invasions of the 1590s, to fill the government
coffers.

42
**EPITAPH FOR AN
OFFICIAL**
Carved slate
1794, Chosŏn dynasty
30 × 35 cm
A.118-1918
Le Blond Gift

朝鮮國訓鍊院判官
金山白公俊民墓誌

公姓白氏諱俊民字國芝金山人新羅大司徒松巌
先生諱宇經之後也高祖諱世弼錬官朝奉大夫
諱瞹良壽爲通政同僉知中樞府事曾祖諱在
松都龍山尙壽湯金階曾向千原遠者諱瑾在
永龍壽階公誠如貞夫人密陽朴氏庵女壽在
詔陵洞國師奉此塋已址原有來德之公子崇禎
甲戌九月七日天質溫良孝發仁篤親人繼忠義
籍而美之晚權武科仕上訓鍊授判官至丁丑三
月十五日壽六十四歲不克以丁丑四月七日實村
許丁坐原有來配清風金氏諱大立比二女孫三
四男三女尙壽尙礎尙祿尙逶尙爾女壽金餘祐
官許簿父柄佐郞馬行忠尙苓一於與朱氏次婿
尙逶四子壽柔婿受軔尙寘受員爰白尚子受文彥

A blue-and-white plaque, (*43*), is a memorial to a Lady Pak of Pannam, who was born in 1752 during the reign of King Yŏngjo. Lady Pak died in 1785, and her memorial tablet lists the names and official positions of her ancestors and her husband, two sons and two daughters, their spouses and children. One of her sons, Yong-gwan, had the inscription produced on the fiftieth anniversary of his mother's death. Filial piety was one of the most important qualities a Korean was supposed to cultivate, as we can see from the wording of this inscription: 'made in grief for my mother by her un-worthy son Yong-gwan in the *ŭlmi* year, the first of His Majesty's reign [1835].'

43
EPITAPH FOR A LADY
Porcelain with underglaze blue painted text
1835, Chosŏn dynasty
21 × 19 cm
C.102-1937

朝鮮淑人潘南朴氏墓誌

故淑人潘南朴氏　英廟壬申二月二十四日

生　純廟乙巳五月十六日卒葬龍仁文秀山

外竉東山宗谷酉坐原考諱師祖諱雨升曾

祖諱泰迪都正妣完山李氏聖集女適延安

簿李公諱明考諱延佟校理祖諱安祥道長

曾祖諱絆佐　贈吏叅妣順天玄氏啓宇女生

二男二女男長用觀令直長次用晉女適潘南

朴宗傳次適咸安趙敦植用觀子祜善榘善

聖上卽阼元年乙未不肖孫串觀泣誌

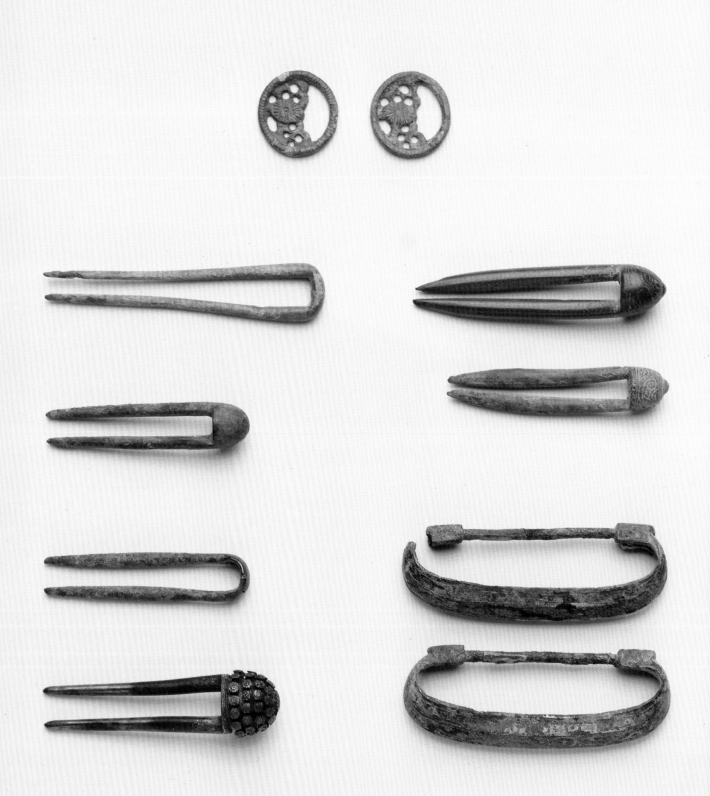

Metalwork

W<small>E</small> have seen earlier that metalworking on the Korean peninsula can be traced to the first millennium BC, when bronze casting was introduced. The fifth to seventh centuries represent the high point in gold working in Korea, as craftsmen worked with gold and jade to make magnificent crowns, belts, head-dresses and ornaments. The tombs of Silla, Kaya and Paekche kings, which show a marked regional artistic diversity even at that early date, have yielded numerous jewels, garment fastenings and belts of gold. Devotional images of the Buddha and his disciples were made in bronze and gilded in gold leaf. Reliquary caskets containing precious, holy objects of devotion were also made in gold. Because these were enshrined in pagodas at important temple sites, many have survived to be excavated. They constitute evidence of the astonishing accomplishments of metal craftsmen of the Three Kingdoms and early United Silla periods.

The transition from United Silla to Koryŏ in the early tenth century stimulated important new developments in both metalworking and ceramics. The expanded ruling élite serving the new dynasty required vessels and ritual objects to be used in Buddhist services, as well as elegant utensils for daily use at court and at home. Wealthy monasteries had enormous statues cast in iron and bronze. Huge bells, gongs and incense burners furnished the temples and played an important role in temple ceremony.

Examples of Koryŏ bronzes are the earliest metal objects in the Victoria and Albert Museum Korean collection. The group of hairpins, openwork ornaments and buckles, (*44*), demonstrates the ability of the Korean metal craftsman to work on a miniature scale. The circular openwork ornaments appear to be clothing adornments or fastenings of some kind, and have elegantly proportioned floral motifs. The hairpins vary in shape and size. The tiny florets in relief on the head of the pin on the bottom left recall the tightly curled hairstyles found in Koryŏ Buddhist paintings and sculpture. Other hairpins, and the buckles on the right, are engraved with rounded spiral designs. All these small personal possessions were buried in Koryŏ tombs.

Mirrors were also buried with the dead in tombs. Considerable numbers of bronze mirrors were cast in Korea, as in China, from about 500 BC onwards. Early Korean mirrors, from the Korean Bronze Age and the Three Han states, have been found to have a high zinc content, but a continuously

44
H<small>AIRPINS AND</small>
<small>ORNAMENTS</small>
Bronze and gilt
1100–1300, Koryŏ dynasty
Maximum length of hairpins 7.2 cm
Maximum length of ornaments
6.9 cm
M.88, M.89, M.90, M.91, M.92,
M.96-1937
M.95-1920

distinctive metallic composition for Korean bronze cannot be confidently identified: bronze mirrors in the Victoria and Albert Museum which were excavated from Korean tombs have been examined with Energy Dispersive X-Ray Fluorescent Analysis and found to be composed of a copper, tin and lead alloy which is extremely close to the norm for Chinese bronze mirrors. There is thus a degree of uncertainty about the ultimate origin of some bronze mirrors found in Koryŏ tombs, since in certain cases the designs closely match those on Chinese mirrors, and there is no doubt that mirrors in the Chinese fashion were both made in and imported to Korea. The bronze casters of Koryŏ certainly had the technical and artistic capacity to produce mirrors matching the finest products of Song (960–1278) and Yuan (1279–1368) China, but their most outstanding achievement was Buddhist temple furniture such as bells, gongs and censers.

Korean mirrors are found both with distinctively Korean decorative schemes, and with Chinese-inspired motifs such as dragons, Four Guardian Animals and references to the sexagenary cycle of the calendar. Mirrors both allowed the owner to see her reflection, and offered a representation of the powerful patterns and forces which were believed to govern the workings of the universe. There was a belief that mirrors had supernatural powers. Before burial, these mirrors would have been polished shiny bright on the reflecting side, but centuries of contact with the soil have resulted in corrosion or patination. On the non-reflecting side, the mirrors have a central raised handle designed to accommodate a silk tasselled holder. When in use, mirrors would be balanced on stands, to free the user's hands for hairdressing or make-up application.

The first of the three mirrors, (45), has a decorative scheme originating in the popular belief that mirrors had magical properties. A toad forms the raised handle in the centre of the non-reflecting side. It is surrounded by bands of decoration depicting magical creatures, eight trigrams, ten heavenly stems and twelve earthly branches, the thirty-six creatures of the zodiac, and the twenty-four solar terms. The other two mirrors, both also dating to the Koryŏ (935–1392) have more abstract decorative schemes: one is covered in bands of zigzag, while the other has a pattern of chrysanthemum florets. These and many other bronze mirrors in the V&A were taken from Koryŏ tombs in the early twentieth century.

45
BRONZE MIRRORS
Koryŏ dynasty (935–1392)
Maximum diameter 18 cm
M.82-1937, FE.229-1974,
M.77-1937

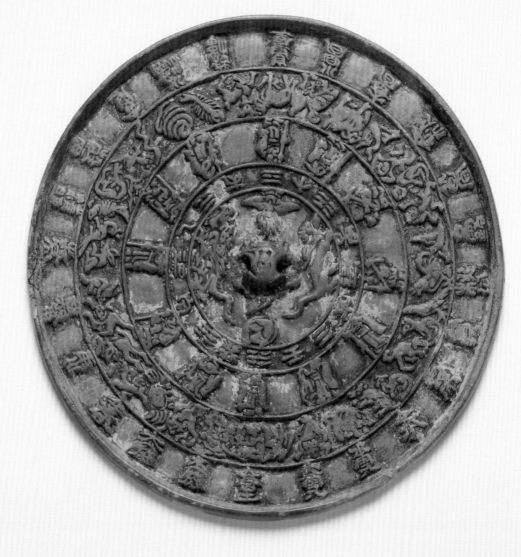

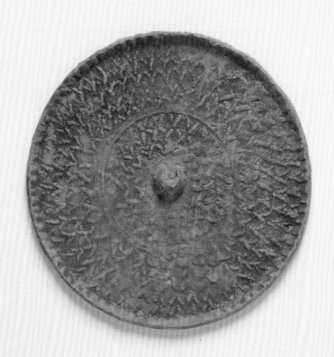

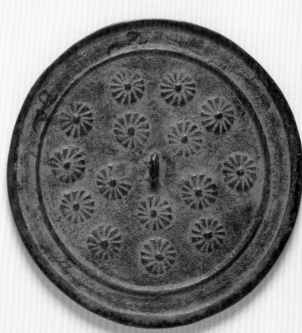

A pleasingly subtle bronze bottle inlaid with silver, (46), is one of the treasures of the Museum's collection of Korean art. When it was presented by the daughter of an American collector, in 1926, it was thought to be Chinese. It is unlikely that any collector today would be unaware that the distinctive waterfowl and willow motif indicates that the bottle was made in Korea in the twelfth or thirteenth centuries.

The bottle has a long neck and a spreading lip. Its body is ovoid, and it has a ring foot. To make the inlaid design, a pattern was first incised in the bronze. Silver wire was then hammered into the depression. The silver inlay is exquisite, the designs covering the surface delicately and in harmonious proportions. With the passage of time, the surface has turned an attractive warm brown colour. Comparison of the inlaid decoration on this bottle and that on late twelfth-century ceramics demonstrates convincingly that workers in different media influenced each other technically and artistically.

Inlaid decoration on metalware continued to be produced throughout the Koryŏ and Chosŏn periods, in the form of bottles, incense burners and boxes. In the eighteenth and nineteenth centuries, silver-inlaid iron came to predominate, as the quality of inlaid bronze work deteriorated.

46

BOTTLE

Bronze, inlaid with silver wire
1100–1300, Koryŏ dynasty
Height 25 cm
M.1189-1926
Brooks Bequest

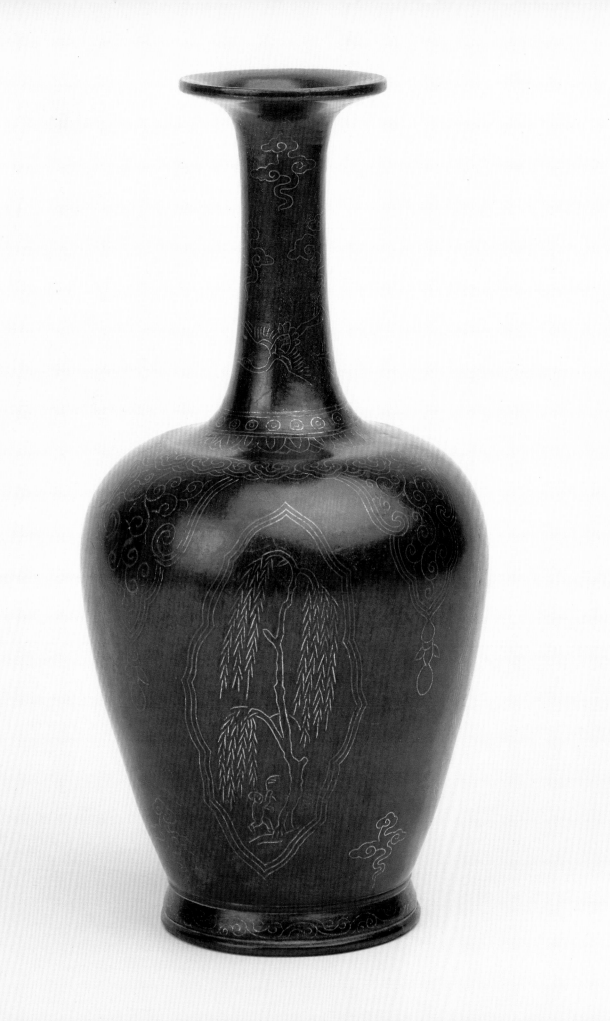

Two Koryŏ bronze bottles, (47), are undecorated apart from join lines near the feet, indicating that the bases were probably made separately and inserted into the bodies. There are also two low ridges on the shouldered bottle. Slight casting faults and variations in corrosion patterns confirm that the bottles were cast in more than one piece. The shouldered bottle is similar in shape to the silver-inlaid bronze bottle discussed above. The surface is extremely corroded due to prolonged contact with earth, in contrast to the warm brown glowing patina of the inlaid bottle. The bottle on the right has a pear-shaped body with an out-turned lip. Its flowing lines retain their austere beauty despite the corrosion that has attacked the entire surface.

Opinion is divided concerning the use of these bottles or vases. Some authorities maintain that they were exclusively used in Buddhist temples as ritual bottles, either filled with water or to hold flowers. Others believe that while Buddhist ritual was one important function, bottles like these also had a secular use as wine or water bottles in the homes of the élite. Analysis of the composition of the bronze showed a standard mixture of copper, lead and tin with traces of iron and silver. This contrasts with results obtained from analyzing bronze spoons of the same period, which were all found to be lead-free or extremely low in lead. Since lead is soluble in wine and other acidic liquids, it seems likely that it was avoided in vessels intended for culinary use, and so perhaps these bottles were not used as wine containers. These bottles were among a wide variety of precious belongings placed in tombs to accompany the deceased into the afterlife.

It is certain that both metal and ceramic versions of the same vessels were made, and that seasonal rather than aesthetic considerations determined which should be used. There is a Korean saying that ceramics are for summer use and metal for winter.

47
TWO PLAIN BRONZE
BOTTLES
Koryŏ dynasty (935–1392)
Maximum height 30 cm
M.101, M.100-1937

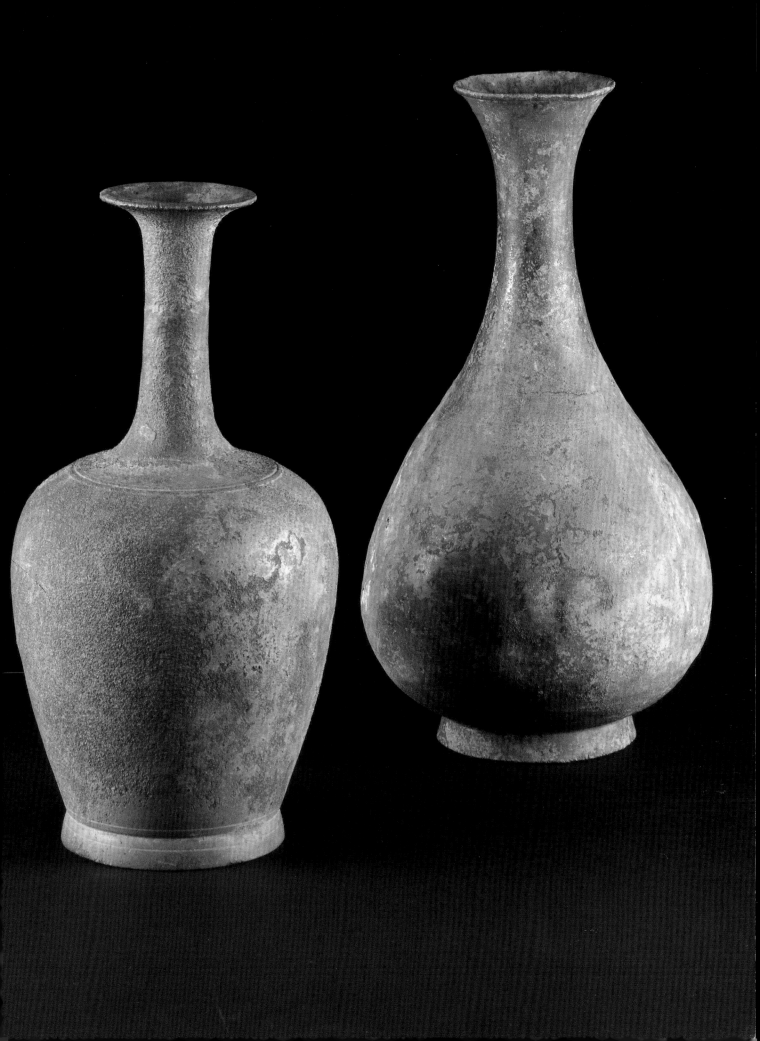

The spoons in (48) form part of a collection of over forty Korean examples in the Victoria and Albert Museum. Very many Koryŏ spoons, and important Silla examples too, are known to us, and it is possible to trace the development of the shape and decoration of Korean spoons over time. The three spoons above are from the Koryŏ period, displaying exaggerated curvature of the handle and 'swallow-tail' shaped ends. The uppermost spoon is early Koryŏ, judging from the gentler curve of the handle and the plain end. The three spoons below are a medicine spoon, a hinged spoon and an early Koryŏ spoon with a decorative knob.

In the eleventh and twelfth centuries, the gentle S-shaped curve of the handles tapered into a plain edge. The shape and decoration of bronze spoons evolved further in the later Koryŏ period, as handle-ends were cut in the elegant swallow-tail shape, the curvature of the handle became exaggerated and the oval bowl was given a pointed tip. On many spoons, one finds incised meandering patterns on the handles. These mid-Koryŏ spoons must have been rather difficult to use. By the end of the Koryŏ dynasty and in the early Chosŏn period, from the fourteenth to the fifteenth centuries, the typical spoon shape changed again, so that they had utilitarian, thick, straight handles.

The bowls, (49), provide further confirmation of the continuum between metal and ceramic wares in Koryŏ times. On the right is a bowl with rather thick walls which curve gently out towards an everted rim. Prolonged contact with the ground has produced a striking corrosion pattern, particularly where the foot joins the body. The shape of this bowl suggests a date in the late Koryŏ period, thirteenth or fourteenth century. The round-sided bowl on the right, while superficially similar in its plain undecorated lines, has features which date it rather later, to the Chosŏn dynasty. It has a low foot and inward-leaning walls. The rim too turns inwards, and is emphasized by a single incised line running just below the edge. At the centre of the inner bowl, four pins are visible, holding the two parts of the bowl together. Fine ringmarks on the walls are a sign that this bowl was probably turned, not cast. The bronze is so thin that it has disintegrated in places, leaving tiny holes in the vessel walls.

Two other bronze bowls, (50), have lids (it is possible that on the preceding plate the bowls previously had lids which are now lost). On the right is a flat-bottomed bowl with a smoothly rounded cover. Its inside has marks where grains of rice have stuck to the bowl. The rather straight walls are extremely thin and have been attacked by corrosion. The second lidded rice bowl stands on a straight foot, to which it is joined by four pins. Turning lines are visible on the bottom and on the lid. The plainness of the shape is offset by a knob pegged on to the centre of the lid, and by a thin incised ring just around the circumference of the rim.

48

BRONZE SPOONS
Koryŏ dynasty (935–1392)
Maximum length 26.5 cm
M.314-1921, M.406-1912,
M.50, M.67, M.68-1937,
M.159-1938

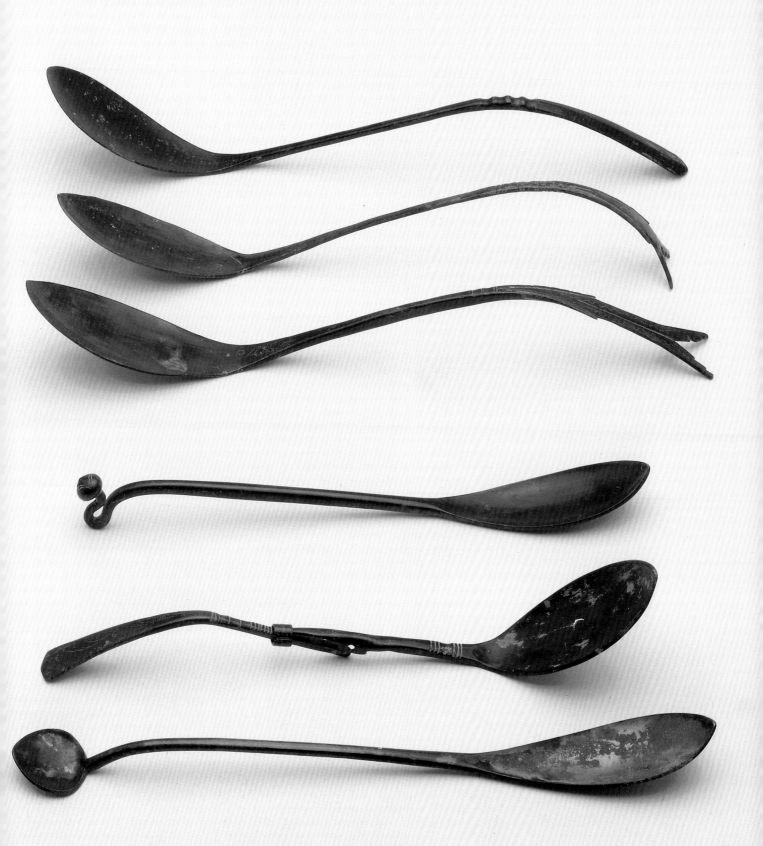

49 (*below*)
BRONZE BOWLS
1300–1600, late Koryŏ/early
Chosŏn dynasties
Maximum height 10 cm
M.107 and M.103-1937

50 (*opposite*)
**BRONZE BOWLS WITH
LIDS**
Chosŏn dynasty (1392–1910)
Maximum height 16 cm
M.579-1936, M.104-1937

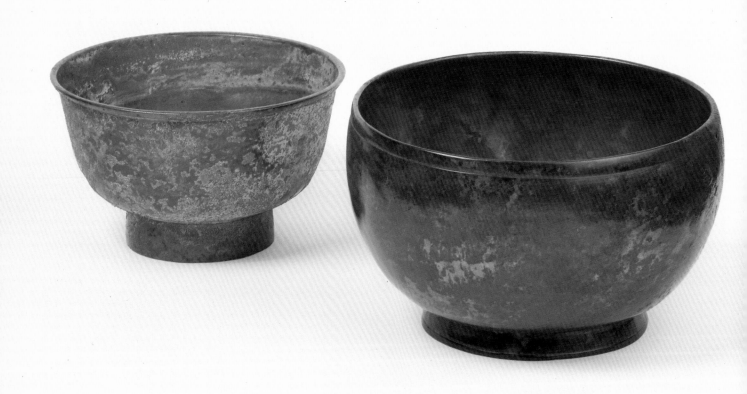

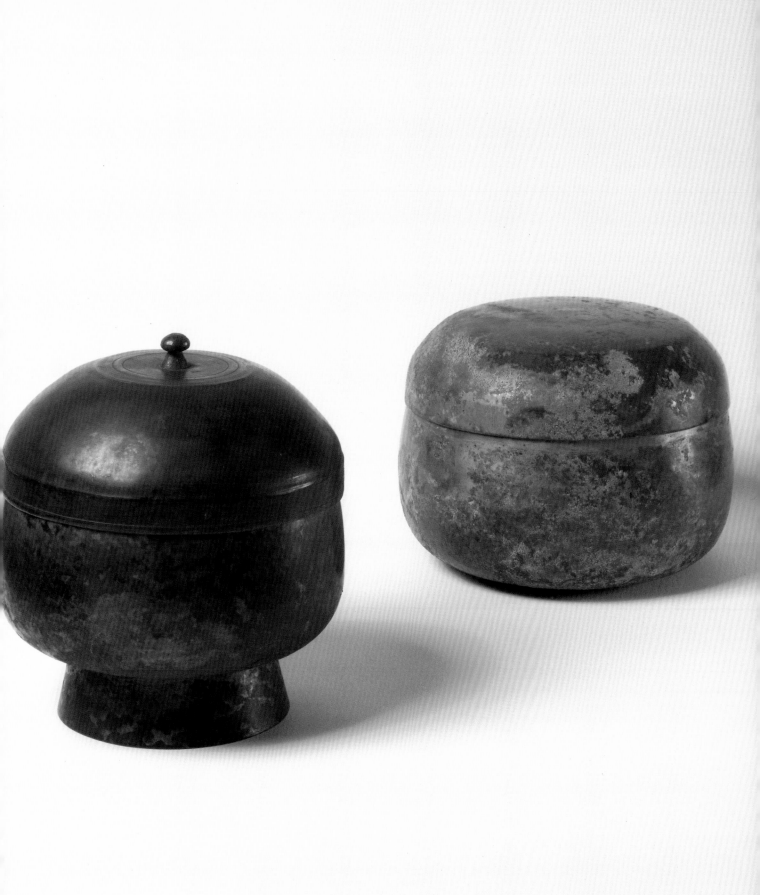

An unusual and historically interesting helmet, (*51*), belonged, according
to the Museum records, to a 'Corean Prince, and was taken by the troops of
the Prince of Hizen [in the north-eastern part of present-day Saga prefecture,
Kyushu] during Taiko Samu's expedition from Japan to Corea in 1594.'
Taiko was an honorific title conferred on Hideyoshi, who launched an in-
vasion of Korea in 1592, and in the absence of contradictory evidence, there
seems to be no cause to dispute this remarkable provenance. Constructed
from two main iron sections joined together with metal strips, the helmet
has a flat-topped piece supporting a hollow hexagonal post, used to hold a
pennant which does not survive. Along the rim are ten protruding pins
which originally supported leather or fur ear flaps, also now lost. A visor
formed of a vertical plate with a curved edge juts out to give protection at
the front. Recent cleaning has highlighted the fine silver-inlaid dragons

which writhe across the separate pieces of the helmet, supporting the claim
that its owner was a prince or high-born military leader. The illustration
from an eighteenth-century Korean manual of military arts shows an armed
soldier wearing a similar helmet, and highlights the similarities between
Chosŏn Korean and Chinese armour.

Domestic and luxury items predominate in the Museum's collection of
later Chosŏn metalwork. Unlike the Koryŏ bronzes described above, these
later brass, iron and bronze pieces have survived not in tombs, but in noble
households, where they formed part of the furniture and were used for
everyday purposes like holding candles or storing tobacco. These metal
boxes, candlestands, incense burners and brushpot holders are difficult to
date with precision, but Western travellers to Korea noticed silver-inlaid
ironwork on sale in the shops and markets in the last decade of the nine-
teenth century, and remarked on brassware in households they visited.

Mounted soldier in armour and
helmet (*left*). From *Muye tobo
t'ongji* (*Complete Illustrated Manual
of Martial Arts*), eighteenth
century

51 (*opposite*)
HELMET
Iron with silver inlay
1550–1650, Chosŏn dynasty
Height 26.7 cm
118-1878

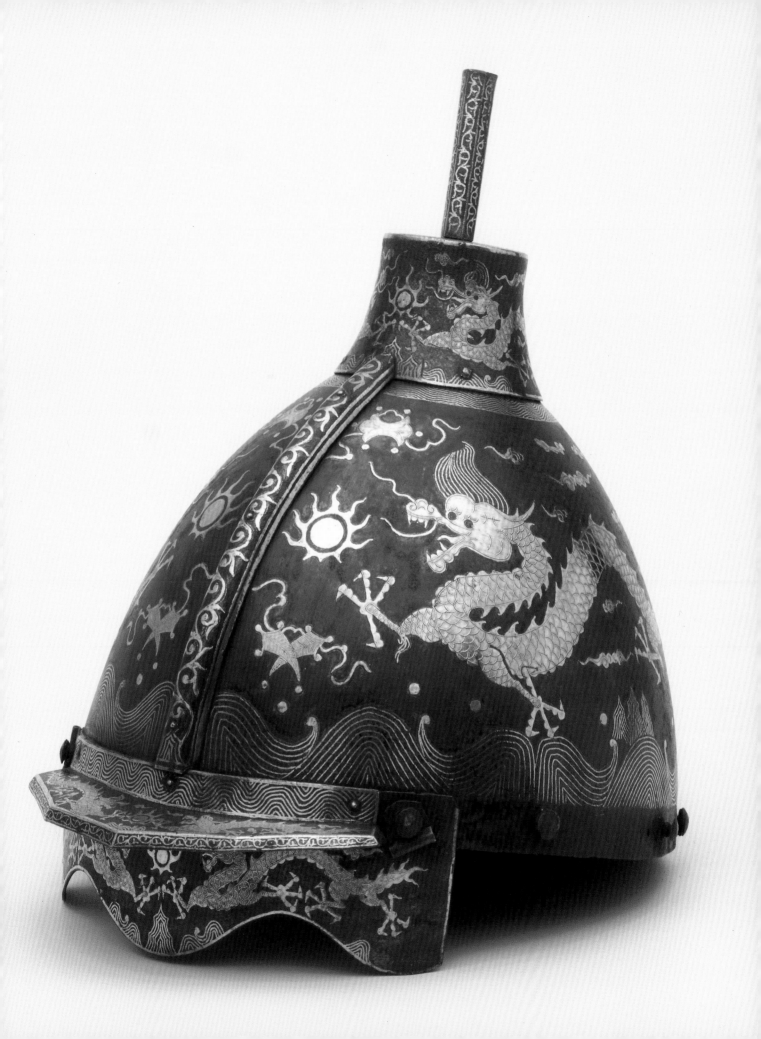

52
CANDLESTICK AND
REFLECTOR
Iron and silver
1800–1900, Chosŏn dynasty
Height 99 cm when assembled
M.96-1920

The candlestick with a draught protector, (*52*), is designed to sit on the floor. The circular draught protector is inlaid with a silver design showing a 'double-happiness' character and a motif of bats surrounded by a key fret. The double-happiness motif is associated with marriage, and the other decorations all imply a happy, prosperous life. Similar candlesticks are found with longevity characters, and with Buddhist 'swastika' emblems. In the Far East the swastika and the character *man* (in Chinese, *wan*) meaning '10,000' both denoted infinity. In all cases, the intention was to bring happiness and good luck to the owner.

Further evidence of the ubiquity of references to good luck and happiness in popular art is found in a group of coin charms, (*53*). Fortune-telling played an important part in everyday life. It was unimaginable for a betrothal, marriage or funeral to proceed unless a professional fortune teller had been consulted. One method of casting a fortune with coins like these was to shake them in a wooden container shaped like a tortoise. A prediction could be made based on how the coins fell out of the tortoise. Coin charms were also carried by women and children in purses, or attached to clothing, in the belief that this would bring good luck and protection to the wearer. Paper charms and talismans were also common, and were used to invoke protection against disease, misfortune or the attentions of evil spirits. Most of the coins are of the typical East Asian shape, round with a central square hole, through which thread could be passed to make strings of cash. The few charms which are not shaped in this way have a protruding loop designed to allow them to be tied on to a belt or clothing. The characters on the charms repeat the themes of longevity, plenty, happiness and good fortune remarked upon before. Larger lucky charms, sometimes known as amulets, also enjoyed widespread popularity in the Chosŏn period. The example shown here is an exuberant composition of swirling dragons, finely worked into a complex openwork whole. Amulets constructed from groups of coins joined together are also common.

53
AMULET AND CHARMS
Bronze
1850–1900, Chosŏn dynasty
Maximum height 14.5 cm
M.72, M.73, M.74, M.75, M.76,
M.77, M.78, M.79, M.80, M.81,
M.82-1920, M.97-1920

Tobacco has been grown and smoked in Korea since the early seventeenth century, when it was introduced from Japan. In the late Chosŏn period, upper-class gentlemen would store tobacco in boxes like this rectangular one, (54). Intricately patterned with inlaid silver, this iron box has a close-fitting lid, decorated with a large double-happiness character, which is opened by pushing the button at the front. The box was part of a substantial group of Korean objects presented to the Museum by Thomas Watters (1840–1901), which included examples of embroidery, jade and basketwork. From about 1885 until 1902, officers of Britain's China Consular service staffed the posts of Consul General in Seoul and Vice-Consul in Chemulpo (as the port of Inch'ŏn was then known). Watters, son of a clergyman from County Down, served in Seoul in the late 1880s.

In the same illustration, a hexagonal iron and silver box of the late Chosŏn is overlaid on each side with the auspicious character *su*, meaning 'long life'. The design conveys wishes for long life and happiness, health and peace, riches and honour. In the centre of the lid, the character for long life is repeated in seal script. The rounded box in the foreground has a bowl and lid of identical shape, apart from the ring foot on the bowl. Here the intricate decoration takes the form of a circular panel in which a pair of writhing dragons rise out of stylized waves to pursue a sacred gem. More dragons surround the central panel, interspersed with long life characters in seal script. Both gold and silver have been used in the decoration of this fine iron box, which was probably used as a tobacco container in a well-to-do house-hold.

Other examples of nineteenth-century inlaid metalwork are the brush-pots, (55), which formed part of the writing equipment in a scholar's study, together with brush, water dropper, ink and inkstone, like those shown on page 84. The two brushpots are of iron. One is hexagonal and stands on six feet which have been cut out from the base. It is decorated in silver wire overlay depicting pine trees, bamboos, a waterfall, deer, cranes and a tor-toise. As we have seen earlier, these are all symbols of longevity, and recur frequently in paintings, furniture and crafts of the late Chosŏn. The unaffec-ted style in which the designs are shown is very appealing. Each of the six panels is beautifully composed. The cylindrical brushpot is equally success-ful in its rendering of the familiar theme of writhing dragons pursuing a precious pearl. On its base is a mark of the reign period of the Chinese Emperor Qianlong (1736–95), but it seems likely that the brushpot was made not more than a few decades before the Museum bought it in 1912.

54
TOBACCO BOXES
Iron inlaid with silver wire
1850–1900, late Chosŏn dynasty
Maximum height 10.5 cm
M.240-1926, M.72-1909,
1842-1888

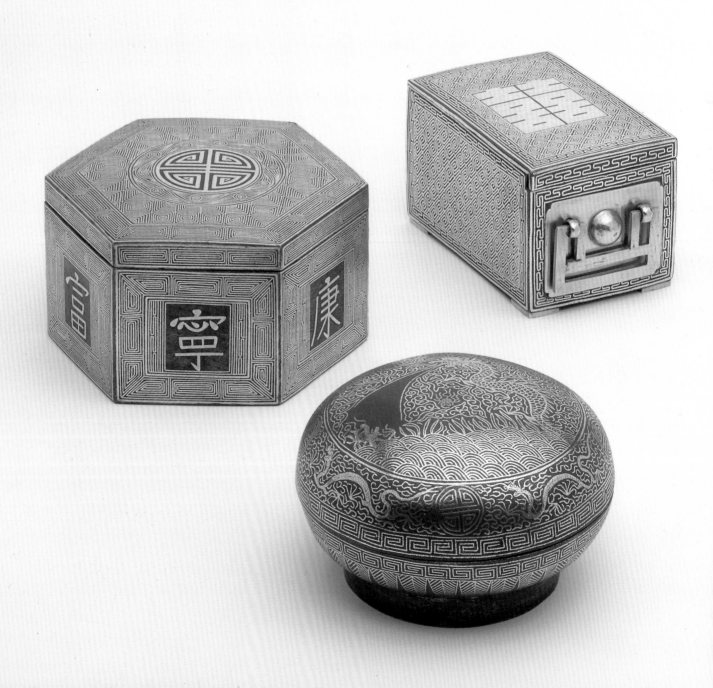

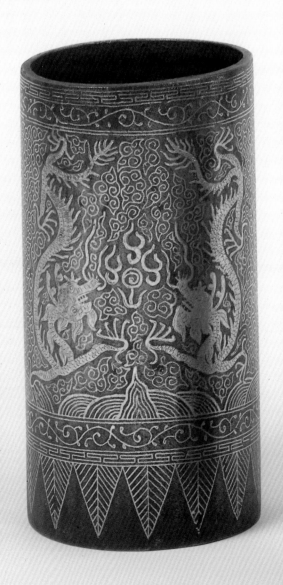

55
BRUSHPOTS
Iron inlaid with silver wire
1850–1900, late Chosŏn dynasty
Maximum height 19.6 cm
M.302 and M.401-1912

A small bronze incense burner, (56), is of a shape associated with Buddhist temple ritual. It is not, however, a Koryŏ piece like many famous inlaid bronze censers of similar form. Its small size, the composition and colour of the bronze, the technique of the decoration and the four Chinese characters of the inscription all place it in the late Chosŏn dynasty, probably the nineteenth century. It has a flat, outward-spreading rim, straight-sided deep bowl, and a trumpet-shaped foot. The inscription can be translated as 'may years be lengthened and longevity increased'. Wishes for long life are usually associated with the Confucian tradition of respect for the older generation. The entire surface is covered in an engraved and punched patterning of scrolls and small circles. This half-size copy of a Koryŏ incense burner may have been made for a respected father or uncle. It was previously in the Eumorfopoulos collection of Chinese and East Asian antiquities.

56
BRONZE INCENSE
BURNER
Chosŏn dynasty (1392–1910)
Height 14 cm
M.581-1936

Textiles, Dress and Embroidery

A T least since the Three Kingdoms period, which ended in 668 when Silla defeated the rival kingdoms of Koguryŏ and Paekche to unify the greater part of Korean territory, Koreans have worn a distinctive style of clothing known as *hanbok*. Materials varied with the seasons, cut and length went up and down with fashion, and with the social standing of the wearer, but the ensemble of a short jacket and full skirt for women and a jacket and loose trousers for men has persisted over the centuries. Wall paintings that decorate tombs in Koguryŏ, the northernmost of the Three Kingdoms, depict indoor and outdoor clothing for people of high and low rank in the fourth, fifth and sixth centuries. In particular, the Tomb of the Dancers, Kungnaesŏng, so called because of the dancing figures depicted in some of its murals, shows an interesting range of fourth- and fifth-century Koguryŏ dress for men and women, masters and servants.

We know from historical records that the Kingdom of Silla introduced one-piece Chinese robes for court wear in the seventh century. Official ranks were distinguished by specific colours, lengths and styles of clothing. For everyday wear, commoners and aristocrats alike continued to favour the short, bolero-style jacket and billowing skirt for women and for men, wide-cut trousers tied in above the ankles. The practice of fastening jackets at the side with a prominent tie has also endured at least since Koguryŏ times, for the murals in the Dancers' Tomb referred to earlier show breast ties on the wearer's left, and garments from the Koryŏ (935–1392) and Chosŏn (1392–1910) periods also have breast ties, on the wearer's right. This method of fastening the jacket or coat adds interest to the plainly tailored monochromes that predominate in traditional Korean dress. Even high-born noblemen and ladies wore predominantly plain clothes except at weddings and court ceremonies. Scholars in the Chosŏn dynasty wore so-called crane-robes, of white with black collars and sleeve edges. Hats and head-dresses were an essential part of the dress code. From the dazzling gold crowns of Silla to the wide-brimmed black horsehair hats of noblemen in Chosŏn times, all headwear signified class and rank. Courtiers wore caps with side-flaps, scholars had square hats, civil and military officials wore hats appropriate to their position; even farmers, Buddhist monks and members of low-class professions could be identified by their hats.

Figures from a wall painting in the Tomb of the Dancers, at Kungnaesŏng (Tonggou), 500–600, Koguryŏ period

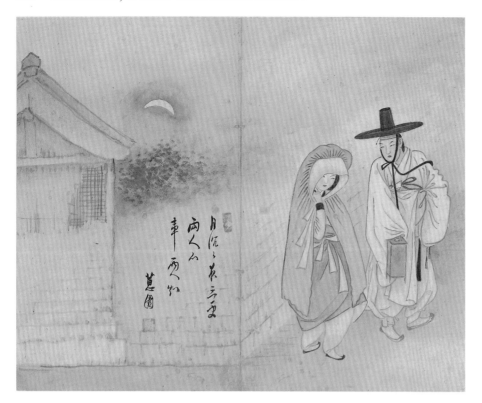

The practice of segregating men and women gave birth to an unusual garment called *chang'ot*. This was a kind of pleated silk cloak worn by women over the head and face to protect the lady's modesty. It puffed round the face while allowing the wearer to peep out. Anonymous behind the folds of the cloak, even upper-class ladies could escape the seclusion of the home for a walk in the streets, usually at night.

The contrast between the muted tones of white that were the everyday wear of commoners and the splendid finery of court costume was a deliberate statement of the absolute authority of the royal house. Dress was a sign of an individual's class and age. A commoner could never dream of putting on a *yangban*'s black horsehair hat. A married lady's blue skirt distinguished her at a glance from her unmarried sister in brighter red and yellow. Hairstyles too had to conform to rules: young men first gathered their hair into a top knot after their coming-of-age ceremony. Married women pinned up their braids, while young girls had a hanging plait.

Since clothes were not regarded as precious objects, and because fabric is subject to chemical change and deterioration, few relics of pre-Chosŏn dress have survived until modern times, and those are all pieces excavated from tombs. Thus knowledge of traditional Korean clothing is strongly weighted towards the past two centuries, and particularly towards court dress, for we have substantial numbers of paintings and portraits depicting ceremonial dress. For a clear picture of the dress of the common people, we have to turn to paintings by Kim Hong-do (born 1745), Sin Yun-bok (born 1758) and

Lady in a hooded cloak (*left*), by Sin Yun-bok (born 1758) Kansong Art Museum, Seoul

'Admiring spring in the country' (*opposite top*), and 'Enjoying lotuses while listening to music' (*opposite bottom*) by Sin Yun-bok (born 1758) Kansong Art Museum, Seoul

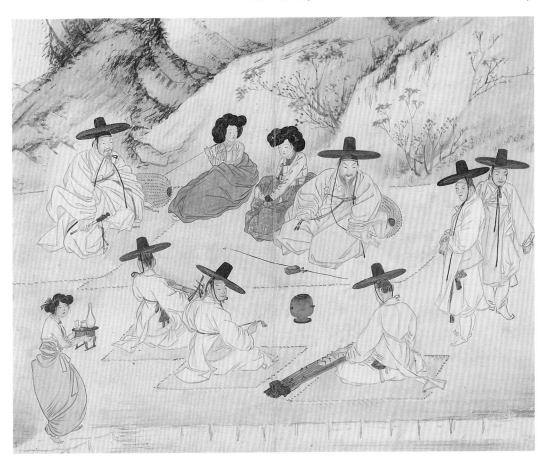

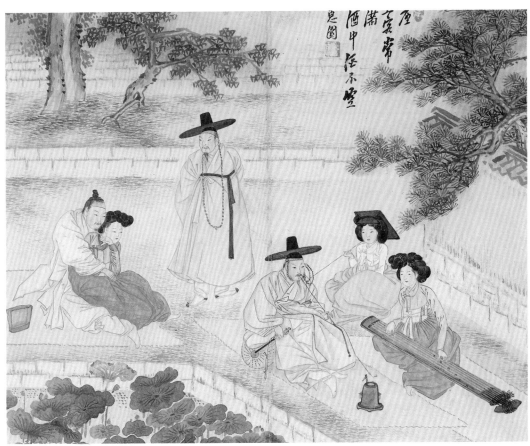

Kim Tŭk-sin (1754–1822) that show high- and low-class Koreans of the time at work and play. Genre paintings of the nineteenth century by artists like Kisan, who was active in the 1880s, were collected by Western visitors to Korea and are another valuable source of information about clothing.

Published accounts of travels in Korea by Western travellers also provide interesting details about the clothing of the time. An English traveller and writer, Mrs Isabella Bird Bishop, for example, noted in the 1890s that Korean men wore 'white cotton-sleeved robes, huge trousers and socks; all wadded. On their heads were black silk wadded caps with pendant sides edged with black fur, and on the top of these, rather high-crowned, somewhat broad-brimmed hats of black "crinoline" or horsehair gauze, tied under the chin with crinoline ribbon.' She also witnessed the procession of King Kojong to the Royal Ancestral Shrine in 1894 or 1895:

> palace attendants in hundreds in brown glazed cotton sleeved cloaks, blue under robes tied below the knee with bunches of red ribbon, and stiff black hats, with heavy fan-shaped plumes of peacock's feathers, rode ragged ponies on gay saddles of great height ... [High officials passed], superbly dressed ... they wore black, high-crowned hats, with long crimson tassels behind, and heavy, black ostrich plumes falling over the brim in front, mazarine blue silk robes, split up to the waist behind, with orange silk under robes and most voluminous crimson trousers, loosely tied above the ankles with knots of sky-blue ribbon, while streamers of ribbon fell from throats and girdles, and the hats were secured by throat lashes of large amber beads ... sleeves were orange in the upper part and crimson in the lower, and very full.

As a country of seasonal extremes, Korea produced a variety of fabrics to meet different clothing needs. Each stage of the labour-intensive and time-consuming process, from the twisting of the fibre to the weaving of the thread into fabric, was done by women. Local production led to centres of excellence, for example Andong in North Kyŏngsang province is famous for hemp, and Hansan in South Ch'ungch'ŏng province for ramie. The noble class wore silk in winter and ramie (a fine fibre spun from the shrub *Boehmeria nivea*) in summer. Common people wore cotton in winter and hemp or ramie during the summer. Cotton was first cultivated in Korea in the fourteenth century, after a scholar named Mun Ik-chŏm (1329–98) visited China in 1363 and brought a few seeds back to Korea with him. His experimental planting was successful, and led to the widespread adoption of cotton farming. Clothes made of cotton were unlined for summer wear and padded for winter.

The wearing of hemp is closely associated with mourning. In its early years, the Chosŏn dynasty (1392–1910) made strenuous efforts to introduce Confucian-style mourning, which was considered an essential step towards instilling a proper spirit of filial devotion in the Korean people. The sons of a deceased parent were expected to wear clothes of rough undyed hemp and straw sandals, and to carry a wooden staff. The proper mourning period was three years, during which time the bereaved son had to live plainly, give up official duties, and avoid all music, entertainment and fine food. Mourning became such an important and significant part of Korean life that Horace Allen, an American doctor who worked in Korea in the 1880s and 90s, wrote that 'the dead seem to receive more careful consideration than the living.' Korea impressed many foreign visitors as a land of white-dressed people. As Horace Allen explained:

> White being the mourning colour and three years the mourning period, it may easily be seen that with ordinary rates of mortality there must be many who are in mourning at any given time. Furthermore when a royal personage dies the whole population must adopt mourning colours for a period of three years . . .

In the twentieth century, Korean dress has undergone many changes. Most women no longer weave their own material or sew their own clothes. Chemical dyes and man-made fabrics have reached all sectors of society. In the cities today, Western clothes predominate. The *hanbok*, however, has not disappeared from Korean life. Ladies can be seen wearing it on traditional holidays and at family gatherings. Men are less often seen in traditional dress, but musicians and actors still perform wearing *hanbok*, and the general public gains an impression of national costume from the many historical dramas shown on Korean television.

Interest in traditional dress has led to lively debate about the authenticity of various styles of clothing, the design of the collar-stiffener, and the proper cut for the full, pleated high-waisted skirt. Visitors to Korea notice that enthusiasm for traditional costume is not confined to the older generation. Young people, including students, are intensely proud of their country's cultural heritage, and have introduced musical and festive events from the past into the mainstream of Korean life. Some Korean wedding ceremonies are held in two stages: one in Western dress and another in the traditional Korean bride and groom's costume. The painstaking detail with which the embroidered costumes of the past are re-created for late twentieth-century brides is clear evidence that Koreans still feel great affection for their country's traditional dress.

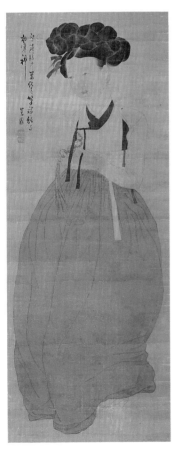

Portrait of a beautiful lady wearing a *hanbok* by Sin Yun-bok (born 1758) Kansong Art Museum, Seoul

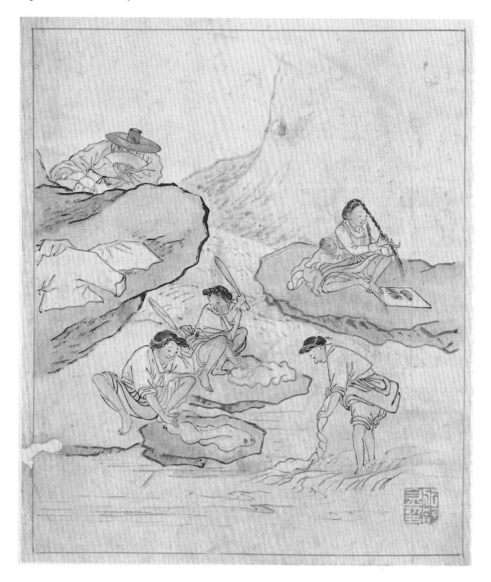

The Museum possesses a contemporary set of women's traditional clothing of ramie, (57). It is an interesting survival of the most widespread type of wear by well-to-do Koreans, and the material was spun from ramie on a traditional narrow loom. The skirt is dyed with indigo, and sewn according to the wearer's notion of the correct pattern for *hanbok*. A white jacket worn with a blue skirt was the dress of a married woman, as can be seen in paintings of the eighteenth century. It was extremely time-consuming to launder such an outfit, because all the material, including the wide full skirt, had to be pounded with heavy sticks in order to release the starch in the ramie which would then give a crisp, glossy texture to the dry garment. The narrow collar-stiffener creates a neatly restrained neckline.

A group of court garments, (58), reflects the pomp and ceremony of late Chosŏn dynasty court life. It consists of a wide-sleeved dark-blue robe with front and rear pleated panels; a red overjacket; an embroidered apron worn at the back; a stiff blue, green and red silk belt with brass plates; and a hat.

Women pounding laundry (*left*),
by Kim Hong-do (born 1745)
National Museum of Korea, Seoul

57 (*opposite*)
BLUE AND WHITE
HANBOK
Jacket – undyed ramie
Skirt – indigo-dyed ramie
Skirt length 125 cm
Jacket 143 × 31 cm
FE.55-1991
Gift of Mrs Jung-So, Minja

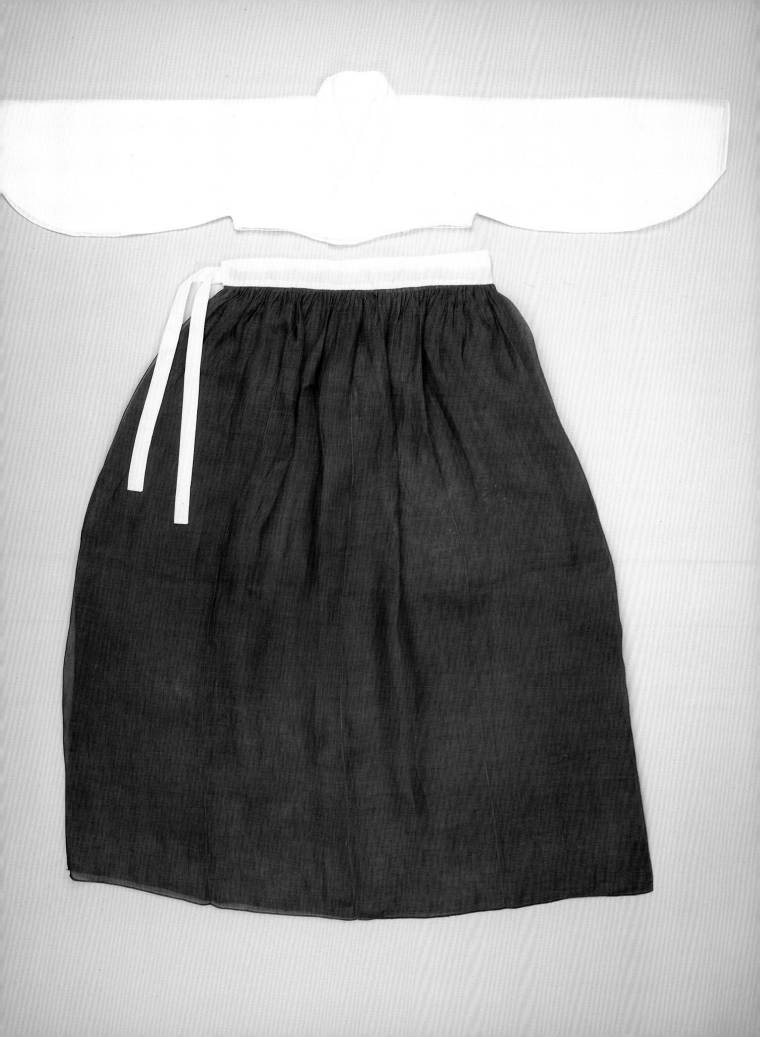

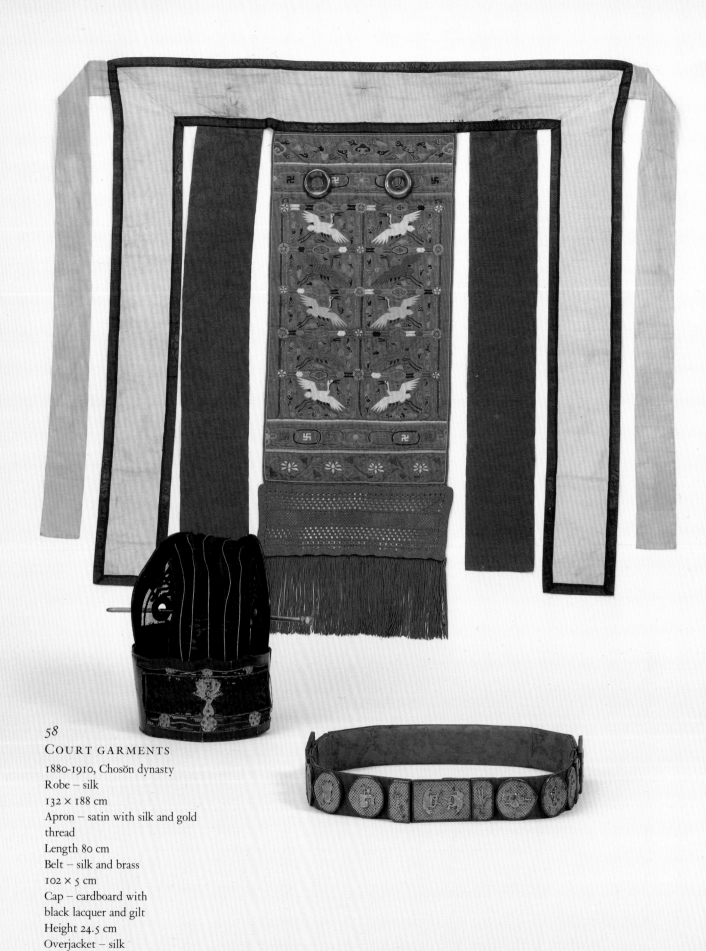

58

COURT GARMENTS

1880-1910, Chosŏn dynasty

Robe – silk

132 × 188 cm

Apron – satin with silk and gold
thread

Length 80 cm

Belt – silk and brass

102 × 5 cm

Cap – cardboard with

black lacquer and gilt

Height 24.5 cm

Overjacket – silk

129 × 186 cm

T.196-1920, FE.428-1992

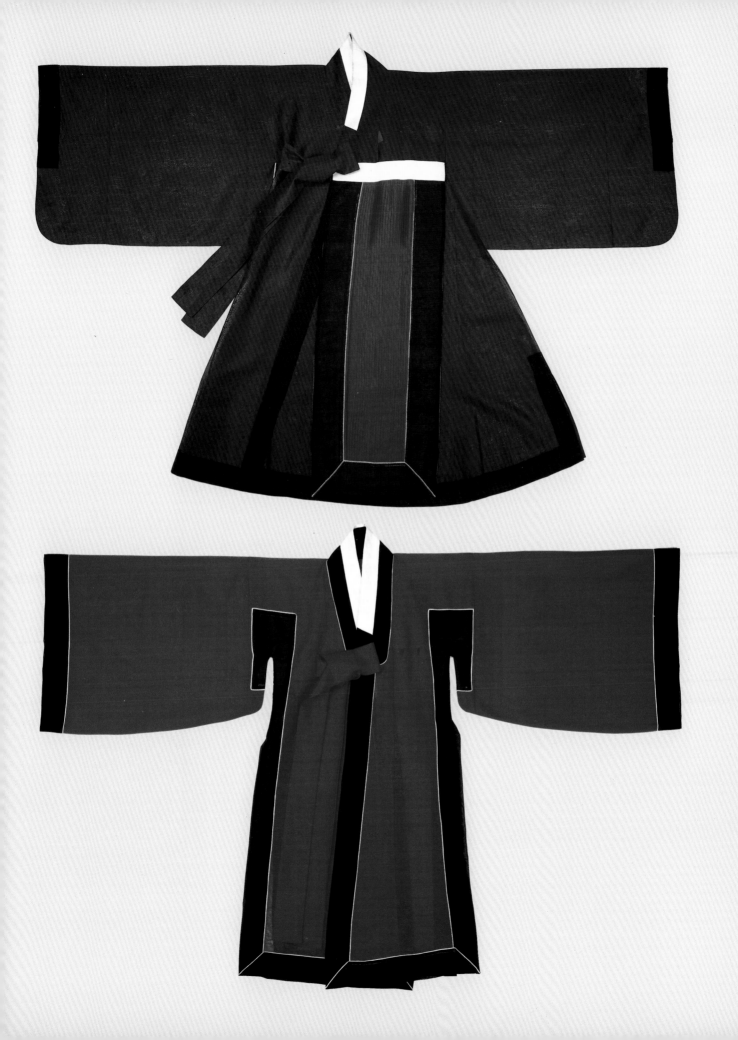

All were worn at court, but they do not form one costume. The robe and jacket would have been worn for an audience with the king or for auspicious court events. The hat, belt and apron were part of a different court costume, worn for the royal ancestral rites which were performed regularly at the Royal Ancestral Shrine during the Chosŏn dynasty. With the exception of the red overjacket which was made in 1991, the garments and accessories were sold to the Museum in 1919 by Stanley Smith, who had returned to the United Kingdom after service with the English Church Mission in Seoul. The Reverend Smith had an important collection of ceramics and various decorative arts, and the Victoria and Albert Museum was able to purchase parts of it.

The blue robe is made of an extremely fine silk gauze, with a pattern of pairs of curling dragons chasing a flaming pearl enclosed in circles. The twisted threads leave little spaces in the gauze to create a semi-transparent effect. Side-fastening, with a broad white collar edge crossing to the wearer's right, the robe is secured internally by a left-fastening integral tie and outside by a right-fastening ornamental tie. There are two integral red pleated silk panels, edged with black.

Since the red jacket which should be worn over the blue robe was missing, a new garment sewn in traditional style was commissioned by the Museum from one of the few tailors in Seoul able to supply the hand-woven and dyed fine silk gauze used in court costume.

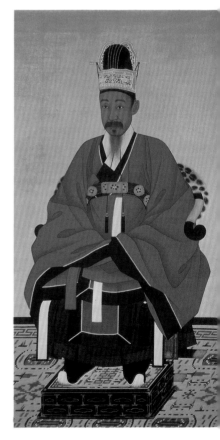

The embroidered apron (*husu*), is composed of two embroidered vertical rows of white, blue and yellow cranes on a red ground, attached to side panels of blue silk and to a surrounding band of white silk with black edges. The cranes strain upwards amidst clouds, and are bordered above and below by two bands of embroidery. The upper border is composed of linked ovals encircling alternate swastikas and flowers over which two large brass rings are sewn, and a top row of embroidered coloured clouds; the lower horizontal bands of embroidery are edged by knotted rows of pale-blue silk leading into long tassels. The belt is jointed, with patterned plaques of deer and pine, cranes, scrolls, and arrows in a quiver. The black and gold hat with five gold lines is known as a *chegwan*, or royal ancestral rites cap. Its five thin gold stripes denote the wearer's rank.

In the Chosŏn dynasty (1392–1910) portraits of distinguished men often showed the subject in full ceremonial dress, in an extremely realistic style. For example, a portrait of an important political figure of the late nineteenth century, Yi Ha-ŭng, or Taewŏngun, father of King Kojong who reigned from 1863 to 1907, shows him in court costume, seated on an imposing, wide chair covered with a tiger skin. This court painting is exact and detailed in its depiction of the facial expression, garments and posture of the sitter. Although Taewŏngun's costume is not identical to the robes in the Museum

Portrait of Yi Ha-ŭng, known as Taewŏn'gun (1820–98) National Museum of Korea, Seoul

because he was of higher rank, the portrait nevertheless supplies interesting information about how official costumes were worn.

The exquisite silk embroidery of cranes on the back apron of the official robe recalls cranes embroidered on official insignia, known as rank badges or mandarin squares (*hyungbae*). The cover illustration to this book is an example of a twin crane badge, and (59) is one of a pair of single crane badges. Throughout Korea's recorded history, courtiers' dress was determined by official rank. The *Great Code of Administration* of 1485 promulgated definitive instructions about the dress to be worn at the various ceremonies which constituted the calendar of court life, and specified the rank badges to be worn by civil and military officials. When the rank badges in the Museum's collection were sewn, the twin crane design had been assigned to civil officials of the first, second and third ranks. Those of the fourth to ninth ranks were to wear single crane motifs. Military officials wore rank badges with animal designs: double leopards for the first, second and third ranks, and a single leopard for the others.

The twin crane rank badge on the front cover of this book was intended for a civil official of the first to third rank. The two cranes dominating the design have outstretched wings among stylized clouds, and hold a piece of *pulloch'o*, the 'plant of eternal youth', in their beaks. The design is embroidered on figured silk satin or damask, and the whole square is interlined with paper, like the embroideries on the rear apron described earlier. The rocks and waves that lie under the cranes are cleverly stitched: a chequered effect is created for the rocks, and close-sewn raised contrasting bands form the waves. Enclosed in a circle in the centre of the rock is a swastika. The stylized waves are raised from the surface by couching tightly rolled pieces of paper on to the pattern before sewing over the top with silk. The feathers and outline of the cranes are also raised, with thread padding formed by stitches.

The single crane square, (59), was worn by a civil official of lower rank. The composition of the embroidery is broadly similar to the twin crane example, but the rocks at the bottom centre are rather loosely sewn in pale and dark blue, white, mauve and yellow. The sprig of 'plant of eternal youth', embroidered partly with couched gold thread, is long and sinuous. The raised effect of the waves and the crane's wings has been created by padding with thread. The badge is completed by a kind of textile frame, made of loosely twisted cream silk twisted together with gilt paper. This example, with its naturally dyed deep blues, is similar to one dated to 1650 in the Suk Joo-sun Memorial Museum of Korean Folk Arts at Dangook University, Seoul. The position of the crane, straining upwards through graceful clouds with long legs trailing below, suggests high-minded integrity, the ideal for civil officials.

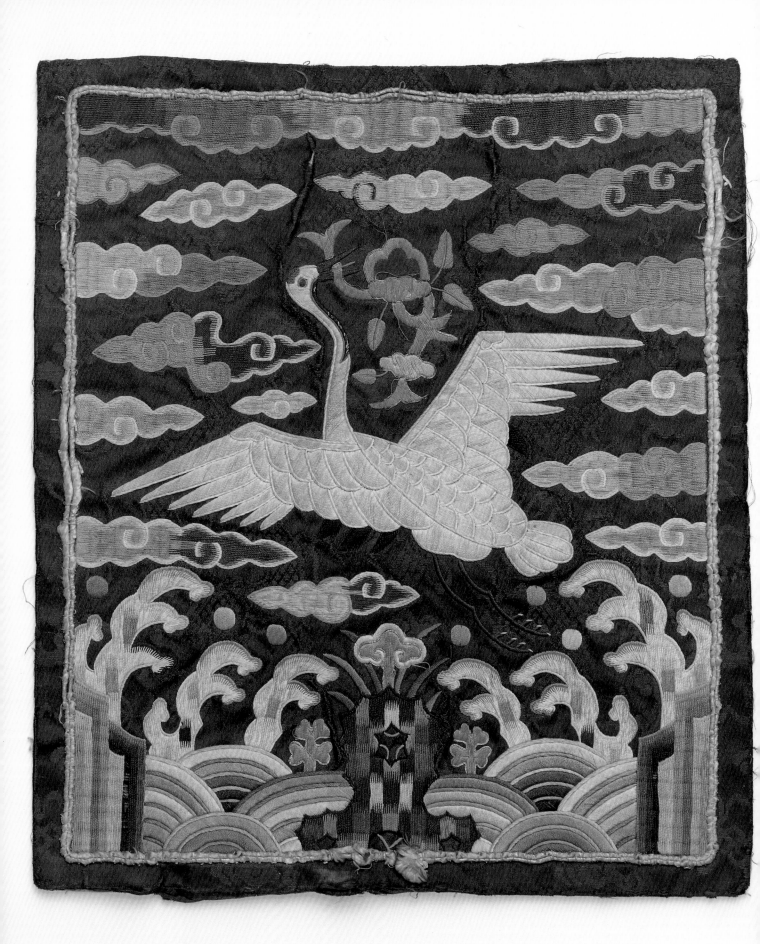

59
RANK BADGE
Coloured silk and gold paper
thread on figured silk
1600–1700, Chosŏn dynasty
26.9 × 24.1 cm
FE.18-1971

Thousands of pairs of rank badges depicting cranes in flight have survived, and although the artistic vocabulary of rocks, clouds waves and 'plant of eternal youth' remained constant for 300 years, the designs, relations of clouds to crane, length and shape of the plant in the bird's beak, and composition of the central rock with surrounding waves appear in infinite variety. Korea's embroiderers, who were almost always women, brought a creative touch to their work. Most rank badges were sewn either by women in the family of the official who wore them, or in a workshop that produced embroidery to commission.

Embroidery was an extremely important part of women's life in traditional Korea. Secluded in the female area of the house, the Korean wife and mother was tailor and embroiderer for the family, producing everyday wear in plain colours, as well as festive dress. In the course of a lifetime, there were plenty of special occasions for which embroidered clothes were needed, including the 100-day celebration of a baby's birth, the first birthday and later the wedding. Old people celebrated their sixtieth birthday, representing the completion of the traditional sixty-year cycle which was accorded great significance in East Asia. Children wore brightly coloured robes and carried embroidered purses and decorative bags that held spoons and chopsticks. Hats and pigtail decorations were also popular, again in bright-coloured thread embroidered on a red silk ground and depicting auspicious symbols like the ten signs of longevity, lucky cash and swastikas. These same motifs, as we have seen, recur throughout the domestic crafts of the Chosŏn dynasty.

Although weddings were special occasions that required special apparel, the hierarchical rules determining that different social groups must wear appropriate clothing were not relaxed for wedding dress. Noble ladies and members of the royal family wore lavishly embroidered over-robes for the wedding ceremony. Commoners wore plainer gowns of the same design. An embroidered panel, (*60*), was originally sewn on to a noblewoman's wedding over-robe. It has been separated from the garment and mounted as a panel. Two other smaller panels, (*61, 62*), were removed from two separate noblewomen's bridal robes, probably from the back shoulders. The noblewoman's wedding robe (*hwarot*), was cut long at the back and short at the front. Embroidered panels on the sleeves, shoulders, and aprons made the *hwarot* a sumptuous, brilliant garment. When the two sleeve panels were held together, they formed a splendid composition, edged by broad bands of blue, yellow and red on the full sleeves. The panels are compositions of lotus and peony flowers and leaves, waves, rocks and birds. All are familiar Buddhist and auspicious symbols which represent wishes for a long and happy marriage.

60 *(left)*
**PANEL FROM A
WEDDING GARMENT**
Coloured silk and gold paper
thread on silk
1850–1900, late Chosŏn dynasty
62 × 27.2 cm
T.201-1920

61 *(centre)*
**PANEL FROM A
WEDDING GARMENT**
Coloured silk on satin
1850–1900, late Chosŏn dynasty
71 × 28.5 cm
T.20-1925
Gift of Mrs G. Eumorfopoulos

62 *(right)*
**PANEL FROM A
WEDDING GARMENT**
Coloured silk and gold paper
thread on silk
1850–1900, late Chosŏn dynasty
60 × 30 cm
T.21-1925
Gift of Mrs G. Eumorfopoulos

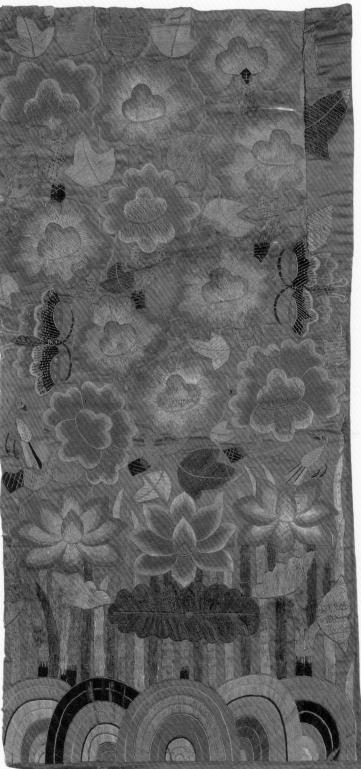

Two embroidered satin purses, (63), show how the embroiderer beauti-fied even a small accessory. The two red purses are secured with decorative green knotted ties. The ties were used to attach the purses to the wearer's belt or dress. Since *hanbok* did not have pockets, purses such as this one were both ornamental and functional. The conventional flower and rock scenes which decorate both purses can be seen on close examination to vary subtly. One of the purses has a coin in a reserved circle in the middle of the rock. Lotus flowers are the main feature of the lower purse, and peony blossoms the other. The character *su*, meaning 'long life', has been embroidered in gold above the central blossom, and the profusion of couching on both purses suggests that they were made for a high-ranking lady.

Embroidered scrolls or screens embellished the austere interiors of Korean homes. The blue and gold scroll depicting archaic Chinese bronzes and inscriptions, (64), reflected the love of classical China among Korea's élite. The bronzes date from a legendary golden age in early Chinese history, remembered because enlightened rulers brought peace and propserity to the people. The design is modelled on printed collections of examples of such bronzes, which were popular among the educated élite. One of the characters in ancient script has been sewn in reverse image, suggesting that the em-broiderer might have copied from a corrupted text. Illustrations of a bell and three different wine containers, together with explanatory text and a copy of archaic character inscriptions, have all been exactly copied from a printed original. The vessels were sewn in straight, satin and stem stitch, and the inscriptions in float stitch. The embroidery appears gold against the blue satin ground, although the thread is yellow.

63 (opposite)
PURSES
Silk and gold thread on satin
1850–1900, late Chosŏn dynasty
Maximum width 10.2 cm
T.102 and T.103-1924
Gift of HM Queen Mary

64 (overleaf)
EMBROIDERED SCROLL
Silk on satin, mounted on paper
1800–1900, late Chosŏn dynasty
181 × 52 cm
FE.25-1984

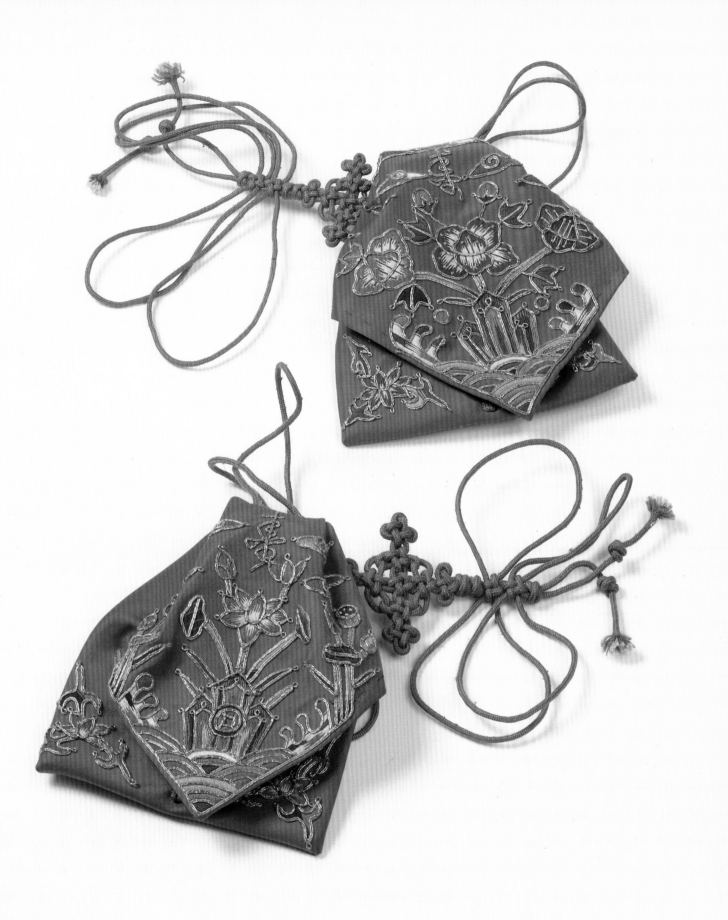

子父癸卣

銘

枚父癸

子　執戈
　　形
　　父癸

其　司　尊　卣　尊　周　謂　商　中　卣
用　所　彝　蓋　獨　則　之　之　尊　之
也　以　皆　周　謂　彝　彝　世　也　為
　　辨　有　官　之　卣　至　總　夏　器

A painted wrapping cloth, (65), is an example of a functional item which has been made with infinite care. Wrapping cloths, *pojagi*, were a familiar part of everyday life in homes of all social levels. They were used to protect clothing in storage, to wrap gifts, to cover food, to store bedding quilts and for many other purposes. They are found in different sizes, made of silk, ramie or cotton, lined or unlined, embroidered, painted, printed or plain, depending on their purpose and the social standing of the household.

The painted cloth shown here is an example of the 'Chinese colours' type. Judging by its size (just over a metre, or three loom-widths square), it was probably used to store hats or footwear, or to wrap around a storage chest. Painted wrapping cloths of this kind were made and used exclusively at court, where a special office was responsible for making clothing and related articles for the royal family. An upsurge of interest in Korea's distinct cultural heritage has led in recent years to a series of publications and exhibitions about wrapping cloths. The leading authority on the subject, Huh Dong-hwa, has identified six types of court wrapping cloths and about thirty separate kinds of commoners' wrapping or covering cloths. They range from large compositions made for the palace to humble patchwork covers for jewellery and sewing equipment kept by women and measuring perhaps thirty centimetres square. Even the humblest wrapping cloths have an unaffected charm, and critics have been struck by their freshness and modernity.

Like many other late nineteenth-century objects from Korea, the painted cloth has an exuberant array of auspicious symbols for its decorative theme. The central circular bands are contained in a square which is surrounded by smaller squares, containing interlocking shapes, *yin-yang* symbols and swastikas. These are surrounded in turn by an outer row of squares containing flower heads, and on the outer edges, a band of brown *yin-yang* symbols. The predominance of red in the colour scheme is thought to stem from the practice at the Chosŏn court of avoiding yellow, the colour reserved for the Chinese emperors. Yellow may have been forbidden, but red and purple were associated with the Chosŏn court and would have been the natural choice for the artisans who decorated this cloth.

65

WRAPPING CLOTH

Colours on hemp
1800–1900, late Chosŏn dynasty
107 × 107 cm
FE.156-1983

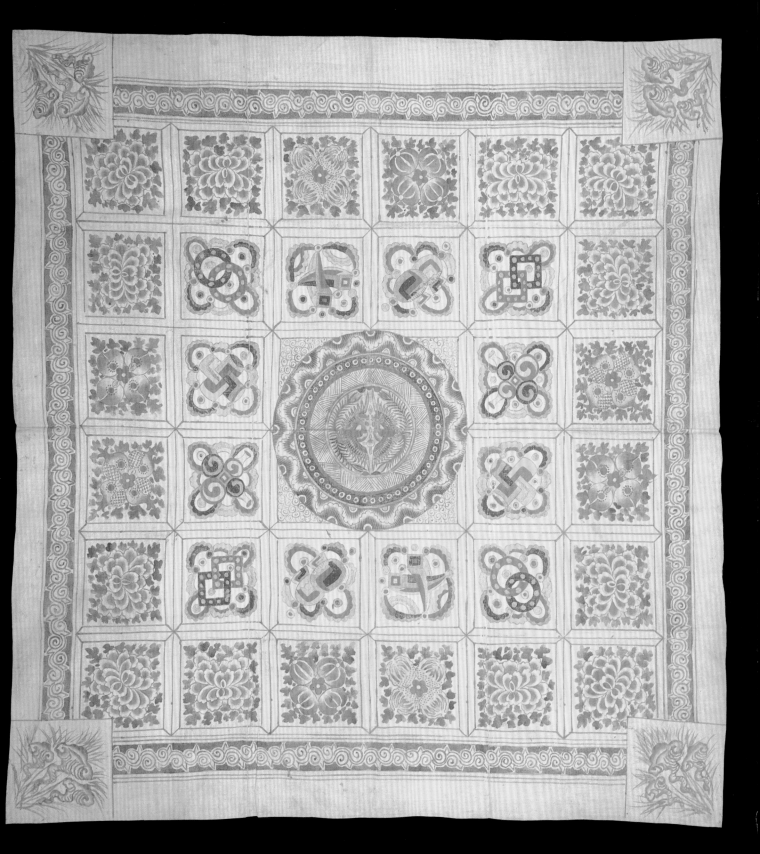

Twentieth-century textile art is represented here by a decorative tassel composition by Kim Ŭn-yŏng (Kim Eun Young), (66). The Korean art of braiding and knotting, *maedŭp*, has close parallels in China, but developed in a distinctively Korean direction. It is still practised today, mostly by women artists such as Madame Kim. Tasselled ornaments have a long tradition in Korea. Koguryŏ wall paintings and Koryŏ and Chosŏn dynasty Buddhist images all show that tasselled ornaments were worn on clothing and hung on door, window and blind fittings. A decorative clothing piece consisting of cord, jewels, knotting and tassels is known as *norigae*. Coral, amber, gold and silver could all be used, as well as the jade pieces shown in the illustration. Like all Korean dress and ornament, tasselled decorations were designed for a specific season, to be worn by a person of a specific rank. The royal family's ornaments were the most sumptuous, followed in order of rank by those of ladies of noble family. Tasselled decorations were either attached to the jacket tie or to the skirt band.

The tying of *maedŭp* is extremely complex. Beginning with the teasing out of silk strands to form the thread, the artist controls every stage of the production and dying of the thread or braid, the weaving of the knot patterns and the composition of the piece. A successful *norigae* reflects the harmonious proportions of the short jacket and full skirt of the *hanbok* in the relationship between the jewel-piece and the tasselling.

66
DECORATIVE TASSEL
WORK
Silk and jade
By Kim Ŭn-yŏng
1991
Length 39.2 cm
FE.426-1992

Furniture and Lacquer

ISTORIANS believe that in Korea the transition from life in dug-out pit dwellings to above-ground wooden houses coincided with the end of Korea's Bronze Age around 300 BC. The earliest surviving pictorial evidence of life in Korea is found in the tomb paintings of the early Koguryŏ capital at Kungnaesŏng, north of the Yalu river in what is now north-east China, and in P'yŏngyang, where the Koguryŏ kings moved their court in 427. Among many depictions of people in everyday life there is a scene of two servant girls carrying food on a portable table to their master and mistress who are seated on the floor, while receiving guests who may be monks. Together with other tomb paintings and a few rare pieces of furniture excavated from Koguryŏ tombs, scenes such as this confirm that Korea has been a floor-sitting culture for at least 1,500 years.

To understand the setting in which Korean furniture was viewed and used, we must look first at the layout and organization of the Korean house. It seems probable that the intense cold of the winters was the inspiration for the ingenious system of underfloor heating, *ondol*, which is believed to have evolved to its present form during the Koryŏ dynasty (935–1392) and is still in use throughout Korea today. *Ondol* heating channels warm air from a stove in or adjacent to the kitchen through flues running under the floors of the house. The floors were made of stone, covered with clay, and surfaced with a particular kind of oiled paper. It was important to seal the flues perfectly, to avoid the danger of asphyxiation from escaping fumes. Alternating with these *ondol* rooms were corridors and store rooms with wooden floors, *maru*.

In a Korean house with its paper-covered walls and windows and wooden structure, the *ondol* floor was a warm, comfortable place on which to sit during the long freezing winters. Floors in upper-class houses were scrupulously clean, and outdoor shoes were always removed before entering the interior. Large pieces of furniture were placed against the walls. Portable tables and cushions were used in the centre of the room, and in general furniture was rather sparse.

Upper-class households in Chosŏn dynasty Korea were segregated into women's and men's areas. Furniture was designed to fit one or the other: plain, restrained designs and wood grains were thought appropriate for the serious atmosphere in the men's rooms, while more cheerful effects were

Figures from a wall painting in the Tomb of the Dancers, at Kungnaesŏng (Tonggou), 500–600, Koguryŏ period

created for the women's quarters. The master of the household would receive guests, compose poetry or calligraphy, study and read in a formal room designed for the purpose. His furniture included bookshelves, cupboards for stationery and various storage chests, all placed on stands to protect the bases from overheating. Screens with calligraphic inscriptions or hanging scrolls provided decoration. Men sat on mats or low cushions on the floor in a cross-legged position, or squatted on their heels, supporting back and arms when necessary with long thin cushions.

In the women's rooms, brightly coloured boxes containing jewellery and sewing materials were always found, and there were screens painted or embroidered with images associated with femininity and conjugal happiness: love birds, flowers, insects and plants. Storage chests for clothes, stationery chests and open-shelved units to display decorative objects were found in both areas of a well-to-do house. Plain chests were used as money boxes, medicine chests, kitchen cabinets and the like.

The most simple and widespread type of furniture in Korean homes was a front-opening chest known as *pandaji*, meaning 'half-closing chest'. Often referred to in English-language descriptions as 'blanket chests', these front-opening chests were in fact normally used to store clothing. Front-opening chests were made all over the country, from local woods and with metalwork fittings of brass or iron. Korean cabinet-makers were fortunate to have a wide variety of fine woods at their disposal. Zelkova (a variety of elm), grows in the southern part of the country, and paulownia, pear and pine grow throughout the country.

The front-opening chest (*67*) is framed and panelled with zelkova. The front panels are *Zelkova serrata* Makino, a hardwood known for its dramatic

Men's quarters (*above*), after a room-set in the National Folklore Museum, Seoul

a wardrobe chest
b book chest
c screen
d oil lamp
e large cushion
f armrest
g inkstone box
h writing table
i ashtray
j small cushion
k pair of stationery chests
l book and display stand

67 (*opposite*)
FRONT-OPENING CHEST
Zelkova wood with brass fittings
1880–1900, Chosŏn dynasty
85.2 × 98.5 × 45.7 cm
863-1905

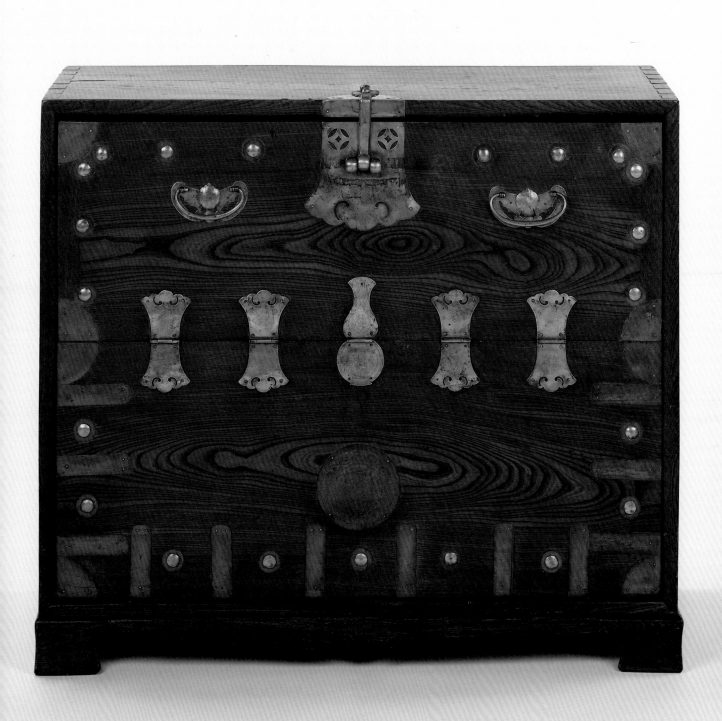

grain pattern. The central brass hinge plate is in the form of a gourd. Two side hinges are in the shape of *hopae*, identification tags carried by commoners and aristocrats alike in Chosŏn times. The curved handles on the hinged section of the chest front are in the form of bats, which were believed to be lucky because one of the Korean words for bat, *pok*, is a homonym of the word meaning happiness, and because the bat is a symbol of longevity. In addition to the decorative brasswork already mentioned, the chest also boasts a large circular plate incised with a pattern of bats and a scroll, twenty-one discs with flat nail heads, ten flat strengthening bands and segmental corner pieces on the opening and fixed parts of the front. Despite the profuse decoration, however, the beauty of the wood grain pattern is not obscured and the overall effect is quiet rather than ostentatious.

A further example of zelkova wood cabinet-work is a latticed book cabinet dating from the nineteenth century, (68). Here, in contrast to the large panels covering the entire front of the front-opening chest, the modest-sized zelkova panels are placed only in the two central lower doors, where their strong grain contrasts with the plain pine outer panels. This two-level cabinet, which is otherwise framed and built of pine, consists of a rectangular structure set on short legs. Its overhanging top surmounts two sections of equal height, each consisting of four doors across the entire width. The fittings of ring pulls and key plates, as well as the interior door hinges, are of iron. A stain or coat of clear lacquer has been applied to the external surfaces.

68 (opposite)

BOOK CABINET

Pine and zelkova wood with iron fittings
1800–1900, Chosŏn dynasty
Height 103 cm
FE.9-1984

Women's quarters (*below*), after a room-set in the National Folklore Museum, Seoul

a screen
b oil lamp
c large cushion
d armrest
e backrest
f charcoal brazier
g small cushion
h low storage chest
i mirror box
j stationery box
k sewing box
l clothing storage chest
m pair of wedding boxes
n wardrobe chest

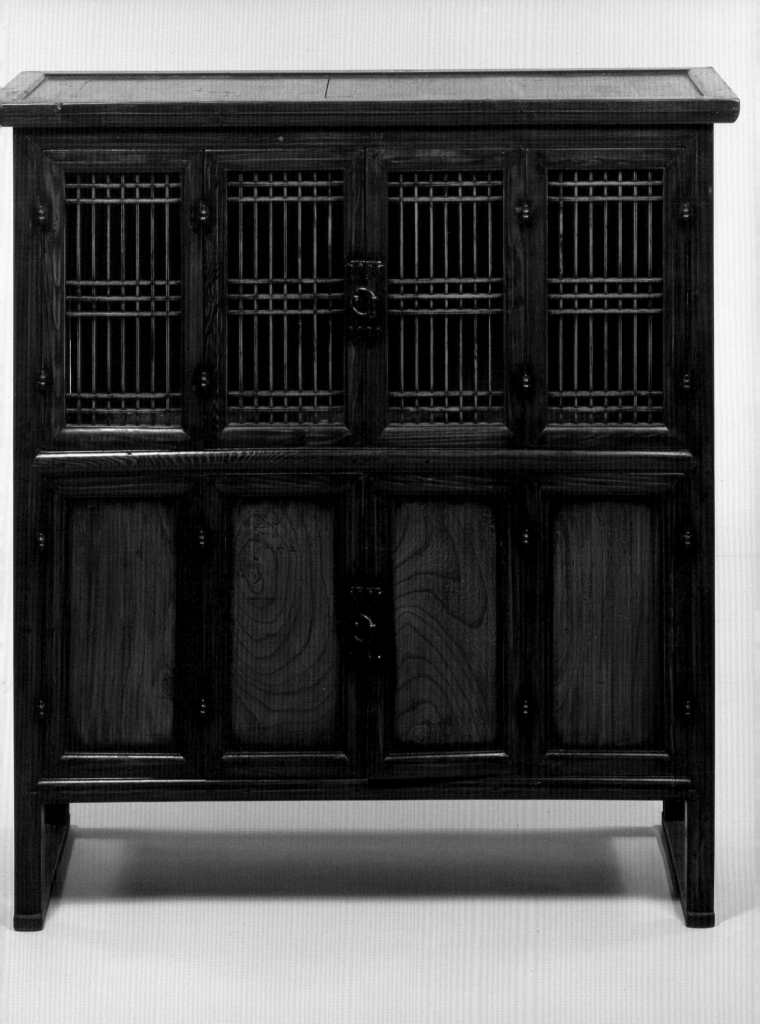

The two preceding pieces of furniture would have been found in the living area of a fairly well-to-do home in Korea. In the area of the dwelling devoted to food storage and preparation one could have found a cabinet like the three-tier kitchen chest, (69). Framed in pine with many small zelkova panels dividing the main surfaces, it is composed of a single-level chest on top of a two-tier chest. A central door with iron hinges and lock fittings gives access to each section, all of which have bases. The cabinet stands on short legs, and there are plain aprons below the front and sides of the bottom tier. On the top level, a pair of drawers veneered in zelkova surmounts the door section. In contrast to the heavy use of metal plates we have noted on some other pieces of fine and utilitarian wooden furniture, the attraction of this type of kitchen cabinet lies in the natural pattern of the wood grain.

69

KITCHEN CHEST

Pine and zelkova wood, with iron fittings

1800–1900, Chosŏn dynasty

172 × 116.5 × 53.5 cm

FE.10-1984

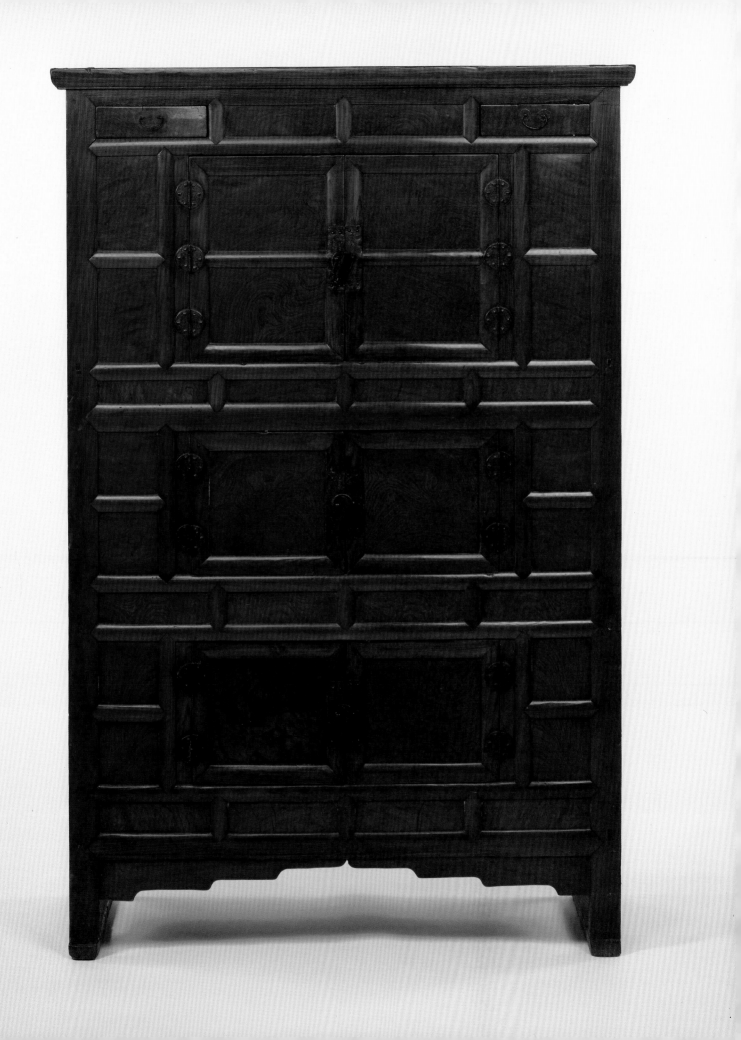

A small mirror box for cosmetics and toiletries, (70), has a zelkova veneer on the outer sides. The hinged lid is composed of a framed veneer of amboyna, a decorative timber. The box is generously fitted with chased brass plates on the handle, lock and hinges, in the shapes of auspicious characters or animals. The central hinge on the lid, which lifts back to form a support for the mirror, takes the form of the character meaning 'long life'. Boxes like this one formed part of a bride's dowry, in which she would keep trinkets, combs, make-up and hair ornaments. The mirror is of silvered glass.

The use of lacquer for the decoration or protection of furniture is widespread in East Asia. The lacquer tree, *Rhus verniciflua*, grows in the mountainous areas of northern Korea near the east and west coasts, and in areas of south-central Korea, including the hills near Wŏnju, Kangwon province (see map p.15). The collection and application of true lacquer, the sap of various species of the *Rhus* tree, is a carefully controlled process. Incisions are made in the bark, and the sap which drips out is collected in containers hung around the trunk before being strained and stored ready for application.

Lacquer can be applied to various surfaces, including wood, metal, ceramics, paper and cloth. The most common base for Korean lacquer is wood, often with a covering layer of cloth or paper. Each coat of lacquer must be left to dry before the next is applied. Since lacquer is extremely toxic, it has to be handled with care.

While clear lacquer in raw or processed form is a finish for hardwood furniture, the greater complexity of the craft of inlaying coloured lacquer with mother-of-pearl, and sometimes with metal wire, has led art historians to study Korean lacquer art separately from furniture finishing in general. Mother-of-pearl is the inside surface of the abalone or conch shell, and the best quality shell is said to come from Cheju Island, in the far south. Two main types of inlay are known: ground shell (*kkŭnnŭmjil*), and whole shell (*najŏn*). Indeed, providing a background for designs inlaid in mother-of-pearl was the most common reason for applying lacquer decoratively in furniture decoration in the Koryŏ and Chosŏn periods. Korea never produced the carved lacquers so admired in China.

Lacquer inlay is an extremely skilled and costly process which is as valued in Korea today as it was in earlier times. As part of a programme to preserve traditional crafts skills, the government of the Republic of Korea has recognized the art of inlaying mother-of-pearl into lacquer as an 'Important Intangible Cultural Property' of the country. Specialist craftsmen are paid a monthly stipend to enable them to pursue the craft and to transmit their knowledge to the younger generation.

70
MIRROR BOX
Zelkova and amboyna wood, with brass plates
1800–1900, Chosŏn dynasty
11.5 × 17.8 × 21.2 cm
M.399-1912

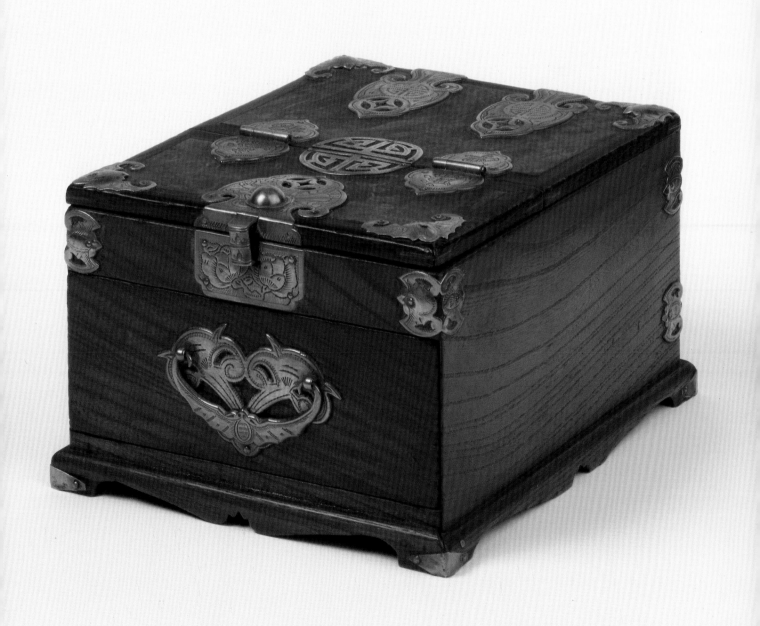

A craftsman inlaying mother-of-pearl into lacquer
Photograph by Kim Tae-byok

The technique of inlaying lacquer with mother-of-pearl was described by Kim Won-Yong, in *The Arts of Korea* (1966):

Modern lacquer workers use native pine wood as a base because pine is best suited for lacquer application. The wooden vessel is well polished with paper before the application of raw lacquer. After a lapse of seven to ten hours for drying, any holes or indented parts of the vessel are caulked with a filler made of sawdust, boiled rice and raw lacquer. Hemp or cotton cloth is then pasted over the vessel with a glue made of fifty-five per cent of raw lacquer and forty-five per cent of boiled rice. After another coating of filler to make the surface even, pieces of shell are pasted on with fish glue and pressed with a hot iron. Layers of lacquer and glue are then coated all over until they conceal the surface of the shells. It is then polished with whetstone and ginkgo wood charcoal in turn until the surface of the shell is exposed to reveal the design. Finishings of finer lacquer are applied at intervals between the charcoal polishings. Finally, the vessel is polished with tooth powder and soya bean oil to obtain a glossy surface.

The history of Korean lacquer was once thought to begin with the Chinese-influenced products of the Lelang (Nangnang) period (108 BC– AD 313), but recent excavations have proved that the earliest Korean lacquers were made in the Bronze Age (800–400 BC). Fine plain black lacquered wooden vessels excavated at Taho-ri, South Kyŏngsang province, dating from the first or second centuries BC are evidence of the development of a tradition of wood lacquering, independent of Chinese influence.

The Paekche (18 BC– AD 663) and Silla (57 BC– AD 935) kingdoms both left evidence of accomplished, technically impressive lacquer production. Tombs of kings and nobles have yielded exciting finds, such as the lacquered headrest and footrests decorated in gold leaf from the tomb of King Muryŏng of Paekche (reigned 501–23). Fine Korean Buddhist lacquers preserved in Nara testify to the vital influence of Korea in transmitting the skill of lacquer decoration to Japan. It is also clear that many practical wooden objects were lacquered to protect and decorate them. Bowls, plates and ornaments excavated at the royal palace at the Pond of Geese and Ducks, Anapchi, Kyŏngju (see p.36), are evidence that the royal household made wide use of lacquer wares. Many red and black lacquered vessels from tombs of the Silla kings have also been excavated at Kyŏngju.

Black lacquered wooden ritual dish from Taho-ri, Kyŏngsang province, about 100 BC National Museum of Korea, Seoul

A few outstanding examples of inlaid lacquer from the Koryŏ period (935–1392) survive. Xu Jing, the Chinese envoy whose account of his visit to Korea has already been mentioned (p.40), wrote of the high quality of inlaid Koryŏ wares. Given that the Chinese generally assumed the superiority of their own artistic production to all others as a matter of course, it is certain that Korean inlaid lacquer wares seen by Xu Jing were extremely impressive and distinctive. In particular, he mentioned that saddles decorated with lacquer inlaid with mother-of-pearl were of fine quality. Koryŏ lacquer is noted for floral designs in mother-of-pearl, set off by gold and silver in some instances. Metal wire was also inlaid, to represent the branches and stems of plants. Inlay was a favourite technique of Koryŏ craftsmen, whether they were working in metal, ceramics or lacquer.

Comparison of the decorative styles of Koryŏ and Chosŏn (1392–1910) lacquer ware shows a shift from precise, repeating patterns to a more fluent representational style. While the dating of many Chosŏn pieces remains problematic, the distinction between the lacquer ware of the two dynasties is fairly easy to draw. From the Koryŏ period, it is chiefly lacquered objects made for Buddhist temples that survive, whereas from Chosŏn personal and domestic products such as boxes, tables and trays predominate.

A fine lacquer box with mother-of-pearl, tortoiseshell and metal wire inlay, (71), belonged to a well-to-do lady who would have kept precious possessions in it. The sides of the dark brown lacquer box have a lotus design. The top and longer sides have two blooms and the shorter sides have one. On the front panel and the lid, the flowers are joined to a small tortoiseshell flowerpot by a stem made of twisted brass wire. The sides of the lid are decorated with auspicious signs, and rows of inter-spaced lozenges form an ornate border to the front panel of the box. Close examination reveals that the flower blooms are made of small pieces of mother-of-pearl fitted together. The stylized decoration and the rather coarse execution of the inlay suggest an eighteenth-century date for this box.

Both this and another exquisite Chosŏn inlaid lacquer box, (72), came from the collection of Sir Harry Garner, the foremost Western collector and scholar of East Asian lacquer. The second box is reinforced at the corners by wire straps and has a hinged lid. Some parts of the box have been given a grey undercoat, which can be seen through cracks in the lacquer. The base and interior of the box are lacquered chocolate brown, without any undercoat. From its shape and size, it seems likely that this box was used as a document container. All the edges carry strengthening bars of plain brass held in place by pins. Large brass lock plates, decorated with scrolling foliage, hold the lock which secures the lid. The top and the four sides are decorated with large, thick pieces of mother-of-pearl inlaid to form a continuous design of vine leaves, grapes and squirrels. The squirrel and vine decorative scheme is

71

BOX

Wood, covered with lacquer inlaid with mother-of-pearl
1700–1800, Chosŏn dynasty
42 × 44.8 × 23.5 cm
FE.84-1974
Garner Gift

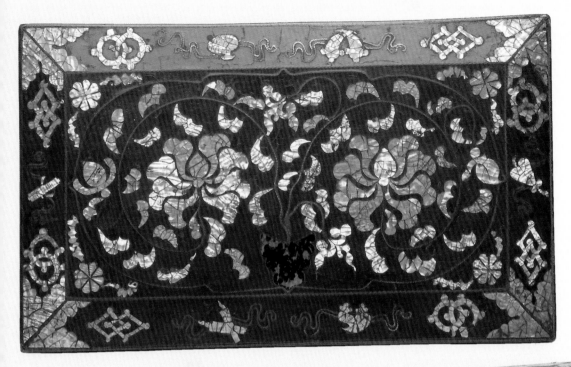

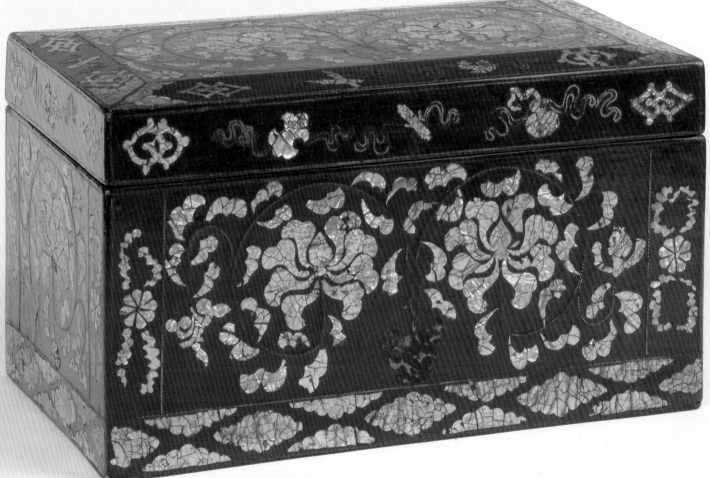

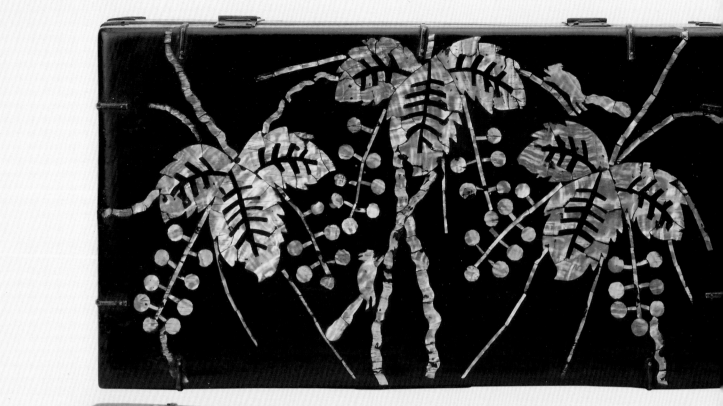

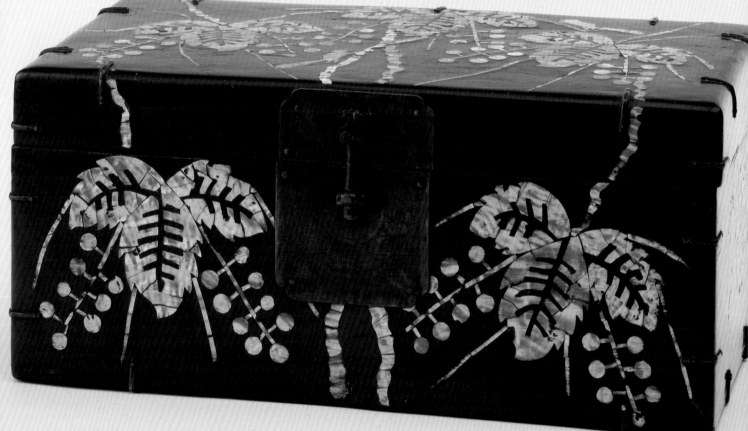

72 (opposite)
BOX WITH HINGED LID
Wood, covered with lacquer inlaid
with mother-of-pearl
1550–1700, Chosŏn dynasty
40.9 × 22.6 × 18 cm
FE.2-1983

73 (overleaf)
STACKING CHEST
Wood, covered with lacquer inlaid
with mother-of-pearl
1890–1910, late Chosŏn dynasty
83.9 × 38 × 142.1 cm
FE.226-1974
Hardcastle Gift

familiar on eighteenth- and nineteenth-century Chosŏn porcelains, and indicates that the box was made in the eighteenth century.

The red lacquer and mother-of-pearl stacking chest, (73), makes lavish use of brass plates and hinges to strengthen and enhance the simple box construction. Chests of this kind are known in Korean as *nong*. The two boxes are not joined, but simply sit on each other. The doors are two thicknesses of pine, and the rest of the chest is simply made of pine, with the sides tenoned into the top, back and front. All the corners and edges of the separate sections and of the doors have decorative or hinge plates, which, like the central lock plates, have incised motifs of flowers and foliage sprays. Each chest is divided into a number of separate panels, with scenes showing figures in a landscape with pine trees, rocks and fish with passing travellers, and pavilions in wooded surroundings. The overall effect is one of cheerful exuberance, and although the lacquer in some places is a little thin, and the mother-of-pearl discoloured, the impression of luxurious well-being is undiminished.

The stand protected the base from heat radiating from the *ondol* floor. Since the chest was designed to be placed against the wall, the back is undecorated. It was used to store special and out-of-season clothing in an upper-class household.

During most of the Chosŏn dynasty (1392–1910) strict sumptuary laws limited the use of red lacquer to the royal household. By the last decade of the nineteenth century, however, the government had lost control over the workshops producing lacquer wares, and over other centres of craft production. Customers were thus able to order lavishly decorated red lacquer wares, and for this reason a number of highly decorated inlaid lacquer stacking chests from the last years of Chosŏn have survived in private and museum collections. A few outstanding examples can even be traced to the royal palaces of nineteenth-century Seoul. The chest shown here was bought by an English traveller to Korea in the 1930s, Miss Christobel Hardcastle, who later presented it to the Museum.

A wooden ornament box decorated with lacquer and mother-of-pearl, (74), would also have been part of the personal furniture of a well-born Korean lady. It has a hinged lid which opens to support a mirror. The front is divided into two drawers. Mother-of-pearl decorates all the visible exterior surfaces. On the drawers are peonies and on the hinged lid cranes and peach trees. The largest pieces of mother-of-pearl are about ten centimetres wide. The box is joined by glue and pins, and stands on a wide scalloped-edged base.

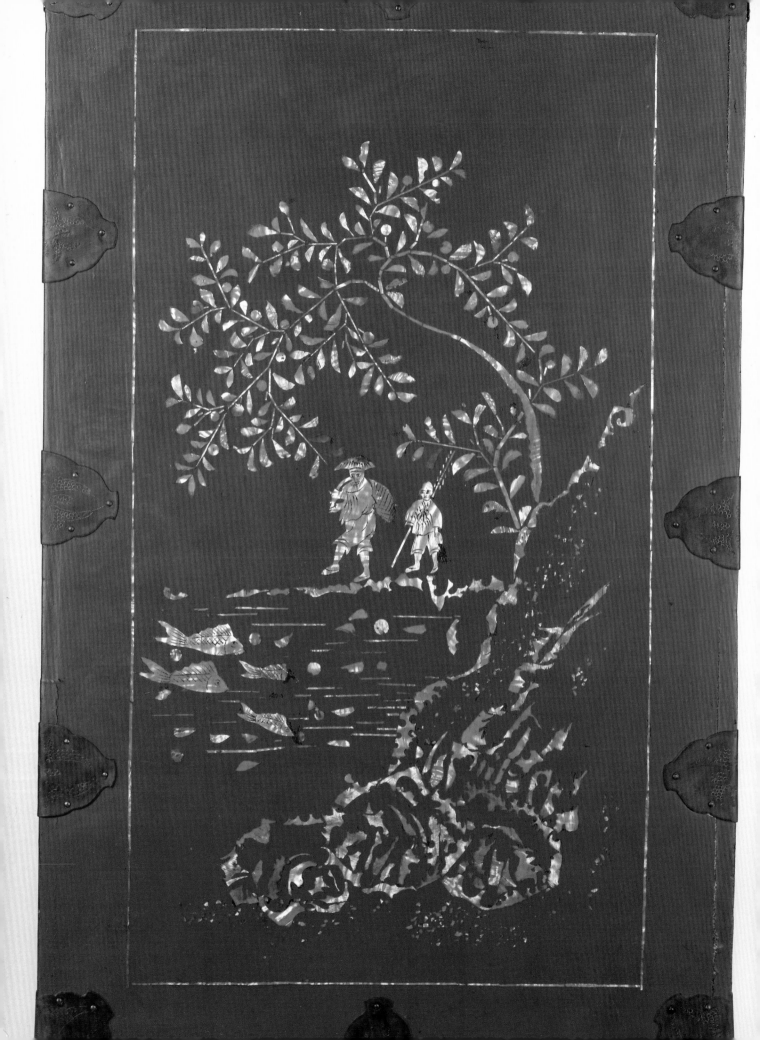

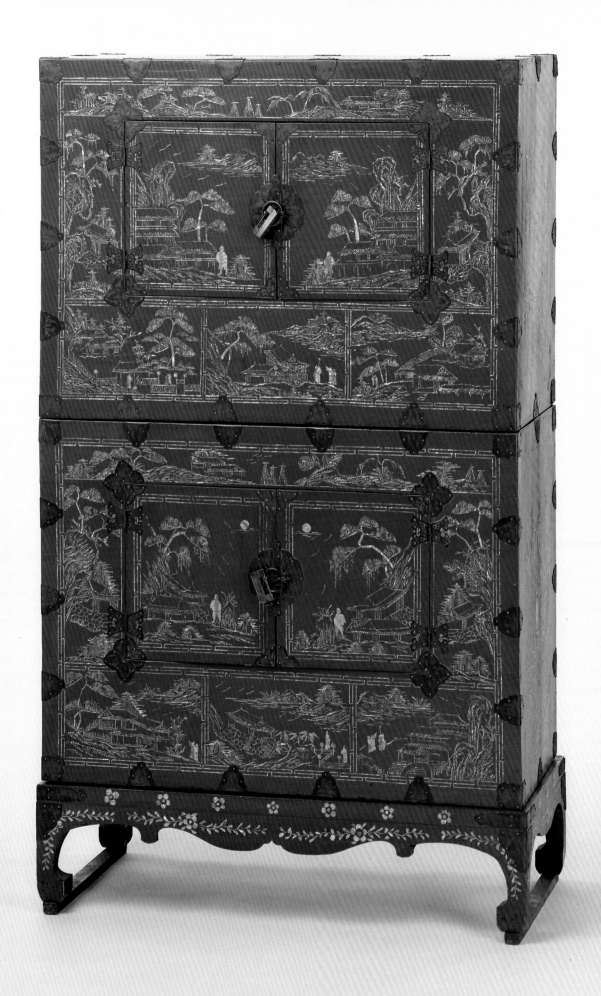

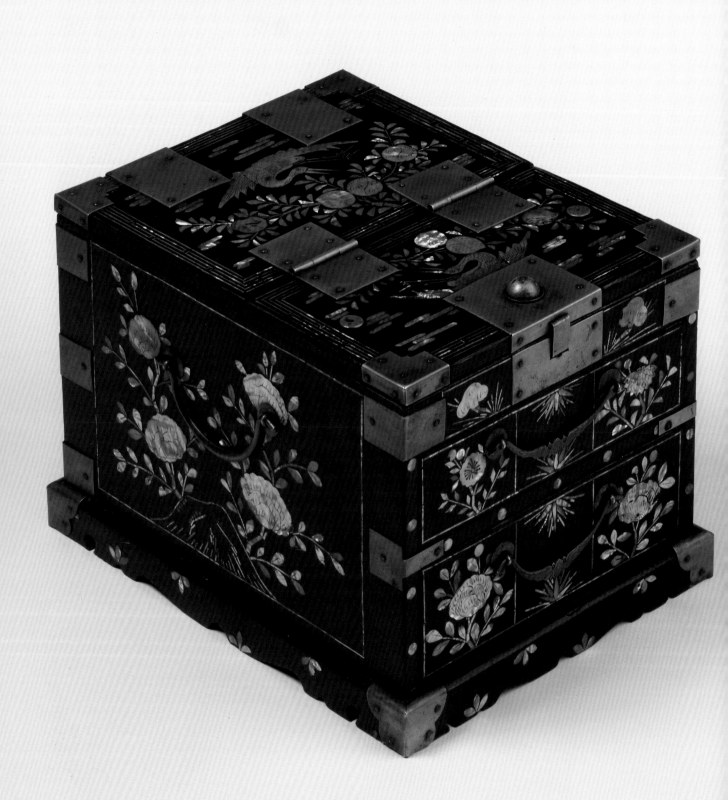

74
BOX FOR ORNAMENTS
Wood, covered with lacquer inlaid
with mother-of-pearl
1800–1900, Chosŏn dynasty
23 × 29 × 19.6 cm
FE.54-1991

The top of a low bow-legged table, (75), is inlaid with a cheerful flower-and-bird scene, framed by a border of rocks, trees and pavilions. Large, thick pieces of mother-of-pearl form the prunus branch with perching birds which dominate the composition. Smaller pieces of shell were used for the stylized figures, plants and landscape complementing the main decoration.

An unusual form of surface decoration is seen in the brightly painted box, (76), decorated with strips of painted ox horn known as *hwagak*. The box has a lid, secured by a vertically joined brass lock on a large circular plate. The predominant colours, yellow and green on a red ground, are typical of ox horn painted decoration. Each panel comprises a self-contained scene, and the recurring images of deer, tigers, peonies and rocks, love-birds, birds of prey and so on are well-known in late Chosŏn dynasty arts of all media. Many of the decorative motifs carry implied meanings that would be immediately apparent to a Korean: the deer stands for long life, the birds augur a long and happy marriage and the tiger protects against evil.

Painted ox horn decoration is an extremely laborious and time-consuming technique which requires an ox horn to be soaked in warm water or steamed, flattened, separated into thin, translucent layers, cut into regular-sized squares or rectangles and reverse painted. Different grades of horn produce different effects, and the best quality horn, which comes from mature bulls, and has an even texture, is much sought after. Recent changes in animal husbandry practice in Korea have made it difficult to obtain the large pieces of ox horn required to make boxes in this design, because today the oxen are slaughtered when they are about two years old, rather than at the age of five or six which is needed for the horn to grow to the size seen here.

The decorated horn was glued to the frame, with the painted side facing the wood, so the design showed through to the undecorated horn surface. The robust outer surface of the horn could be polished to a brilliant finish, protecting and displaying the painting on the inside. The most serious disadvantage of painted ox horn decoration is that the horn panels are highly susceptible to changes in atmospheric conditions. Significant alterations in temperature or humidity cause splitting and cracking of the horn panels, which then curl away from the wooden frame underneath. Many older pieces are in poor condition for this reason. In preparation for its display, the box shown here required extensive repair.

The technique of ox horn decoration is unique to Korea, and is found in the form of sewing boxes, small chests, and clothes boxes used by high-born women. Ox horn chests for writing materials or books and scrolls also survive in significant numbers.

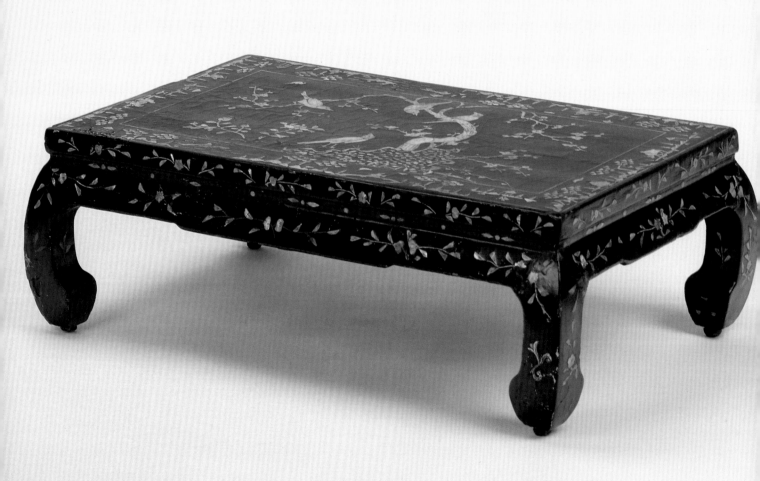

75 (*left*)
TABLE
Wood, covered with lacquer inlaid
with mother-of-pearl
1800–1900, Chosŏn dynasty
99.7 × 64.5 × 33.5 cm
FE.34-1991

76 (*right*)
PAINTED OX HORN BOX
Painted ox horn on wood with
brass fittings
1880–1910, late Chosŏn dynasty
50.8 × 27.9 × 24.5 cm
W.38-1920

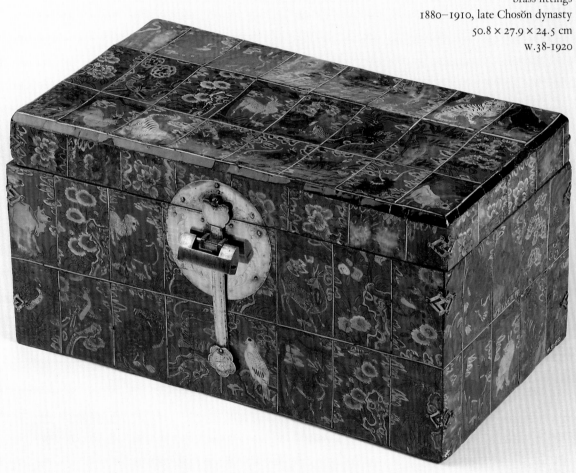

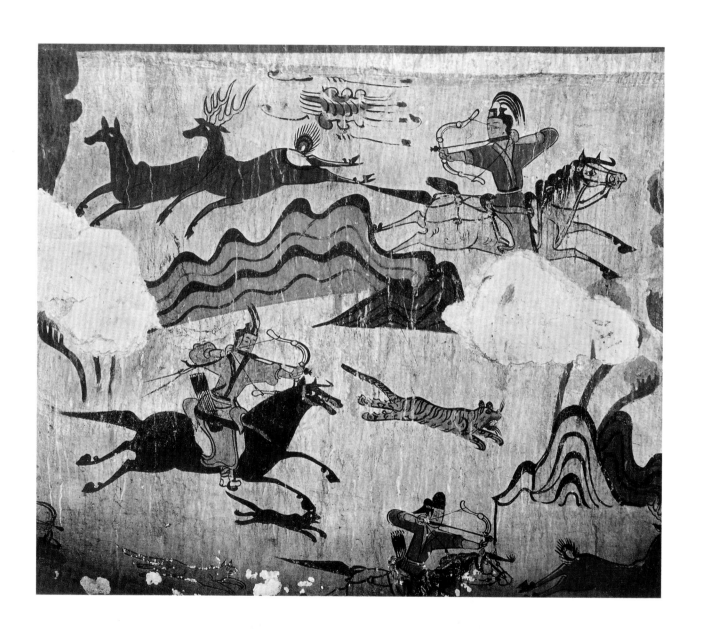

Screens and Paintings

KOREAN screens are known as *pyŏngp'ung* meaning 'protectors from draughts'. As a floor-sitting people, whose houses were divided in to rooms by paper windows and lattice work, Koreans used screens as a practical and aesthetically pleasing means of keeping the warmth in and dividing up the living spaces flexibly. Until fairly recent times, most Koreans regarded only court and palace screen paintings as being worthy of attention. An upsurge of interest in popular tradition and folk art in general has now led to heightened interest in screens painted for commoners.

A four-panel screen, (77), showing hunters in a fantastic landscape, exemplifies the martial skills in which officials of the military class were expected to excel. The seated figure of a prince or general surveys the scene from beneath his luxurious canopy on the far right. The riders and bearers both wear Mongolian-style fur jackets over their loose clothing. The attendants dressed in red boots and hats are shown presenting a tiger trussed up and tied to a carrying pole for their master's inspection. A drummer is preparing to sound a celebratory salvo. Tiger skins were highly prized, and were used as chair or sedan covers by high-ranking noblemen. Elsewhere, another tiger, some deer and a pair of cranes are also under attack from the hunters, who pursue their prey with spears, bows and arrows.

Competing for our attention with the potentate in his canopied splendour is the enormous, upstanding tiger, under attack by two hunters bearing spears. Although the screen has been painted to form a continuous whole, with gentle slopes in the foreground receding into distant mountains, each panel can be viewed as a separate episode, to be seen without reference to the other parts. This was not uncommon in screen painting, because the artists must have anticipated that part of their work might be folded away from time to time.

Subdued browns and creams predominate in the main part of the screen, lightened by the horse-riders' pennants, the gay green and ochre of the hunters' clothes and the magnificent trappings of the watching lord, who sits reading at a low table in front of a screen, waiting for his servant girl to serve his wine. The overall mood is one of celebration and enjoyment, and even the tiger seems more friendly than ferocious.

Wall painting of mounted hunters from the Tomb of the Dancers, at Kungnaesŏng (Tonggou), 500–600, Koguryŏ period (*left*)

77 (*overleaf*)
HUNTING SCENE SCREEN
Colours on paper
1800–50, Chosŏn dynasty
106 × 255.5 cm
(dimensions of painting)
FE.22-1991

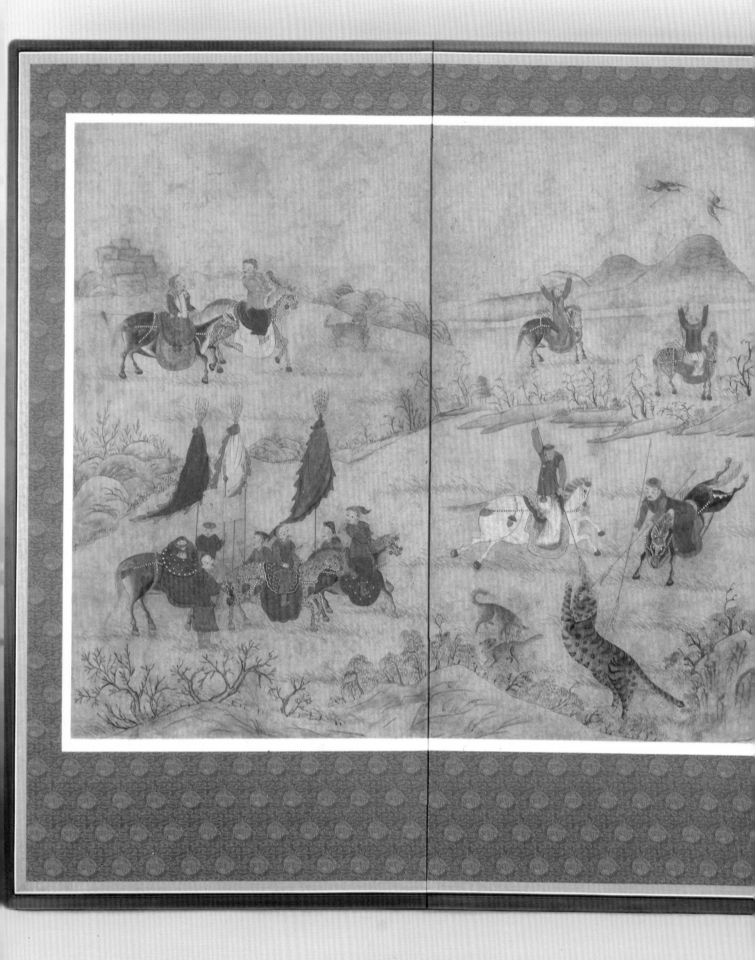

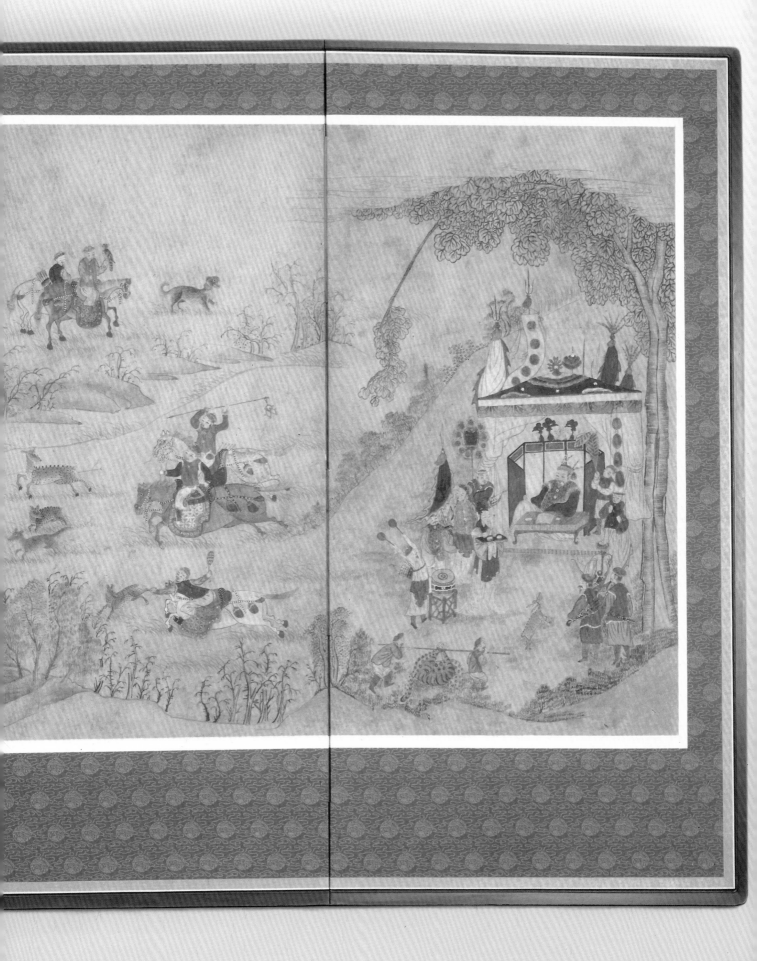

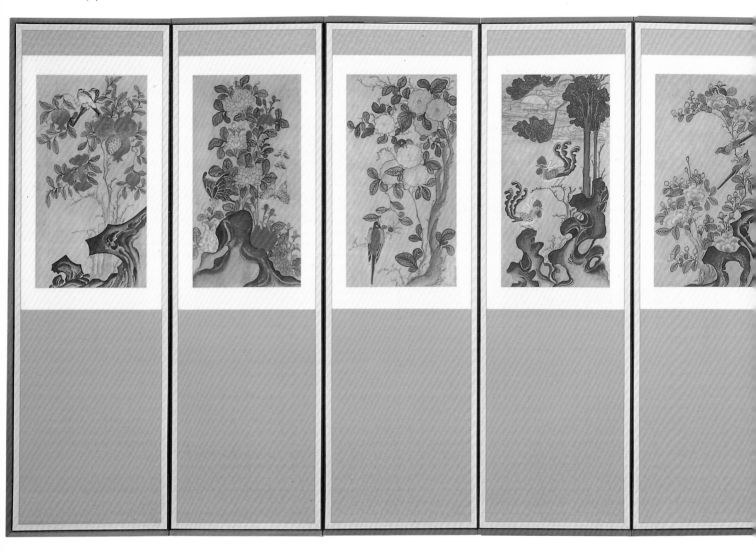

Hunting scenes are one of the oldest subjects in Korean painting. An extremely famous Koguryŏ tomb painting of the fourth to sixth centuries shows hunters in hot pursuit of their quarry, one rider shooting backwards at a deer while another fires at a tiger (see p.170). Until the nineteenth century, country people lived in fear of tigers, who preyed on any possible source of food, especially in the hard Korean winter, when they left their mountain habitat and came down to inhabited areas. The people of Koguryŏ, the northernmost of the Three Kingdoms, had a reputation for being fearsome warriors and hunters, as we know from Chinese historical records. Hunting scenes of the Chosŏn period lack the urgency of the Koguryŏ murals, perhaps because the martial vigour of Koguryŏ had long been overtaken by a peaceable, scholarly temper.

It is typical of Korean hunting screens that the figures are shown wearing Mongol dress. The Mongol empire extended to Korea in the thirteenth and fourteenth centuries (see p.20), and Mongol horsemen were much admired for their riding and martial skills. Fascination with the horsemanship and

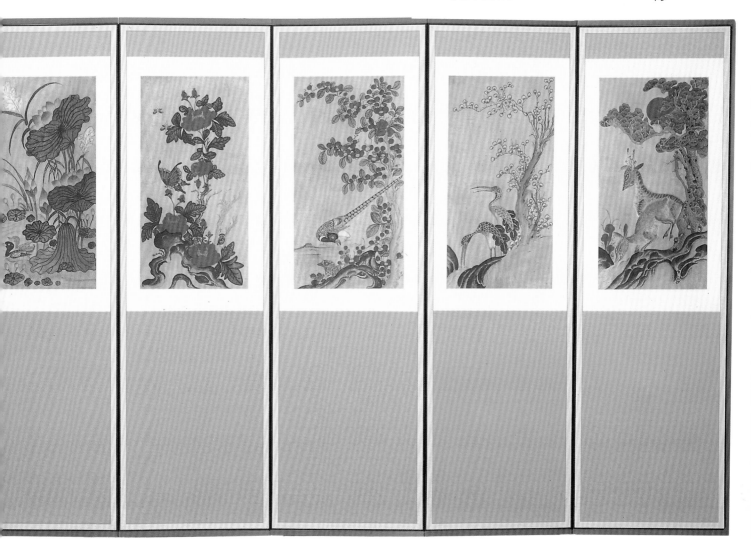

78

FLOWER AND BIRD
SCREEN
Colours on paper
1880–1910, late Chosŏn dynasty
136.9 × 422 cm (each panel
painting 56 × 30 cm)
FE.21-1991

exotic clothes of the Mongols took root in the imagination of Koreans after the wounds of occupation had healed, and stimulated a style of painting that endured for centuries after the Mongols had lost power.

A screen painted for the women's area of a house, (78), is made up of a vibrant series of flower-and-bird scenes. It is a folk painting, and may well have been commissioned by a family from an itinerant artist. Unlike court painters who produced refined works for the élite, folk painters of screens and scrolls were uneducated artisans with low social status. The best of their work finds freedom and vitality in the expression of wishes for a long and happy life and marriage. In this, as in other similar screens, no two panels are alike, but all have the unifying feature of couples. To the Koreans of the nineteenth and early twentieth century who might have used this screen as a decorative draught-excluder, all the animals, birds and plants had an obvious significance. As well as the familiar symbols of longevity, there are flowers representing the four seasons (prunus, magnolia, lotus and chrysanthemum), allowing the appropriate section to be shown for the season of the

year. Each of the scenes shows a pair of creatures, symbols of marital happiness and fidelity.

A late Chosŏn painting, (79), is an Amitābha trinity of gold and colours on hemp. Amitābha (Amitap'ul), the Buddha of the Western Paradise, sits in the lotus position on a magnificent lotus pedestal with his right hand turned outwards in the gesture of reassurance known as the *abhaya mudrā*. His left hand is in the position of liberality, the *varada mudrā*. The Buddha is flanked by the standing figures of two Bodhisattvas, Mahāsthāmaprāpta (Taeseji) and Avalokiteśvara (Kwanseŭm). Two disciples, Ānanda and Kāśyapa, appear in profile in the rear.

Amitābha is twice-haloed, in gold and green. His tightly curled hair rises to a precious jewel, atop his flat countenance with wide-set eyes and long-lobed ears. Avalokiteśvara can be recognized by the small Amitābha image in her head-dress and by the flask she carries. Mahāsthāmaprāpta has a vase in his crown. Both are standing on a pair of pedestals, and wear white under-robes which can be seen below the folds of their splendid, gold-patterned red over-garments. Gold bells hang on pendants from the Bodhisattvas' robes.

Multicoloured wavy rays spread out behind the group, symbolizing the radiating splendour of the Buddha's power. The predominating colours of red and green are characteristic of Korean Buddhist devotional painting. The hemp on which the painter executed the work was sewn together from three separate pieces, and the joining seam is clearly visible. Although the painting has been trimmed and remounted flat at some point in the past, it is in fairly good condition except for some fading and slight loss of pigment.

79
BUDDHIST PAINTING
Colours and gold on hemp
1600–1800, Chosŏn dynasty
101.5 × 102.9 cm
FE.108-1970
Rowland Gift

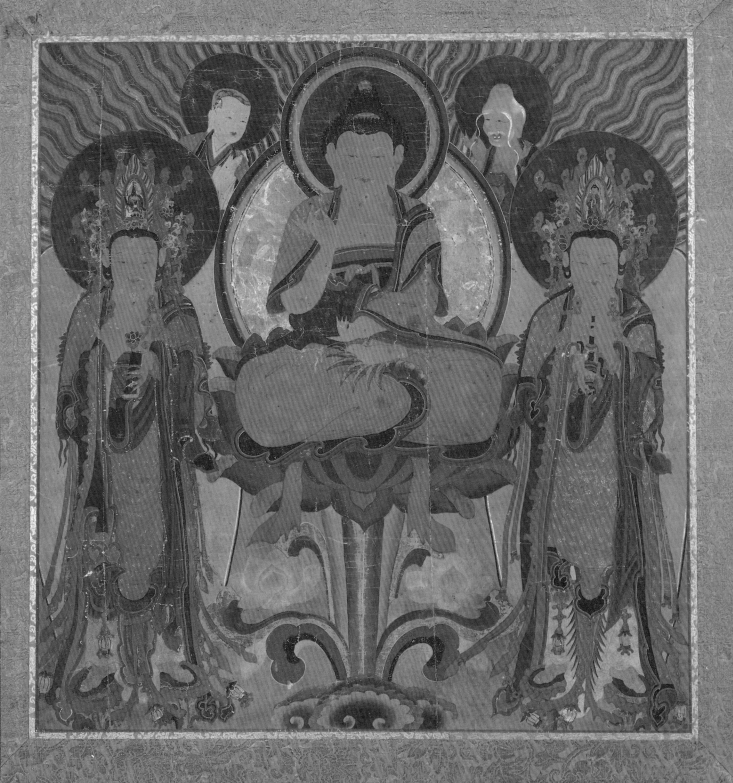

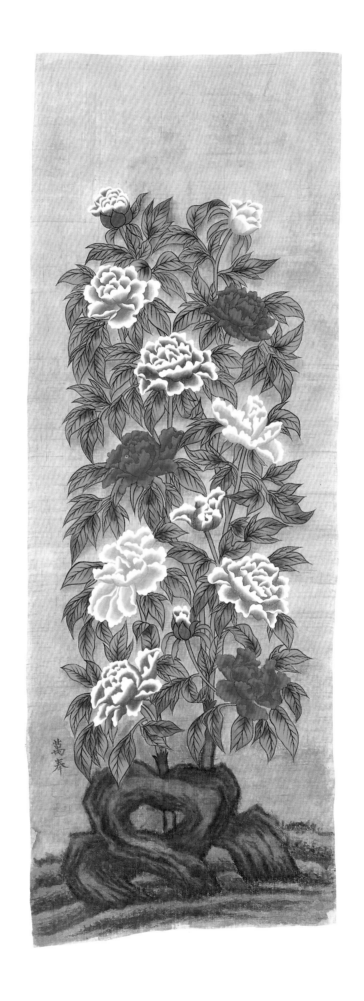

Contemporary Arts and Crafts

SINCE embarking on preparations for the Samsung Gallery of Korean Art, the Far Eastern Collection of the Museum has begun to acquire representative examples of recent Korean work. Conscious that it would be impossible to reflect more than a fraction of the diverse contemporary art scene, it was decided to focus on the ways in which the traditions of the past are being interpreted and reworked today. A number of works made by contemporary craftsmen have been acquired. One of the makers has been recognized as an 'Important Intangible Cultural Property' (IICP) under the Cultural Properties Protection Act of 1962 of the Republic of Korea.

Popularly known as human cultural treasures, artists and performers achieve the status of IICP not as individuals but as practitioners of a skill. In 1989, ninety-five individuals and groups were officially rewarded in this way, because their work was seen to 'increase Korean and international cultural awareness, knowledge and appreciation' of the country's heritage. The process of selecting IICPs is not static; on the contrary, lively debate surrounds the choice of art forms and their representatives. Musicians and dancers, ritual performances, puppets and dramas are listed alongside craftspeople specializing in textile, metal, lacquer and other handicrafts in the official register of properties. Exhibitions are held regularly of outstanding work by IICPs, and they are expected to pass on their knowledge and experience to the next generation.

In selecting a screen panel, (*80*), painted by Yi Man-bong (Lee Man-bong, born 1909) we were influenced by its vibrant floral design. Venerable Man-bong is a Buddhist monk, one of the first three painters designated an IICP for *tanch'ŏng* painting, the brightly coloured architectural decoration and wall painting in Korean temples. Traditionally, *tanch'ŏng* painting was done with mineral colours, but nowadays chemical pigments are generally used because of the scarcity and high cost of mineral paints. The artist works on the floor, crouching over the canvas, which in some cases will extend over several square metres. Having followed the traditional path to mastery of *tanch'ŏng* painting by studying for over ten years with a master of the art, Venerable Man-bong in turn now passes on his skills. His disciples progress from tracing to sketching and on to drawing before they are deemed to have

80
PANEL FROM A SCREEN
PAINTING
Colours on hemp
By Yi Man-bong (born 1909)
1991
166 × 59 cm
FE.44-1991
Purchased with the aid of the
Friends of the V&A

sufficient command of the art of *tanch'ŏng* painting to direct and produce their own work.

The peony heads, painted in intense red, blue, purple and yellow, are dramatically lit up by the use of white pigment to highlight the edges of the full spread-open blooms. One of the hallmarks of *tanch'ŏng* painting is the application of a carefully mixed palette in a sequence starting with the basic colour, followed by accentuation of the outline and highlighting of designs. The immediacy and lifelike quality of the red blooms is achieved through painstaking attention to colour and brushwork. This panel was painted to form part of a large screen for use as a backdrop at important social events.

Korea's strong ceramic tradition is now enjoying a revival after the difficult period in the early twentieth century when occupation by Japan followed by civil war disrupted the normal patterns of life. Although too little known outside Korea, there are many fine ceramic artists at work in the country today, producing studio pottery in both international and native-influenced idioms. The task of selecting ceramics for the new gallery was both difficult and rewarding. Our decision to choose work with echoes of Korea's indigenous ceramic history arose from the conviction that the Museum's audience would be curious above all to know how Korean potters are reinterpreting their own country's ceramic traditions.

The inlaid celadon vase, (*81*), is by Sin Sang-ho (Shin Sang Ho, born 1936), a graduate of Hongik University and an accomplished potter whose work has been widely exhibited in Korea, Europe, the United States and Japan. Narrowing towards the shoulder from a broad flat base, the vase pays homage to the Koryŏ tradition with its spreading rim, small loops at the shoulders, and delicately inlaid pair of white and black cranes in flight. The trunk of a pine tree seems to grow out of one of the edge lines that divide the bottle into irregular facets, and its branches and leaves trail into the lines of the glaze crackle.

Two *punch'ŏng* works, (*82* and *83*), by young potters were chosen because they explore a uniquely Korean ceramic technology in imaginative ways, each realizing a synthesis of the qualities of the present age and its predecessors. Yi Chŏng-do (Lee Jeong Do, born 1953), another graduate of Hongik University, trained in Korea and Japan. He has exhibited in group shows in Seoul. He creates natural, simple forms and textures, and has devoted himself to creating new works in the *punch'ŏng* tradition, the green-grey glazed stonewares with slip decoration of the fifteenth and sixteenth centuries.

On his stamped and inlaid dish, (*82*), he has demarcated three areas of decoration at different levels. The main part is divided by inlaid slip into squares which enclose stamped flowerheads. Two small areas of close-set stamped groups of three lines cover the two wavy-edged sections to the

81 (*opposite*)
CELADON VASE
Stoneware, inlaid under a celadon glaze
By Sin Sang-ho (born 1936)
1991
Height 29.4 cm
FE.41-1991
Purchased with the aid of the Friends of the V&A

82 (*overleaf left*)
DISH
Punch'ŏng ware with inlaid decoration
By Yi Chŏng-do (born 1953)
1991
Diameter 44 cm
FE.42-1991
Purchased with the aid of the Friends of the V&A

83 (*overleaf right*)
BOTTLE
Punch'ŏng ware with stamped and painted decoration
By Min Yŏng-gi (born 1947)
1991
Length 25 cm, height 21 cm
FE.43-1991
Purchased with the aid of the Friends of the V&A

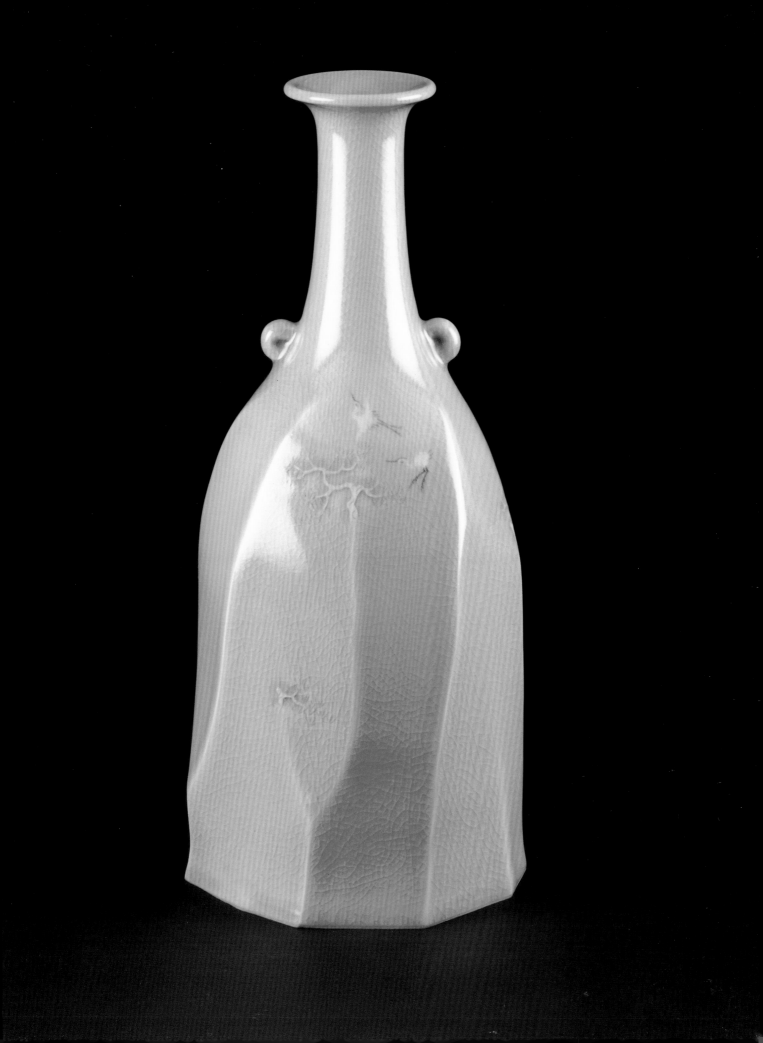

right and left. The pattern of squares enclosing flower heads continues on the external wall, leaving only the base plain.

Min Yŏng-gi (Min Young-ki, born 1947), a native of Sanch'ŏng, South Kyŏngsang province, works in the rough clay of his home town. His interest in *punch'ŏng* has led him to undertake historical studies and investigations of kiln sites in a conscious attempt to gain inspiration from the Korean ceramic tradition. The bottle in the shape of a rice-bale, (*83*), evokes the rustic decoration on *punch'ŏng* of the fifteenth century. A simple thatched house, tree and sun motif is framed by repeating star-like flower-heads and close-set wavy lines.

Paper-making has a long history in Korea, and there is evidence of its manufacture from hemp and mulberry (*Brousssentia papyrifera*) as early as the Three Kingdoms period (see p.17). In both Koryŏ (935–1392), and Chosŏn (1392–1910), beautiful, strong, long-fibred paper was made, which earned a high reputation even in China, where the inferiority of all things foreign was considered axiomatic. This paper was not only printed and written upon, it was also used to paper floors and windows, and to make bags, boxes and umbrellas.

Sewing boxes are among many decorated paper-cut craft works made today by artists continuing the traditions of the past. Paper-decorated objects are made by covering the structure, which is usually of wood, with a few layers of white paper, and applying the coloured papers that form the design. A coat of lacquer then seals and protects the coloured paper. The square box, (*84*), was bought from an exhibition of work by members of the Multicoloured Paper-cut Craft Society at the Museum of Handicrafts in Seoul in 1991. The artist, Yi Mun-cha, was one of twenty-six women displaying recent work ranging from large clothing chests through tables, jewellery boxes and wall-mounted letter racks to sets of sewing boxes and fans. Unexpected colour combinations, like the orange, lime-green and lilac of the lining of the sewing box, give Korean paper-decorated crafts a distinctive appearance. The intricately shaped decorations, which typically include Buddhist symbols, pairs of birds and floral arrangements, continue a popular artistic vocabulary seen earlier in the crafts of the Chosŏn dynasty. This sturdy paper box makes an aesthetically pleasing container, and if a Korean saying is to be believed, it will last a long time: 'Paper lives a thousand years but silk for only five hundred.'

84

SEWING BOX

Coloured and lacquered paper on wood
By Yi Mun-cha
1991
33 × 33 × 12.5 cm
FE.38-1991
Purchased with the aid of the Friends of the V&A

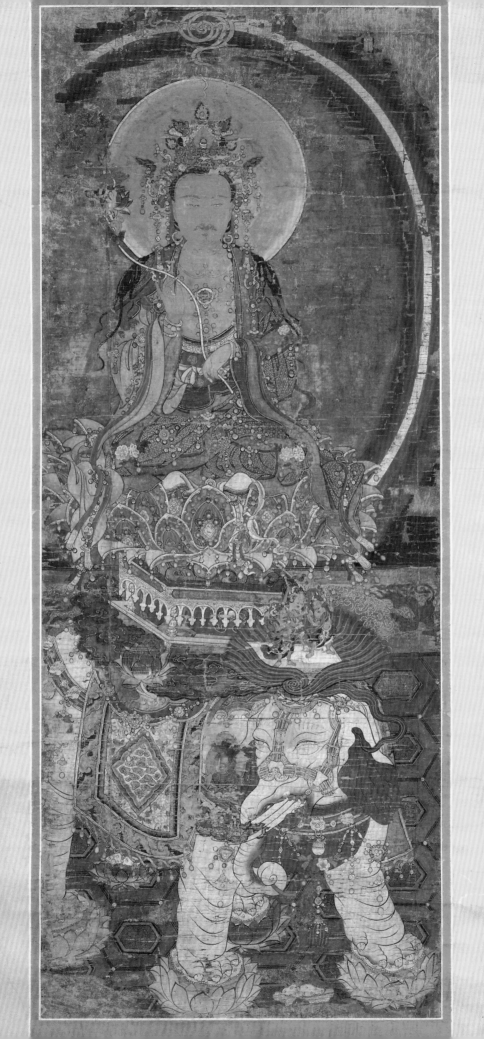

Appendix

AN exquisite painting of the Bodhisattva Samantabhadra seated on a six-tusked elephant, (85), is the subject of academic debate between scholars of Buddhist paintings. When the V&A bought the painting there was broad agreement that it was of Korean origin, but developments in research have led some authorities to believe that it was painted somewhere in China. Further painstaking comparisons of pigments, facial expressions and decorative motifs on the few Buddhist paintings of the period that can be firmly attributed to Chinese and Korean centres will be needed before the question can be resolved. In the late thirteenth and fourteenth centuries, when the work was composed, both China and Korea were part of the Mongol empire, and significant numbers of monks and officials travelled between the two countries. Buddhist temples engaged painters, sculptors and metalworkers to produce images and objects of devotion, but, unless a dedicatory note giving details of who commissioned the painting was in-cluded in the composition, there is no possibility of identifying the place, precise date or authorship of a particular painting, except by stylistic analysis.

Samantabhadra often appeared as the right-hand figure of a triad with the historical Buddha Śākyamuni at the centre and the Bodhisattva Mañjuśrī on the left, and it is likely that the painting illustrated here was originally part of such a group. Samantabhadra was revered in East Asia as the protector of the faithful. He was always depicted carrying a blue lotus, and riding an elephant, recalling the legend that when Śākyamuni Buddha descended to earth, he took the form of a six-tusked elephant.

Close examination of the painting reveals two interesting groups of three and six small figures, on the elephant's fan-shaped mane and on the tusks. The larger figures, which stand on a platform on the mane, represent differ-ent aspects of the Buddha's wisdom and power, and the small figures, who appear to be musicians, sit on lotus cushions.

Samantabhadra bears a precious jewel surrounded by flames in the centre of his splendid crown. Gold has been generously applied to create an effect of opulent grandeur, both on the crown and on the garment and the elephant's trappings. The right hand is in the position of discussion, the *vitarka mudrā*.

During remounting at an unknown time in the past, the painting was trimmed on the left, at the top and the bottom, undoubtedly to remove areas

85
SAMANTABHADRA
RIDING ON AN
ELEPHANT
Colours and gold on silk
1200–1350
139 × 56 cm
FE.51-1976

where the silk had dried and cracked severely. The painting is still in a delicate state, but considering its age it retains a remarkable freshness and immediacy. In publishing the painting of Samantabhadra as an appendix to this book, we hope that the public will enjoy a reunion with a great master-piece of Buddhist art while the academic debate on the painting's origin proceeds towards a new consensus.

Suggested Further Reading

Adams, Edward B., *Korean Folk Art and Craft* [Catalogue of Onyang Folk Museum Collection] (Seoul 1983)

Allen, Horace N., *Things Korean* (New York 1908)

Bishop, Isabella Bird, *Korea and Her Neighbours* (London 1905)

Choi, Sunu and Hasebe, Gakuji, *Sekai tōji zenshū* (*Ceramic Art of the World, volume 18, Koryŏ Dynasty*) (Tokyo 1978)

Gompertz, G. St G.M., *Korean Celadon* (London 1963)

– *Korean Pottery and Porcelain of the Yi Period* (London 1968)

Griffing, Robert P., *The Art of the Korean Potter: Silla, Koryŏ, Yi* [Exhibition Catalogue] (New York 1968)

Hayashiya, Seizo and Chung, Yangmo, *Sekai tōji zenshū* (*Ceramic Art of the World, volume 19, Yi Dynasty*) (Tokyo 1980)

Ho-am Art Museum, *Masterpieces of the Ho-am Art Museum* (Seoul 1984)

Honey, W.B., *Corean Pottery* (London 1947)

Itoh, Ikutarō and Mino, Yutaka, *The Radiance of Jade and the Clarity of Water: Korean Ceramics from the Ataka Collection* [Exhibition Catalogue] (New York 1991)

Kim, Chewon and Kim, Won-Yong, *The Arts of Korea: Ceramics, Sculpture, Gold, Bronze and Lacquer* (London 1966)

Kim, Wonyong *et al, Sekai tōji zenshū* (*Ceramic Art of the World, volume 17, Korean Prehistoric and Ancient Periods*) (Tokyo 1979)

Kim, Won-Yong, *Art and Archaeology of Ancient Korea* (Seoul 1986)

Kim, Young-suk and Son, Kyong-ja, *An Illustrated History of Korean Costume* (Seoul 1984)

Korean National Commission for UNESCO, *Traditional Korean Painting* (Seoul and Oregon 1983)

McCune, Evelyn B., *The Inner Art: Korean Screens* (Berkeley, California and Seoul 1983)

– *The Arts of Korea: An Illustrated History* (Rutland and Tokyo 1962)

Moes, Robert, *Auspicious Spirits: Korean Folk Paintings and Related Objects* [Exhibition Catalogue], (Washington D.C. 1983)

– *Korean Art from the Brooklyn Museum Collection* (New York 1987)

National Museum of Korea, *Beauty of Korea: Traditional Costumes, Ornaments and Cloth Wrappings* (Seoul 1988)

National Museum of Korea, [*Illustrated Catalogue*] (Seoul 1991)

Pak, Youngsook, *Koreanische Tage – Korean Days* [Exhibition Catalogue] (Ingleheim am Rhein 1984)

Rackham, Bernard, *Catalogue of the Le Blond Collection of Corean Pottery, Victoria and Albert Museum* (London 1918)

Rhee, Byung-Chang *et al, Masterpieces of Korean Art* (*3 volumes: History of Korean Art, Koryŏ Ceramics, Yi Ceramics*) (Tokyo 1978)

Suk, Joo-sun, *Clothes of Josŏn Dynasty: The Suk Joo-sun Memorial Museum of Korean Folk Arts, Dankook University* (Seoul 1985)

Wright, Edward Reynolds and Pai, Man Sill, *Korean Furniture: Elegance and Tradition* (Tokyo, New York and San Francisco 1984)

Whitfield, Roderick *et al, Treasures from Korea; Art through 5000 years* [British Museum Exhibition Catalogue] (London 1984)

Whitfield, Roderick and Pak, Youngsook, *Korean Art Treasures* (Seoul 1986)

Yi, Ki-baek [Lee, Ki-baik], *A New History of Korea* (Cambridge, Massachusetts and London 1984)

An exhibition of National Art Treasures of Korea (London 1961)

Index

References to the illustrations of objects from the V&A collection are given in *italics*.
Other illustrations are indicated by an asterisk * against the page number.